RICK SAMMON'S

Travel and Nature Photography

OTHER HOW-TO PHOTOGRAPHY BOOKS BY RICK SAMMON

Rick Sammon's Complete Guide to Digital Photography

Rick Sammon's Digital Imaging Workshops

RICK SAMMON'S

Travel and Nature Photography

W. W. NORTON & COMPANY
NEW YORK • LONDON

Copyright © 2006 by Rick Sammon

Manufacturing by R. R. Donnelley, Willard
Book design by Rubina Yeh
Production manager: Amanda Morrison

Library of Congress Cataloging-in-Publication Data

Sammon, Rick.
 Rick Sammon's travel and nature photography.—1st ed.
 p. cm.
 Includes index.
 ISBN 0-393-32669-1 (pbk.)
1. Travel photography. 2. Nature photography. I. Title: Travel and nature photography. II. Title.
 TR790.S256 2006
 778.9'3—dc22

 2005026367

W. W. Norton & Company, Inc., 500 Fifth Avenue, New York, N.Y. 10110
www.wwnorton.com

W. W. Norton & Company Ltd., Castle House, 75/76 Wells Street, London W1T 3QT

1 2 3 4 5 6 7 8 9 0

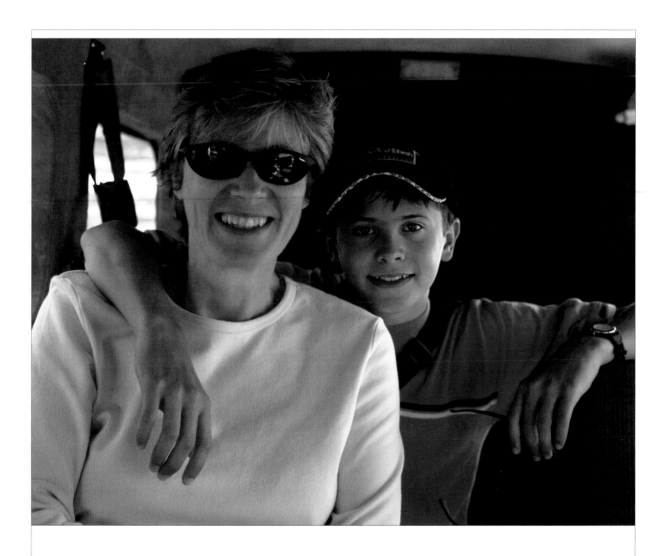

For Marco and Susan

Traveling together—through life and
around the planet—is a wonderful and magical experience

"In the end,
we will conserve only what we love,
we will love only what we understand,
we will understand only what
we are taught."

—Baba Dioum

A tamarin and her newborn and an inspiring quote carved in stone at Jungle World
at the Bronx Zoo, home of the Wildlife Conservation Society

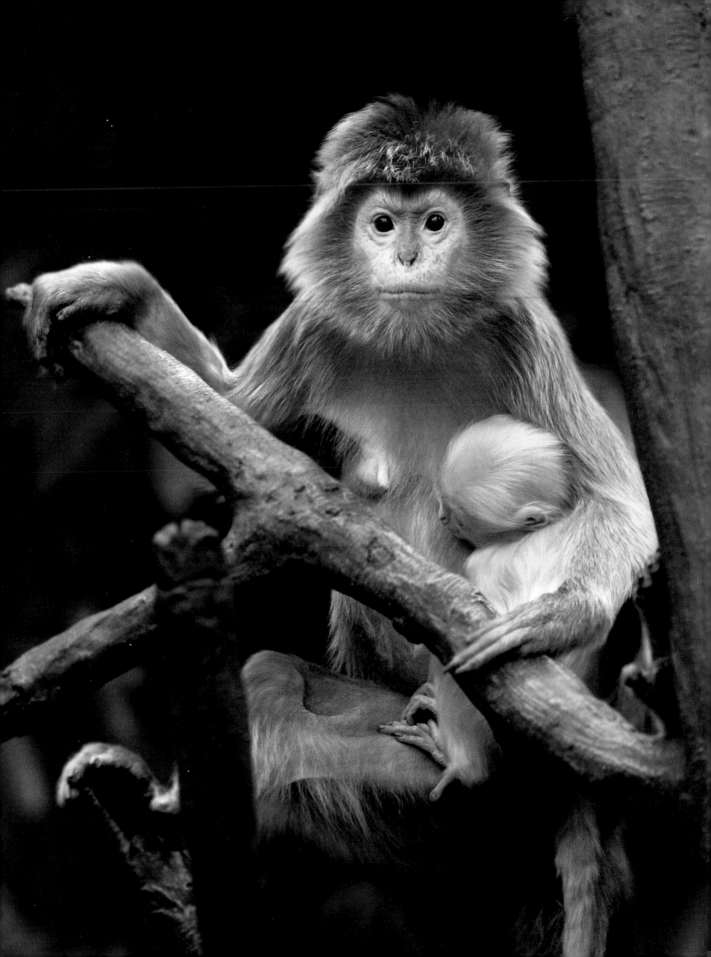

Contents

Introduction

As a travel and nature photographer, I am often asked, "What's your favorite place to photograph?"

My reply: "The next destination, of course, because that's where I'll find the most exciting and rewarding picture opportunities."

And that's where, I believe, *you'll* find your most rewarding photographs, because each trip, each adventure, and even each photograph teaches us something about picture taking, and perhaps about ourselves. These experiences, no doubt, make us better photographers, as well as more vibrant individuals who appreciate the beauty of the world in which we live.

I've been learning about the art and craft of travel and nature photography (and about myself) for more than twenty years, photographing in dozens of countries around the world. On the pages of this book I'll share with you what I've learned over those two decades. My goal is that you will take more pictures that you like during and after your travels.

To digress just a bit . . . If you have dreams of becoming a travel photographer, here's my personal photo philosophy. During one of my photo workshops, I was telling my students that I found it amazing that my camera—a little black box filled with metal, glass, and plastic—had taken me around the world. My camera was, in effect, my magic carpet. That night, I was thinking that it was not actually my camera that had transported me to faraway places. Rather, it was my ideas of traveling and, more important, acting on those ideas. This philosophy is important to think about, wherever you want to go on the planet, and in life. Anyone can have an idea. Doing something with that idea makes all the difference in the world.

Okay, back to talking about digital photography.

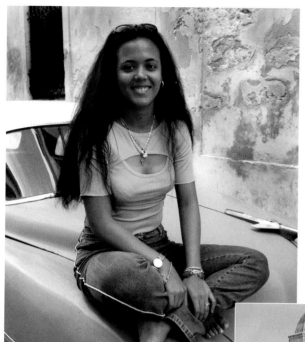

Since a 2000 trip to Cuba, I've shot digital exclusively, using digital single-lens-reflex (SLR) cameras to record my memories and digital image-editing programs to enhance them.

⇧ ⇨ Here are two of my favorite pictures from that trip, taken with my 3-megapixel digital SLR.

I'll never go back to shooting film. The benefits of digital photography make digital photography more creative, as well as more interactive with my subjects, who can view a shot instantly on the camera's LCD monitor.

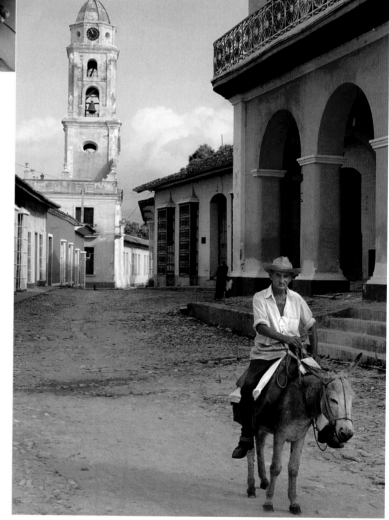

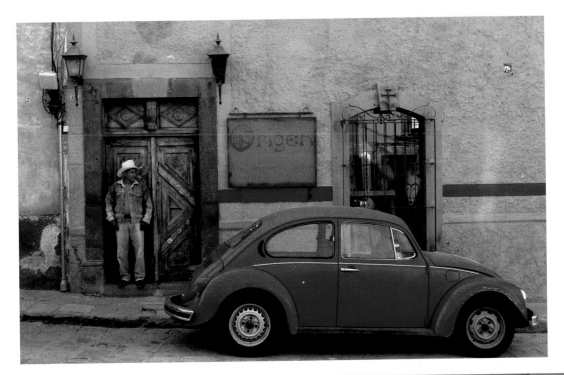

These days I shoot with 11.1- and 16.7-megapixel Canon digital SLRs. Here are two of my favorite photographs from a 2004 trip to the colonial heartland of Mexico.

⇑ This street scene was taken in San Miguel de Allende.

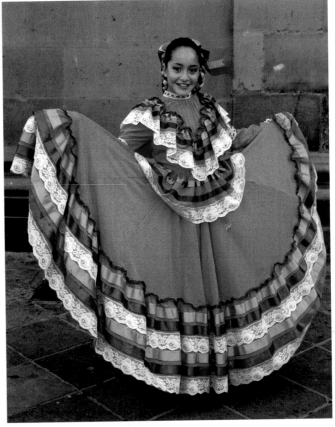

⇒ This little girl was photographed in Guanajuato.

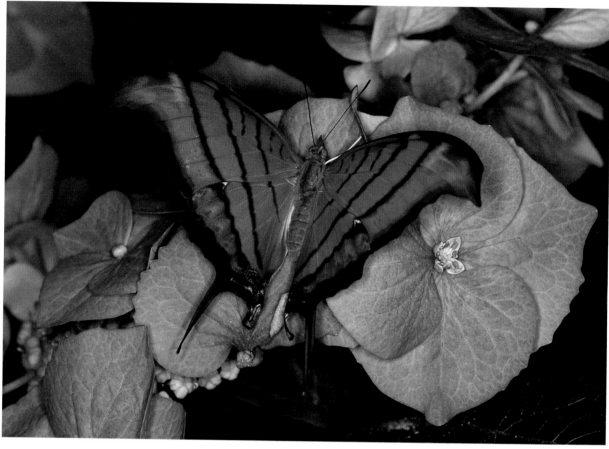

The quality of the images produced by professional digital SLRs, and even some high-end consumer digital SLRs, equals the quality of 35mm film. Digital capture may surpass film capture when we consider that even a scanned slide is a second-generation image, as opposed to an original file straight out of a camera.

When this image of a Small Postman butterfly is enlarged to 30 by 40 inches, we can see the individual scales that comprise the butterfly's wings. How's that for quality!

I believe digital photography is 50 percent image capture and 50 percent digital darkroom work. In this book, the emphasis will be on image capture, because capturing the image that we see in our mind's eye is the key to becoming a better outdoor and travel photographer. If you would like to learn how to enhance your digital pictures, two other books of mine cover all the digital darkroom basics: *Rick Sammon's Complete Guide to Digital Photography* and *Rick Sammon's Digital Imaging Workshops*, both published by W. W. Norton. You'll find just about everything I know about digital image editing in these two books.

I edit my images in Adobe® Photoshop® CS2 or Adobe® Photoshop® Elements. While I may refer to these valuable programs as "Photoshop" or "Photoshop CS" in later pages, I remove the ® only to keep the prose as smooth as possible.

Jaguar, Fort Worth Zoo

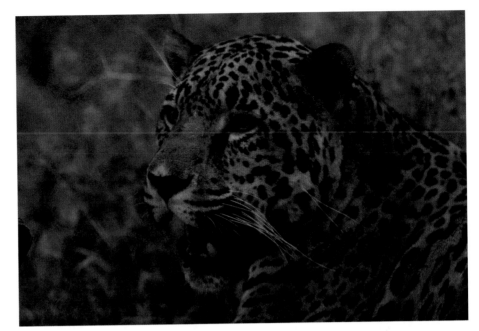

⟫ Image straight from the camera. The day was overcast and the animal was resting in the shade.

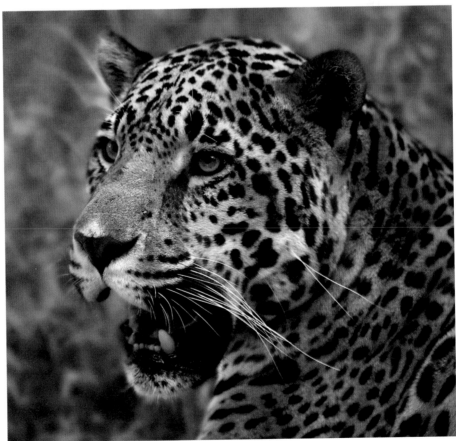

⟫ Digitally enhanced image.

Double Arch, Arches National
Park, Utah

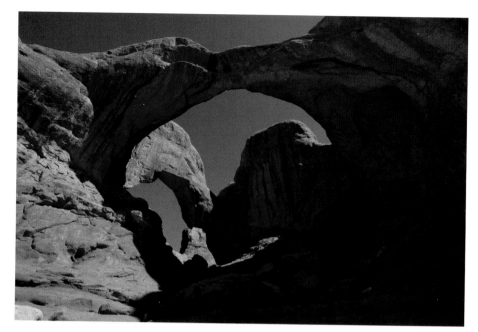

⟹ Image straight from the
camera.

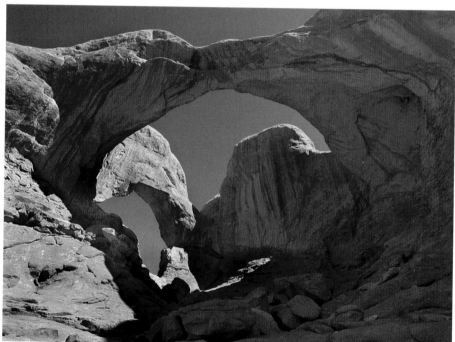

⟹ Digitally enhanced image.

Young Native American,
Monument Valley, Arizona

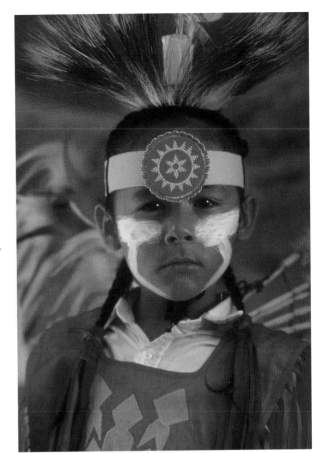

⇛ Image straight from the camera.

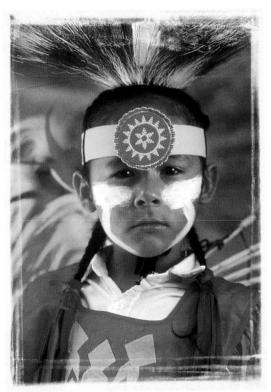

Digitally enhanced images.

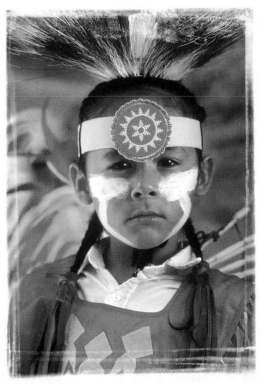

The preceding before-and-after sets of photographs offer just a glimpse of how digital files can be enhanced. The enhancements for all three images included cropping, boosting contrast, color, and sharpness, and, in the last example, adding a digital frame.

To be honest, just about every picture in this book was enhanced to some degree in the digital darkroom, even if that enhancement was simple cropping, burning, dodging, sharpening or blurring, or increasing or decreasing contrast, brightness, or color saturation. This is not photographic trickery. Professional film photographers have been enhancing their images in the wet darkroom since the early days of photography.

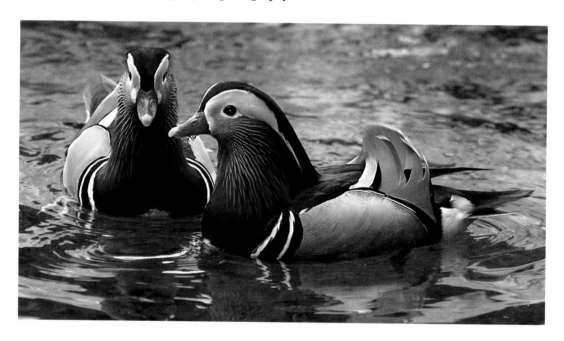

Speaking of enhancements, if you plan to have your pictures published, it's important to tell readers that an image was digitally enhanced. What's more, if an animal was photographed in captivity, as were these mandarin ducks that I photographed at the San Diego Zoo, it's important to state that, too. That's important information for amateur photographers, who may think they can easily get the same kind of picture in the wild or straight out of their digital camera. Another reason for honesty is that some readers may look for scientifically accurate photographs, and some man-made habitats are not 100 percent scientifically accurate.

So, keep the saying "Honesty is the best policy" in mind when submitting your pictures for publication.

Getting back to my opening comment about my favorite place to photograph . . . I'm writing the introduction for this book after my third day of shooting (and after downloading several 1GB SanDisk CompactFlash cards to my Mac laptop's hard drive) in the picturesque and romantic colonial city of San Miguel de Allende, Mexico.

If you have not heard of San Miguel de Allende—declared a National Monument by the Mexican government and an International Treasure by the United Nations—do a Web search on the city (and check out some of my San Miguel de Allende pictures in this book). I think if you shoot there—framing in your viewfinder the magnificent and awe-inspiring Spanish churches, the

colorful homes that line the cobblestone streets, and, of course, the warm and friendly people—I think you'll add it to your favorite places to photograph. It's certainly one of mine.

I mention San Miguel for a special reason: there is an underlying creative energy and inspiration in this place. It's a feeling that draws artists from all parts of the world. I found that energy and inspiration at just the right time . . . to begin writing and organizing this book, one I've wanted to write for almost ten years. You could say that San Miguel jumpstarted this book. *Muchas gracias*, San Miguel!

It's with this energy and enthusiasm that I share with you my techniques for taking nature and travel photographs.

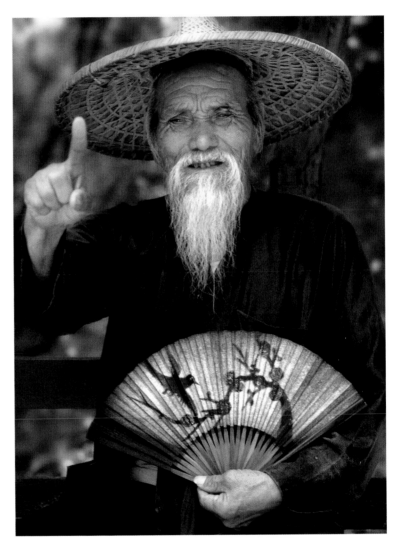

⇒ Before we get going, I'd like to share an early travel picture, one on the first roll of film I ever shot on location. I photographed this man in Hong Kong in 1975 with my 35mm SLR film camera and a 100mm lens. The photograph is still one of my favorites, because it tells a story.

In the photograph, the man is asking me for another dollar, because he was charging one dollar per picture and I was on my second shot. So here's the first tip for travel photographers: Travel with small bills to compensate select subjects. See "Jumpstart #5: Travel Smarts" for more on compensating subjects, which is something that we don't always want to do.

My second tip is this: consider signing up for a photography workshop. Mine are listed on www.ricksammon .com. Many of my photographer friends also lead workshops. See www.mentorseries.com for more information.

Reading this book is a good way to start learning about outdoor and travel photography. Shooting on location, however, is the best way to apply what you've learned.

We can jump into some tips right now.

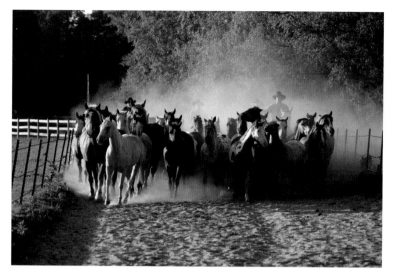

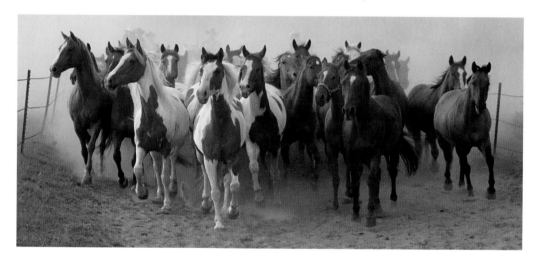

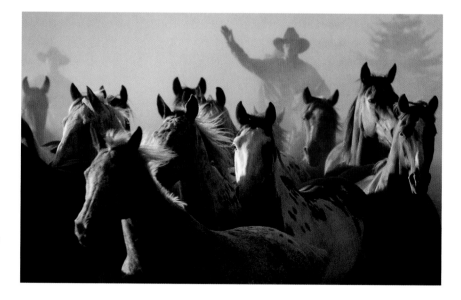

≪ This picture of a herd of horses running toward me is a simple snapshot. There is too much dead space around the horses.

⇓ For a picture with more impact, I took a series of tighter pictures to get just the right shot. A bit of creative cropping in the digital darkroom resulted in a picture that is much more than a snapshot.

⇒ Zooming in on the action, an isolated cowboy amid a few horses, added a human touch to the photograph.

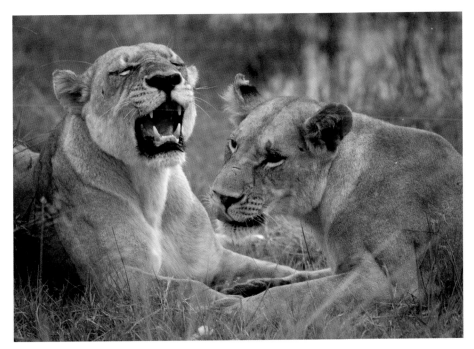

⇐ One of my more recent trips was to Botswana, a spectacular country for wildlife photography. Our guides had tracked these lionesses for hours while the lionesses themselves were tracking an impala. This shot was taken after the lionesses regrouped without getting their prey. Local knowledge is often critical to capturing a subject.

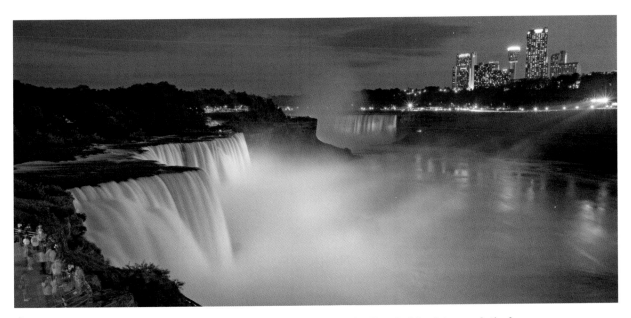

⇑ However, you don't have to travel far to get good photographs. I took this picture relatively close to home, from the New York side of Niagara Falls.

So wherever you go, I wish you the best of luck with your travel and nature photographs.

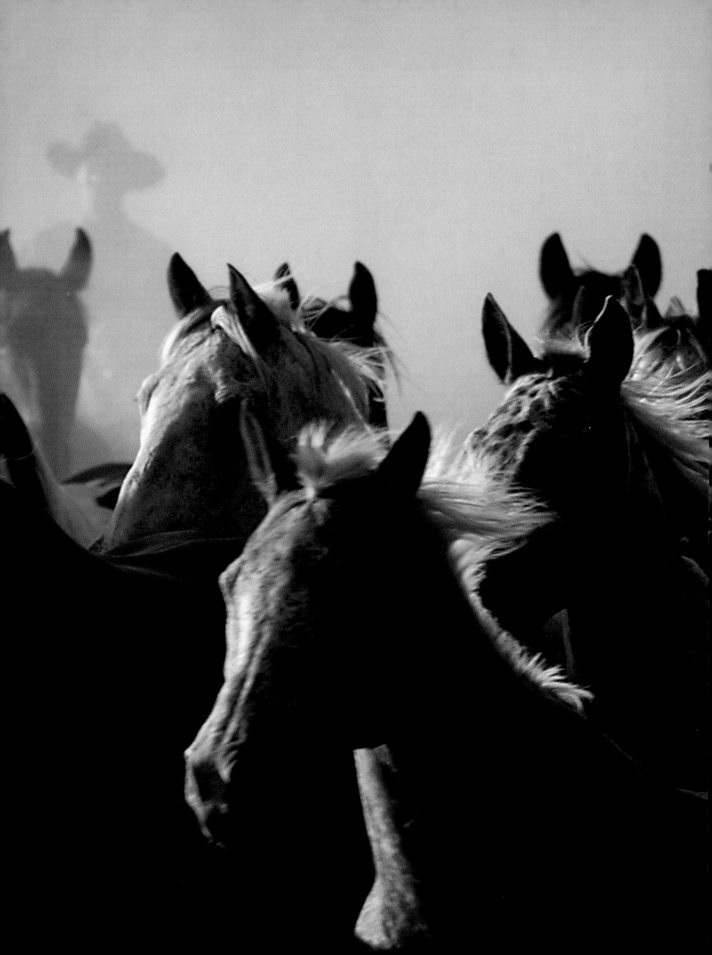

PART I

Jumpstart Your Photography

Horses and riders, Double JJ Ranch, Rothbury, Michigan

Arches National Park, Utah

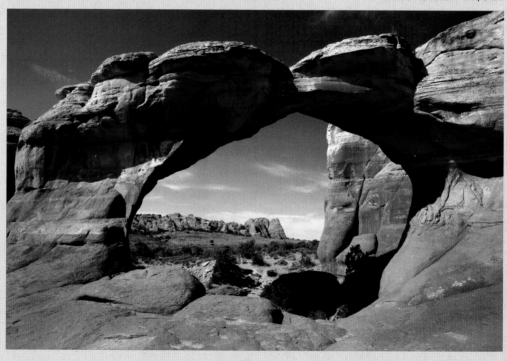

If you're in a hurry to jumpstart your travel and nature pictures, this section is for you. On the following pages I offer some quick tips that are easy to digest and apply to your own photography. However, even though they are short tidbits of information, I think you will find them quite useful in the field, where I wrote many of them during downtime on my travels.

First, please do yourself a favor: Enjoy the wonderful process of taking pictures and traveling. As I write this, at 30,000 feet on the way to Alaska with my family, I am reading *Zen and the Art of Motorcycle Maintenance*, by Robert M. Pirsig. I had read the book in the 1960s, and I'm finding it just as interesting and relaxing as I did back then. The message of the book is

that we really should enjoy the process, and care about what we are doing, rather than rushing through something with simply the end result in mind.

For some of my friends, those who see me as a totally hyperactive person, my advice on slowing down may seem a bit strange. But the more I travel and learn about photography and myself, the more I realize that enjoying the process can make all the difference in the world—even if it appears that there are not pictures to be found. If we enjoy the process, we'll find pictures everywhere.

⇒ Had I been rushing, I might not have noticed the intriguing shadow on this woman's veiled face.

⇘ Patience was also needed to wait for this cheetah to lick his nose.

If you enjoy the moment, the people you photograph will enjoy the moment as well. And who knows? Perhaps even the animals you photograph will sense that you are more relaxed.

Enjoying the moment and process brings to mind a work by *National Geographic* photographer Jim Brandenburg. For ninety days, this pro shooter took only one picture a day. The result is a work of amazing beauty, compiled into the highly acclaimed book *Chased by the Light*.

Some novice photographers use the "shotgun" approach to their pictures. They put their cameras on rapid frame advance and shoot as fast and as much as possible. Sure, they get some keepers, but my guess is that they'd be more satisfied, and have a higher percentage of keepers, if they took their time and used the "rifle" technique—that is, taking careful aim and thinking before they shoot.

Don't Skip This Very Important Message!
Before you jump off, I'd like you to use your imagination for a few moments.

Imagine you have X-ray vision and can see inside your computer. You focus on the computer's hard drive. With your X-ray vision, you see the hard drive spinning so fast, as it does, that you are surprised it does not fly right out of the computer. You are amazed that the reading and writing hardware moves so

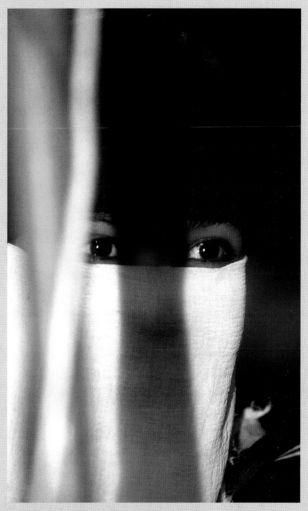

Moroccan woman

Cheetah, Fossil Rim Wildlife Center, Glen Rose, Texas

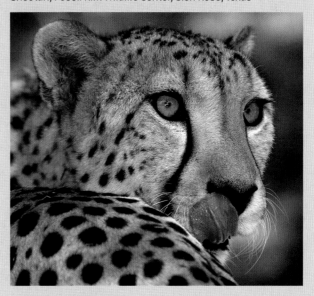

quickly. You know your precious photographs are on the drive, whirling around with tornado-like speed with all the other data you've stored.

Suddenly, you see the drive stop! A power surge or metal fatigue or some other factor has caused your hard drive to crash. You have no backup. You are, however, not even slightly worried. You have an extra $7,000 to spend to recover your pictures and data from the hard drive.

Okay, back to reality. Hard drives do crash. I've had two crashes in six years. The second crash happened while I was working on the final stages of this book. Fortunately, I had the book backed up, in two places: one copy on an accessory external hard drive in my office and another copy on a hard drive in my home.

After the second crash, I called a data recovery service. The going rate to recover data from the 80GB hard drive (which cost about $90) was near $7,000.

So the message of this little homily is to back up all your important photographs.

To drive home this point, and to get your attention, I'm including some product shots right up front in this book, a book that I wanted to start with pretty and informative pictures.

↗ Internal backup hard drives (inside your computer) are a space-saving way to back up data. If your main hard drive crashes, your pictures will be safe. However, if you can't start your computer due to a crash, you will not be able to "see" your backup drive. You'll need a new hard drive before you can do that. Therefore, I recommend an external hard drive for data backup, like the one pictured here. If you have an external hard drive, you can plug it into your laptop and "see" all your data.

↗ Portable hard drives are a good way to backup your pictures while traveling with your laptop. Transferring data from a laptop to a hard drive is much faster than burning a CD or DVD. When you get home, you can plug in the portable hard drive to your main computer for data transfer.

⇑ CDs and DVDs are the safest way to store your pictures permanently, because, unlike hard drives, they have no moving parts. That said, if the CD or DVD gets scratched, the disk might become unreadable.

Again, back up. Or else!

Recipe for Successful Photographs

Numerous ingredients add to the success of professional nature and travel photographs.

Here is a quick look at the most important ingredients.

Cameras, Lenses, Accessories, and Computers

It's important to choose the right camera for our needs (see "Jumpstart #2: Compact vs. SLR Cameras"), and the lenses, memory cards, and accessories that will enable us to record our

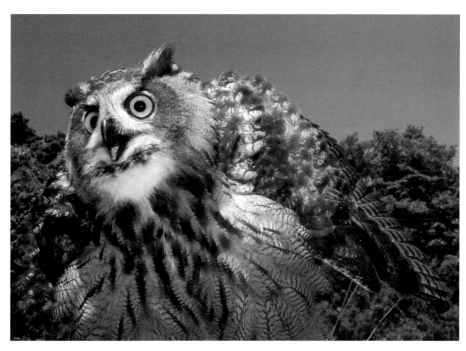

own unique vision of a scene. Digital travel gear includes a camera (or two), a laptop, a memory card reader, and, as I've said, plenty of memory cards. When it comes to a computer, if we have a choice of more random access memory (RAM) or a higher gigabyte (GB) capacity hard drive, we should go for the RAM. Our digital image-editing program will run faster with more RAM, especially when we have other applications open.

Choose Our Lenses Wisely

Lenses deserve special consideration. Because we can enlarge our digital pictures more than 200 percent on our monitors, we can see flaws in image sharpness (overall or in parts of an image) that we did not see when viewing our prints and slides.

Because these flaws are more visible, we need to be especially careful when choosing a lens. This is particularly true if we plan to make large

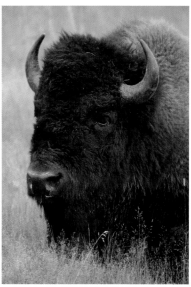

prints of subjects with fine detail, like the fur on the face of the bison, which I photographed in Yellowstone National Park, Montana, and the feathers on the owl, which I photographed in upstate New York.

Usually, fixed focal lenses are sharper than zoom lenses. That said, we could sharpen somewhat soft pictures in Photoshop. However, an expensive zoom lens may be sharper than an inexpensive fixed focal length lens. Usually, we get what we pay for.

Other lens considerations are close focusing distance, weight, and size.

How do we find out which lenses are sharp and which are not, and which lenses we should choose? The choice can be difficult. In the end, it's up to you. One way is to go to www.google.com and type in "sharp lenses" in the search window. That will bring you to a host of pages offering lens reviews.

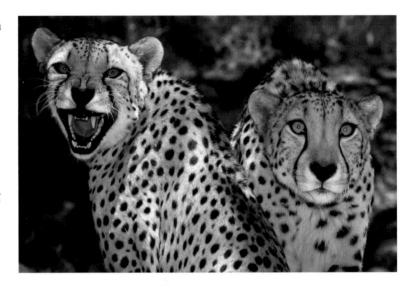

Of course, we can go to the Web site for our camera and then go to the link for the lenses for a listing of all the lenses that can help us take better pictures.

Select an Interesting Subject

Of utmost importance is an interesting subject. The subject is the reason why most of us travel to take pictures. I have traveled to Fossil Rim Wildlife Center, in Glen Rose, Texas, three times to photograph the exquisite animals, including these cheetahs.

Get Inspired

Of course, we need to be inspired to take good pictures, as I was at the Double JJ Ranch, in Rothbury, Michigan, during this magnificent sunset. That inspiration drives us to get up extra early to photograph sunrises and keeps us out into the night to photograph sunsets. It compels us to approach strangers in strange lands with our cameras, hoping to capture an interesting face or activity. That inspiration draws us to sweeping landscapes and seascapes, places where we can "stop and smell the roses," recording our memories to be relived through our photographs.

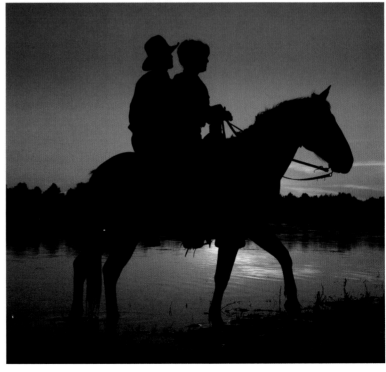

Patience Pays

Oftentimes, we need patience for a good picture. That may mean waiting hours for just the right light, waiting for someone to walk in or out of a scene, waiting until we get comfortable shooting in a location, or waiting for our subject or subjects to get comfortable with us. At first, these girls at Angkor Wat, Cambodia, were a bit timid about being photographed. After a while, we all felt comfortable with each other, which is reflected in this photograph.

Attitude Affects Our Pictures

Pros know that our attitude affects our pictures. I was called by Canon U.S.A., Inc. for a commercial assignment to take pictures in New York City. While I was being briefed on the technical requirements for the project, I was concerned about getting technically perfect shots. I only had a short time frame during which to shoot. On the way out the door, the project's director, Canon's Dave Metz, said two words to me that totally changed my outlook. Dave said, "Have fun!" So, rather than coming back with technically perfect and static shots of New York City, I came back with lots of people having fun. Dave's advice changed my attitude and made all the difference. Most important, Canon loved my pictures.

Know Our Camera and Image-Editing Program

Knowing what our camera and image-editing program can and cannot do will help us make decisions to get creative pictures. Frequently we need to make on-site decisions in an instant about exposure, shutter speed, f-stop, and so on. What's more, in the digital darkroom we have endless possibilities from which to choose. We have the tools at our fingertips. It's up to us to craft our images to our own liking. This image of two cheetahs in Botswana was the result of on-site knowhow and a bit of digital darkroom work.

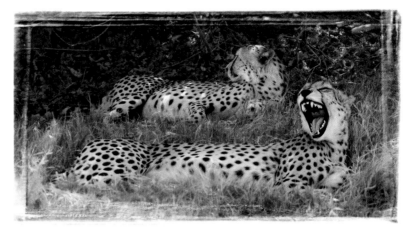

Learn about Our Subject

Another ingredient in the recipe for successful photographs is learning about the subject, be it a landscape, a person, an animal, or a place. The more you understand a subject, the better you'll be able to photograph it. At a casual glance, this may look like a statue of Buddha with some flags in the background. But the flags are special. They are called "prayer flags." They are inscribed with prayers that, Buddhists believe, the wind takes to distant lands. Knowing that made taking the picture at Monkey Temple more meaningful for me.

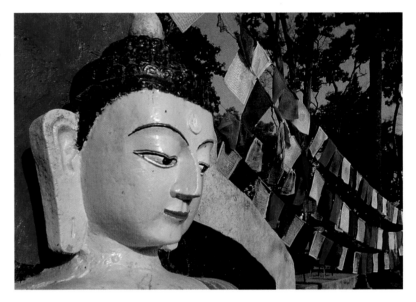

Take *and* Make Pictures

Taking pictures means that we simply photograph what we see, as illustrated in the first of these two pictures, taken at a Ngobe-Bugle village in Panama. Making pictures means using our artistic eye to create a more informative and

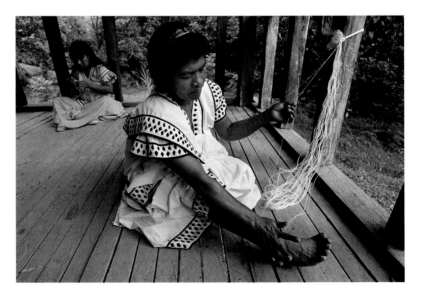

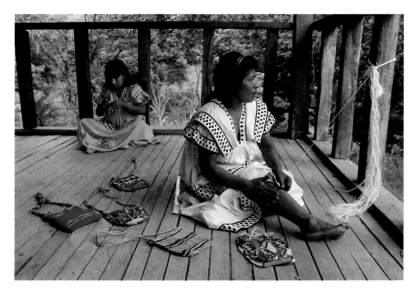

better-composed image. In the first picture, we see the woman with some thread, but we don't know what she is making. Before taking the wider photograph, I placed several of the bags that she and other women in the tribe had made on the wooden deck, filling the dead space in the scene with context.

Get Lucky

Luck is also an important ingredient. ⇒ I was darn lucky to see these Isabella butterflies mating at Butterfly World, Coconut Creek, Florida, and this pelican coming in for a landing in St. Augustine, Florida. ⇓

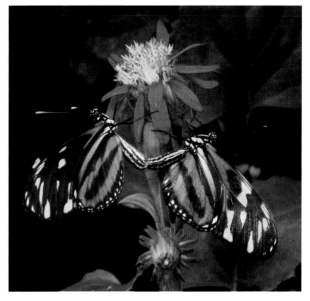

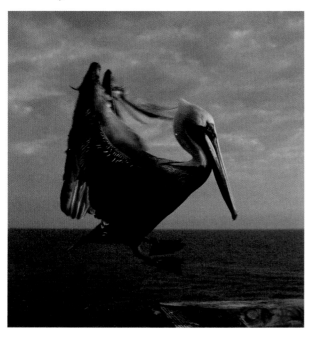

I've been very lucky when it comes to my travel photographs (see "Evolution of Two Photo Sessions" in "Lesson #1: People," for just one example).

When it comes to luck, however, I can tell you this: The harder you work, the luckier you become. I work hard when I'm traveling, staying out all day looking for photo opportunities everywhere.

So work hard! You'll be surprised at how lucky you become.

Be Positive When the Weather Turns "Bad"

⇒ Hey, as much as we'd like all our days to be filled with sunshine, it's sometimes going to be overcast or raining or snowing. The key is not to put your camera away when the sun goes away. Keep a positive attitude and get out there and shoot! You may be surprised at the "moody" scenes you capture. This picture, taken in Monument Valley, Arizona, is one of my favorites from the area. The subdued effect created by the overcast sky helps convey the feeing that the land is sacred to the Navajo who live there.

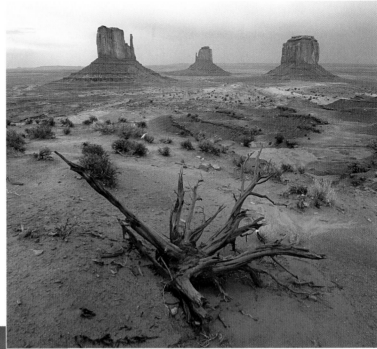

Of course, you need to protect your camera from the elements if it's raining or snowing. See "Lesson #10: Gear for Travelers" for details.

Check the Weather

⇐ We can improve our chance of getting the kinds of pictures we want if we check the weather for our destination before we leave home. I do that for every trip; go to the Web site for the Weather Channel: www.w3.weather.com.

On a trip to St. Augustine, Florida, I specifically wanted pictures of birds at the beach. The weather forecast was for minimal winds. Because there would be minimal ripples on the water, I expected that I could get some nice shots of seagulls and their reflections in the small ponds formed by the receding waves. Turns out, the weather forecast was right.

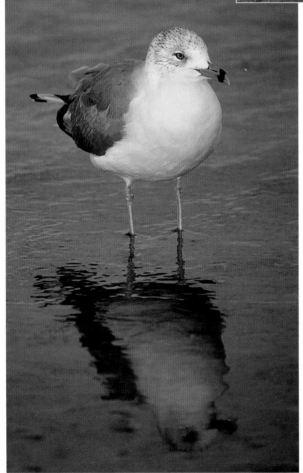

Always Look Back

While we are growing as photographers, it's a good idea to look back on our progress and to learn from our mistakes. In addition, while we are out taking pictures, it's a good idea to look back, literally.

Often we are in such a rush to get someplace to take pictures, or we get so caught up with and focused on a scene, that we don't look for other picture opportunities, some of which may be directly behind us.

Above and on the following page are two sets of pictures that I took specifically to illustrate this point. They're from St. Augustine, Florida. After taking what some may call the more dramatic picture, I swung around and took a picture of a subject almost directly behind me. Different light, but quite nice.

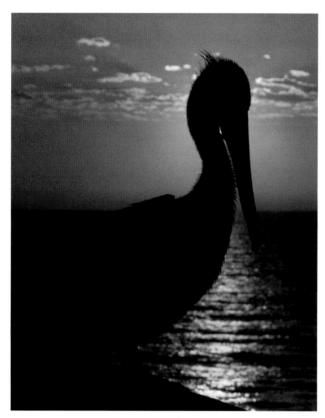

Pelican backlit by the rising sun

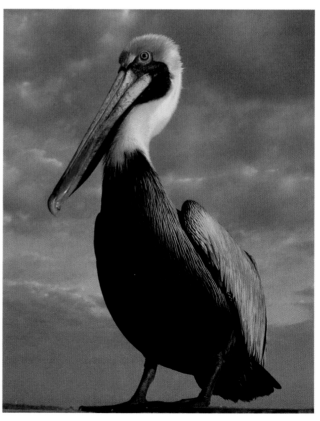

Pelican frontlit by the rising sun

Go beyond the Straight Shot

It's nice to get the sharpest and clearest unobstructed pictures of a subject. However, sometimes it is also nice to hide a subject somewhat with a foreground element, as I did here when photographing this wood duck at the St. Augustine Alligator Farm and Zoological Park. I used a telephoto lens set at a wide aperture to blur the foreground leaves. This set of photographs illustrates another technique: Moving just a few feet or even inches from one position to another can make a big difference.

On the pages of this book I hope to help you make good decisions when it comes to your photographs.

I'll also "take" you to some of my favorite places for photography.

Finally, I hope to inspire you, simply to take better pictures and perhaps even to turn pro, something I did not do until I was forty years old (leaving a suit-and-tie job on Madison Avenue in New York City). As for patience, attitude, and luck, those ingredients are up to you.

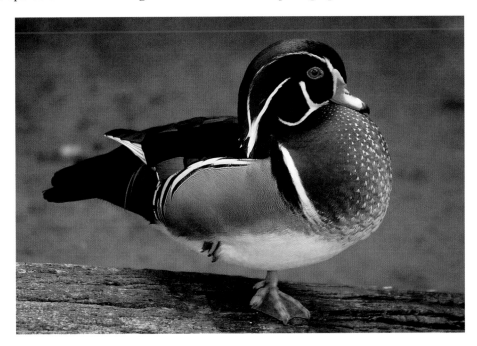

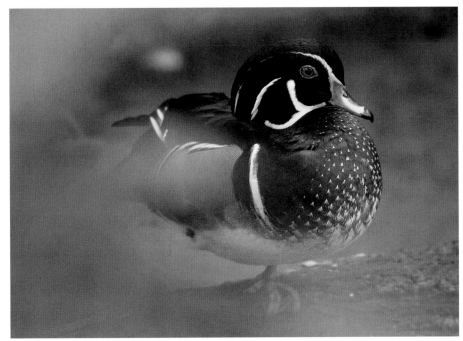

Like many professional travel photographers, I've been shooting with digital single-lens-reflex cameras for several years. But as you will read, my photo shoots are not limited to digital SLRs.

These days I shoot with Canon digital SLR cameras, which offer tremendous versatility with accessory lenses and flash units. Most of the photographs in this book were taken with those cameras.

⟫ I photographed these baboons in Botswana with a Canon EOS 1D Mark II camera, with the addition of a Canon 550EX flash. An in-camera flash on a compact camera (or on an SLR) would not have been able to illuminate the subjects at the camera-to-subject distance, which was about thirty feet. You'll see these baboons again in "Lesson #4: Wildlife."

⟱ This photograph of barber Bill Kief of Belfast, Maine, was taken with an 11-megapixel Canon EOS 1Ds. With that many pixels, I can see every hair on Bill's head, even when the picture is greatly enlarged.

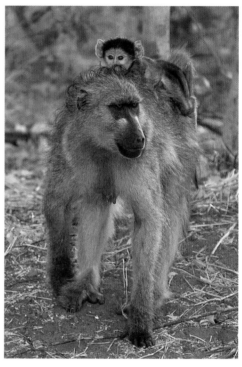

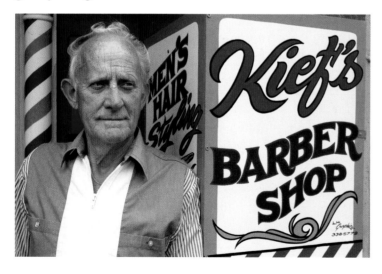

When I travel, however, I sometimes don't want to lug around my gear bag, filled to the brim with two SLR bodies, several lenses, and accessories. Sometimes, especially at night and when I'm going to breakfast or lunch, I simply want to see the sights, and take some fun snapshots. There's where my compact, point-and-shoot digital camera, a Canon G5, comes in. Most of the time, I'm very happy with the capabilities of the smaller camera.

For me, each type of camera has its advantages. Here's a look at the benefits of the digital SLR system:

- wide-angle and telephoto zooms, which far exceed the zoom range of my compact camera;
- image stabilization (IS) lenses (which help steady the camera when shooting at slow shutter speeds in low-light situations);
- focus tracking, in addition to one-shot auto-focus (AF), which tracks a moving subject and sets the focus right up until the moment of exposure;
- a higher light sensitivity (ISO) beyond 400 ISO, which is needed to stop action in fast-paced situations;
- relatively minor digital noise (grain), even at high ISO settings (compared to the digital noise in my compact camera at high ISO settings);
- rapid frame advance when photographing action sequences;
- no noticeable shutter lag;
- viewing the scene through the lens (as opposed to looking through a viewfinder in a compact camera), so what I see is what I get (as far as composition goes);
- the addition of millions of pixels gives me unsurpassed image quality.

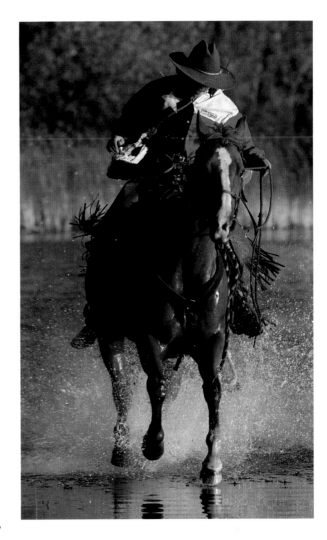

↗ Capturing fast-moving action, toward and past us, especially in difficult lighting conditions, is made easier with a high-end or professional digital SLR that offers focus tracking and super-fast focusing speeds.

⇒ Fast-paced action sequences are also made possible with high-end or professional digital SLRs that offer rapid frame advance and fast card-writing speed.

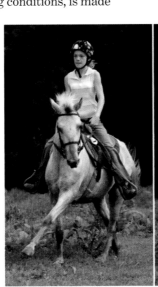
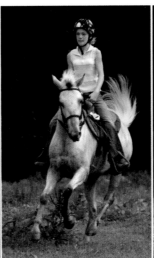
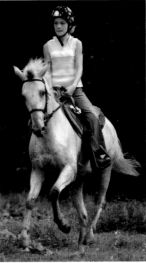

Here are the features that I appreciate in my compact camera:

- lightweight and compact (fits in my pocket);
- ease of operation;
- built-in zoom lens;
- built-in flash;
- close-focusing capability with good depth of field;
- different effect modes (black-and-white, sepia, and so on);
- with 5 million pixels, enlargements up to 11 by 14 inches still look sharp;
- less intimidating to strangers in strange lands when I'm taking their pictures.

Naturally, there is another big difference between the two types of cameras: price. I could buy several G5 cameras and fly from New York to Florida to take some pictures for the cost of one EOS 1Ds. These days, I travel with both cameras for maximum flexibility.

Creative Features Are the Key

Shutter speed controls the period of time during which the camera will capture light. Shutter speed or exposure time is measured in fractions of a second—for example, 1/30 or 1/250. It's also measured in minutes and even hours. On your camera readout, shutter speeds may be simplified to the denominator—for example, 30 or 250. Higher numbers mean that the subject will be captured for less time. Hence a higher shutter speed means less light from the subject will reach your camera. A rule of thumb is that shutter speeds below 1/60 of a second will blur a subject's hand if it is photographed waving at you.

Aperture size controls the volume of light the lens will send to the camera's capture device in any given moment that the shutter is open. A smaller-diameter opening creates a narrower aperture. Aperture is measured by the focal length that is created by a specific opening size. For a given lens, smaller openings create a longer distance to the plane of focus, as the light has less length. Hence a larger opening creates a shorter focal length (or f-stop). So a very wide lens opening, such as an f/2.4 aperture with short

depth of field, lets in much more light than the narrower f/16 setting, with its deeper focal length. But less of the main subject's background and foreground will be in focus. Because the wide opening lets in so much light, your camera may have compensated by using a very fast exposure time. So bigger aperture numbers mean more of your subject will be in focus.

Cameras with Program, Aperture Priority (or Aperture Value) and Shutter Priority (or Time Value), and Manual exposure control let us select different combinations of shutter speed and f-stop to achieve a desired effect.

When set to the Program mode, the camera selects the appropriate shutter speed and aperture for the lens in use for the best possible picture. For example, a camera will set a higher shutter speed for a telephoto lens (to help prevent a blurred picture caused by camera shake) than it would for a wide-angle lens (which does not exaggerate camera shake as much as a telephoto lens).

Keep in mind that the ISO setting affects the shutter speed/aperture combination. The higher the ISO setting, the faster the shutter speed and the smaller the aperture.

Most Program modes are adjustable, meaning that you can change the selected shutter speed and f-stop combination with a dial or button to stop the action or change the depth of field.

In the Aperture Priority mode, we set the aperture to control the depth of field.

In the Shutter Priority mode, we select the shutter speed to stop or blur subject movement or the camera's movement, which is important to prevent blurry pictures caused by camera shake.

In the Manual mode, we select both the shutter speed and aperture for a desired effect.

Creative exposure modes are available in digital SLRs. They can also be found in compact cameras, but usually not in low-end models.

In addition, a camera that offers Focus Lock allows us to lock in the focus on a certain off-center point in the scene other than the default center area of the image, recompose the picture, and then shoot.

We will look at many examples of how to control our image using different shutter speeds, apertures, and focus points. For now, here are a few examples.

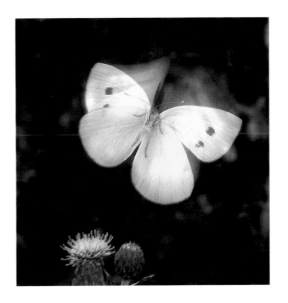

⇒ In capturing the beautiful movements of this cabbage white butterfly in flight, selecting a slow shutter speed let me show the wings in motion. Selecting a small aperture let me get the moving butterfly in sharp focus. The ability to control the output of my accessory flash allowed me to balance the flash output to the daylight. This picture would be nearly impossible had I used a compact camera with a built-in flash.

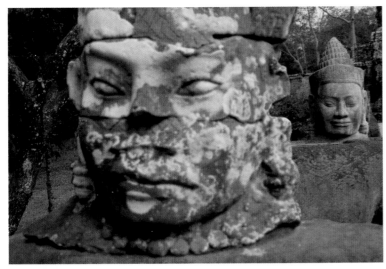

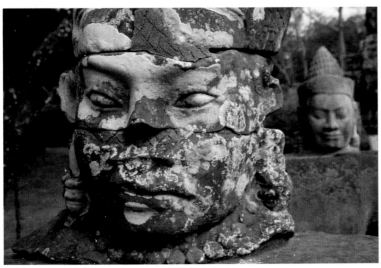

⇐ Compare these two pictures, which I took to illustrate a point at the Angkor Wat temple complex in Cambodia. In one picture, the foreground statue is out of focus, because the focus point was set on the background statue with my camera's Focus Lock. It is an unacceptable picture, but useful in this good/bad example. In the second picture, the foreground statue is in focus, because the focus point was set on that statue. This is the effect I wanted to achieve. These pictures were taken with my professional digital SLR, but I could have taken exactly the same pictures with my compact camera using its Focus Lock feature.

Fun Snapshots

I'd like to share with you a few shots I took with my compact camera one rainy day during a January 2003 trip to Michoacan, Mexico. As you will see, even if you do not have a pro camera, you can still take nice photographs.

⇒ This little girl was standing under the awning of a vendor stand. Low light required a high light sensitivity setting of ISO 400 for a steady, hand-held shot. An enlargement may have a touch of digital noise, but—as is the case with some pictures—grain can add to the mood of a picture.

⇓ During a rainstorm, the hotel at which I stayed in Anganguero took on an increased charm of romance. I dashed out of my room with my compact G5 camera and snapped the hotel's colorful courtyard.

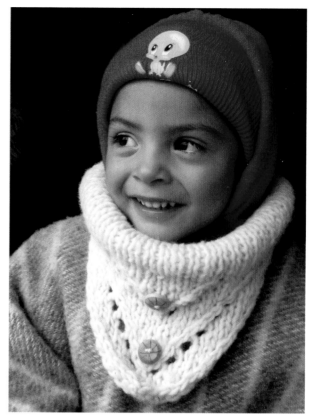

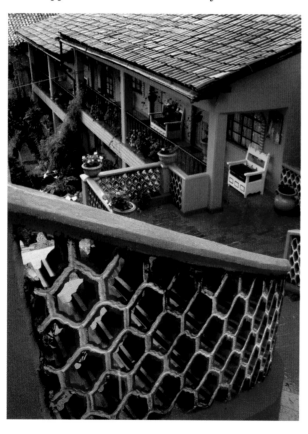

⇑ Sure, we can make black-and-white pictures from our color files in the digital darkroom, but it's fun seeing the black-and-white effect on the camera's monitor. This graphic shot of a stairway seemed to me to lend itself to black-and-white.

⇒ I enhance all my pictures—pro shots and snapshots—in Adobe Photoshop CS. This before-and-after set of a picture from one of my G5 shots of a calla lily shows a bit of cropping, sharpening, contrast/brightness correction, and retouching.

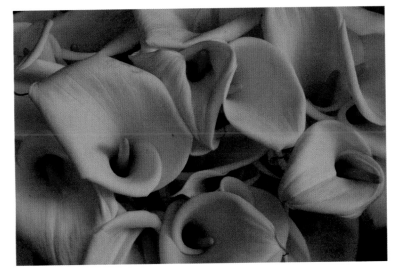

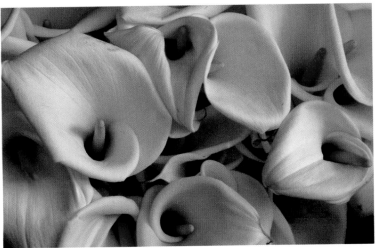

⇒ Always having a camera with us has a major advantage: We will always be ready to take a picture. This lovely painting was on the wall outside my hotel room in Mexico. I was going to shoot real butterflies in the mountains high above the next morning. Because I had a camera with me, I was looking for pictures, and got this shot of the painted butterflies. If you always carry a compact camera, you will see more opportunities and will take more pictures!

As I mentioned, I enjoy shooting with my point-and-shoot compact digital camera. For my pro work, however, I'll stick with my digital SLRs for people, wildlife, scenery, and action photographs. With that in mind, can you tell which one of these pictures was taken with my pro camera and which one was taken with my point-and-shoot camera? The vertical photograph was taken with my Canon G5; the horizontal photograph was taken with my Canon EOS 1Ds. Both pictures look sharp in this book and when I make prints on my desktop.

SLR Lens Quality vs. Compact Camera Lens Quality

As long as we are making comparisons, we should also compare lenses (SLR to SLR and SLR to a built-in lens), because although some photographers believe in the expression "Cameras don't take pictures, people do," others feel that "Cameras don't take pictures, lenses do."

On the next page we'll take a look at three pictures taken with my digital SLR lenses and one taken with my G5. The G5 costs close to $500 a camera affixed with a permanent lens (at the time of this writing). That's less than most of my SLR lenses. The Canon 400mm f/2.8—which I borrow from Canon's Professional Services—costs about $7,000. For updated prices, do a Google search.

I make this comparison to illustrate sharpness, the main technical feature I look for in a picture.

Tiger, Big Cat Rescue, Tampa, Florida. Canon 28-135mm f/3.5-5.6 IS (Image Stabilizer) lens

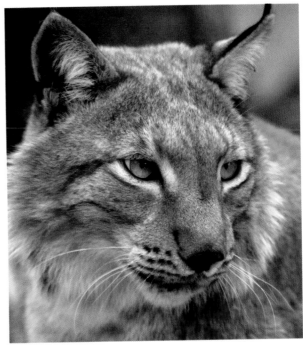

Lynx, Big Cat Rescue, Tampa, Florida. Canon 400mm f/2.8 lens

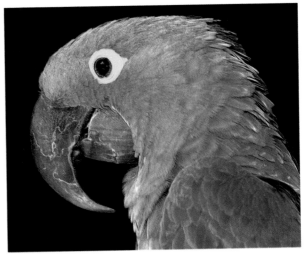

Blue macaw, Parrot Jungle World, Miami, Florida. Canon G5

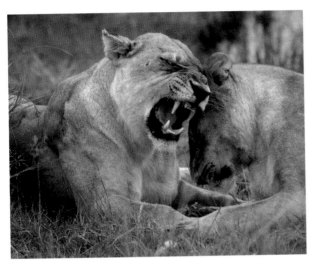

Lionesses, Botswana. Canon 100-400mm f/4.5-5.6 IS lens

If all these pictures look sharp to you, you are not alone. Printed on these pages, they look very sharp to me, too. Straight out of my cameras, the pictures were acceptably sharp. However, like all digital images, they need some sharpening in Photoshop for publication and for making fine-art enlargements. All digital photo pros would agree that a digital picture needs

sharpening. That is especially true for RAW files. I know that's a strong statement, but digital sharpening is easily accomplished in Photoshop.

When choosing a lens and compact camera, you usually get what you pay for. No doubt, the $7,000 400mm f/2.8 lens is technically sharper at 400mm than my 100-400mm IS zoom, which costs about $1,500. And, both of these lenses produce a sharper telephoto picture than one from my G5 with its fixed zoom lens.

The good news is that if you can't afford the sharpest lens on the planet, you can easily sharpen a picture in Photoshop CS, Photoshop Elements, or any other image-editing program. However, you can only sharpen a picture to a point, and you really can't sharpen a blurry or out-of-focus picture.

So, keep in mind that all digital pictures need sharpening, some more than others.

Here's a closing, and important, thought on choosing a digital SRL: Consider the image sensor size. Most consumer and proconsumer SRLs don't have full-frame (35mm size) image sensors. That means the focal length of a lens is magnified. So, on a digital SRL with an image sensor having a 1.6X magnification factor, a 100mm lens functions like a 160mm lens. That's an advantage in wildlife photography, when you want to get close to a subject. However, it's a disadvantage in wide-angle photography, where you want to encompass a wide area of a scene.

⇊ For this photograph (cropped) of a beach scene in Corsica, I used a 15mm fisheye lens on my full-frame digital SRL. Had I used a smaller-than-full-frame digital SRL, say a camera with a 1.6X magnification factor, I would have lost the fisheye effect—because my 15mm lens would have functioned like a 25mm lens.

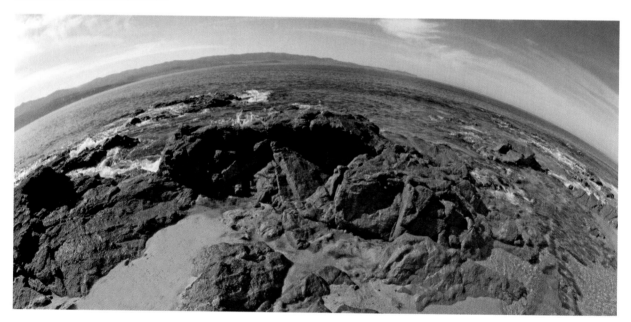

Digital Photography on the Go

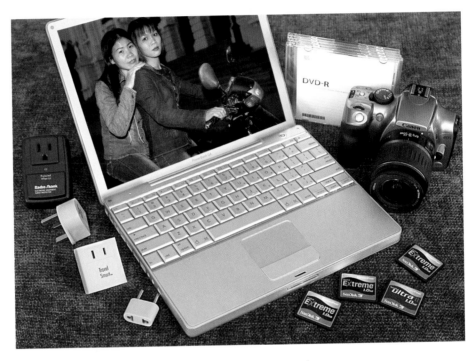

I once heard a film critic say, "You have to see a film at least three times to see all that's there."

Some of the ideas presented in this lesson are covered in more detail later on. I present these quick tips here for the totally impatient photographer (like me).

All these pictures, except the postcard that was taken in San Miguel de Allende, Mexico, and the broken laptop shot, which was taken in China, are from a 2003 trip to Vietnam. I shot with my Canon EOS 1Ds digital SLR and enhanced my pictures in Adobe Photoshop CS. All images were recorded on my SanDisk CompactFlash cards.

Keep in mind that we can use a less sophisticated camera and imaging program and still get great photographs on the road.

Gear Up

Gear plays an important role in the life of a digital travel photographer. In addition to my cameras and lenses, my travel gear bag includes: several memory cards so I don't have to delete pictures during the day, laptop for storing my pictures and for viewing my pictures at night, power/plug converters so I can plug in my computer in hotel rooms in foreign locations, surge suppressor so my computer does not get "zapped" by a power surge, and DVDs on which I save my pictures each night (I always like to have my pictures saved in two places before I erase a memory card). If you don't want to travel with a laptop, the smaller and more affordable Epson (P2000) (www .epson.com), Nixvue (www.nixvue.com), and FlashTrax (www.smartdisk.com) portable hard drives, complete with LCD screens, are an option.

Check Out the Postcards

Upon arriving in a city, one of the first things I do is check out a local postcard stand. The postcards offer a range of photo opportunities that are available in the area, day and night, including vantage points that these photographers favored. Then, I check my guidebook to review the photo locations I have already targeted.

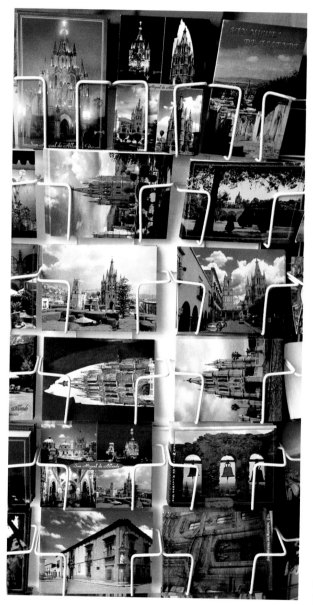

Pick a Quality Setting

A RAW image file takes up more space on a memory card than a JPEG file. RAW files are "raw" or unprocessed digital files containing all the information your camera's sensor captured. JPEG (Joint Photographic Experts Group) are compressed files, which contain less information than RAW files. If you want absolutely the maximum in image flexibility and quality, shoot RAW. If your camera does not have a RAW file setting, you may have a "fine or superfine" resolution setting for high-quality JPEG files. For fun snapshots that you only want to post on a Web site or send as e-mail, use a low JPEG setting.

When you are out shooting, check your quality setting from time to time to avoid disappointment in image quality on an important picture. I shot this picture in the RAW mode. In a 16×20-inch print, the woman's eyelashes are tack-sharp.

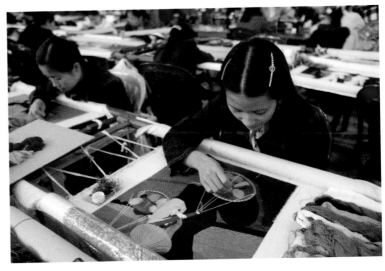

Set the ISO

With digital cameras, you can change the ISO setting from picture to picture, from a low setting (ISO 100), for outdoor shooting, to a high setting (ISO 400, 800, 1000, 1600), for indoor shooting. For the smallest amount of digital noise in your pictures, try to shoot at the lowest possible ISO setting. Also, and this is important, check the ISO setting from time to time to make sure you are shooting at the lowest setting. (I've made the mistake of not checking my ISO a few times.)

Set the White Balance

Auto white balance does a good job of making the whites white in many lighting situations. But for the best results, set the white balance for the existing lighting condition—that is, Daylight for sunny days, Shade for shooting in the shade, and so on.

As with your ISO setting, check the white balance setting from time to time. If it is set incorrectly, your

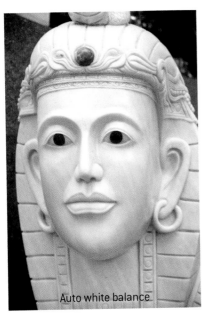

Auto white balance

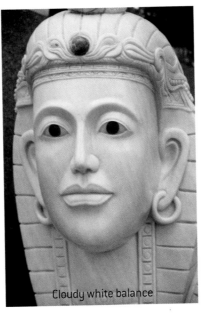

Cloudy white balance

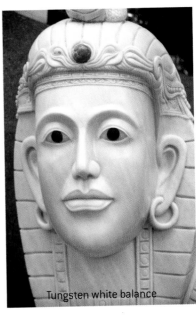

Tungsten white balance

subject may be off-color, as illustrated by the picture with the blue cast, taken with the white balance set to Tungsten. With that in mind, however, I often set my white balance to Cloudy on sunny days for a "warmer" picture, as illustrated by the picture with deeper shades of red and yellow.

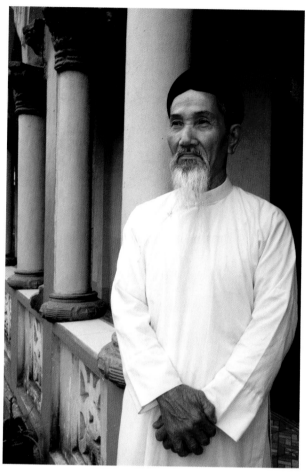

Use the Magnifying Feature

An out-of-focus, slightly blurry, or soft picture can look sharp on a digital camera's LCD monitor, due to its small size. If your camera has a magnifying feature, zoom in on the main subject to see that it's sharp. In these portraits, I checked the man's eyes to be sure that they were in sharp focus.

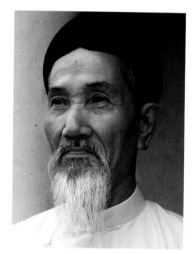

See the Light

Sure, we can correct some exposure mistakes in the digital darkroom, but why not begin with the best possible exposure? That starts with seeing the light—the light and dark areas of a scene. To avoid washed-out (overexposed) areas in an image with bright whites or extreme highlights, which are almost impossible to recover in the digital darkroom, I slightly underexpose all my digital pictures. That's what I did for this picture and the top picture on the next page, because shooting at the "0" setting would have resulted in

the whites in both pictures being overexposed. Take advantage of the $+/-$ exposure compensation settings on your camera for correcting exposures and for creative effects.

Check Out the Histogram

Most novice photographers wait a while before they get into viewing the histograms of their pictures on the camera's LCD monitor. (Not all digital cameras offer a histogram, but all pro SLR cameras do.)

Basically, a histogram shows the distribution of dark and light areas of a picture—with dark areas indicated by "mountains" of pixels on the left, and light areas indicated by "mountains" on the right. When you get a sharp spike on the left, you'll lose shadow details. A sharp spike on the right shows that your highlights will be washed out.

\Rightarrow In the histogram for the river picture, the spike on the right side shows that the sky will be overexposed. A more evenly lighted scene will show a more evenly distributed "mountain range," as illustrated in the histogram for the photograph on the next page of the woman with the straw hat. By looking at the histogram you can make adjustments in exposure, composition (by changing your position), and lighting (by adding a

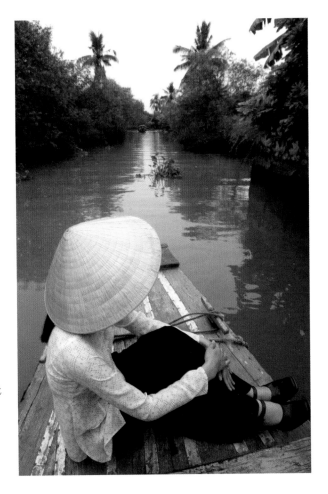

flash, using a neutral density filter or by using a reflector or diffuser)—or you could wait for a different time of day or different weather conditions. Along the same lines, if your camera has an overexposure warning (overexposed areas blink on the LCD monitor), activate it and use it. If areas of your LCD are blinking, you'll need to make some exposure adjustments.

⇑ This histogram shows that highlights and shadows will not be washed out.

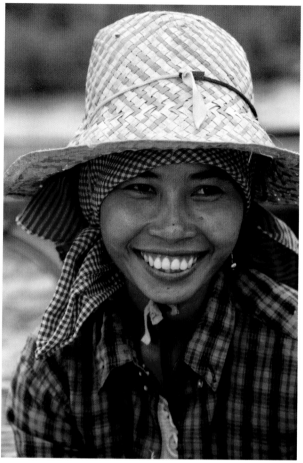

Optimize with the Optical Zoom

Before zoom lenses, photographers used a low-tech but very effective technique: They zoomed with their feet! The photographers moved closer to or further away from their subject. Today, zoom lenses make it easy to change composition and perspective without changing position.

When using a digital camera with both an optical and a digital zoom lens, use the optical zoom lens for the sharpest results. Digital zooms don't really zoom, they simply enlarge the center part of the frame— something you can do in the digital darkroom.

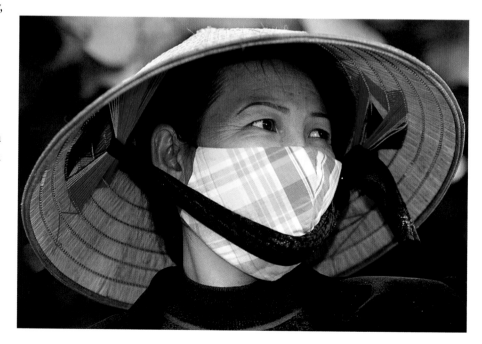

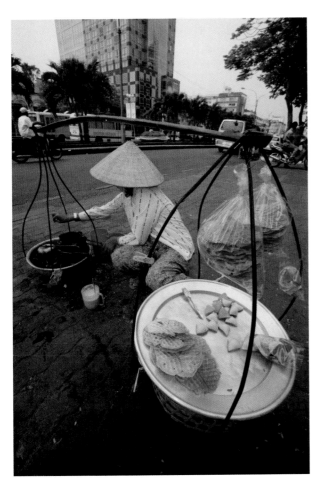

Don't Delete Too Quickly

If a picture on your LCD monitor is not perfect, consider how you can enhance it in the digital darkroom—by cropping and by boosting the color, brightness, and contrast. Also consider how digital filters can enhance a scene, as nik multimedia's Color Efex Pro 2.0 (www.nikmultimedia.com) Sky Blue graduated filter enhanced the sky in this picture.

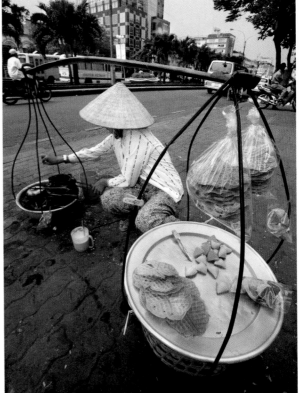

Watch Your Power

Reviewing pictures on a camera's LCD monitor, zooming, using a flash, and using image stabilizing and vibration reduction (VR) lenses all consume battery power. Keep an eye on your battery power. Pack an extra battery (or two) and you won't be left in the dark when it comes to getting fun shots.

Love Your Laptop

This is the last thing you want to see and experience when you are traveling with your laptop: a cracked screen. That happened to me when I was leading a workshop in China. Our team had jet lag after the long flight from New York. When I was checking into the hotel, I placed my laptop on the hotel's check-in counter. One of my fellow travelers leaned on my closed laptop with his elbow, cracking the screen.

When traveling with a laptop, keep in mind that pressure on the top panel can crack the screen. Have a "hands-off" policy with fellow travelers. Better yet, pack your laptop in a hard case or padding to ensure that you'll be able to use your computer on site.

Okay. Now that we have reviewed some digital photography basics, let's jump into twenty-six different situations.

Travel and Nature Photography Basics from A to Z

Still in a hurry to soak up photo know-how before you head out on location? I don't blame you! Here are some quick tips for better digital images when taking nature and travel pictures.

Aerials

When shooting from a small airplane, you'll most likely be shooting through Plexiglas. For a sharp shot, ask for the door to be removed. This is not for the faint-hearted, and it's not always possible. To avoid reflections on the Plexiglas, cup your hand around your lens and hold it near but not on the window. Wearing a black shirt will also help reduce reflections. Likewise, wearing a white shirt might create a bright reflection.

Before you take off, ask the pilot where you should sit for the best pictures. Sometimes it's in the copilot's seat, sometimes it's in the back of the plane. It's never over the wing.

When taking pictures from an airplane, especially a small one, you don't want any part of your upper body to touch the window or any part of the interior of the plane, for that matter. If your

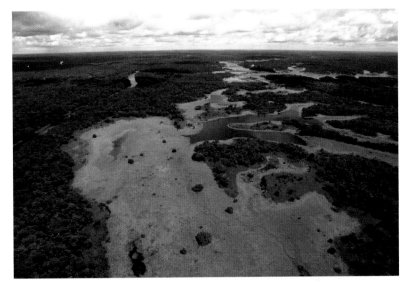

Amazonas, Brazil

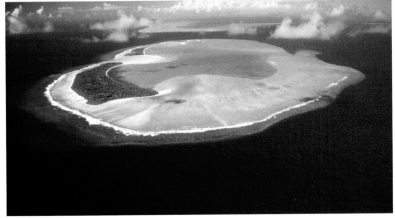

Palau, Micronesia

upper body comes in contact with, say, an armrest, the vibration from the plane can be transferred to your camera, causing camera shake, which, in turn, can cause a blurry picture. To reduce the effects of camera shake, use an ISO setting that gives you a shutter speed of at least 1/250 of a second. I usually set my ISO to 200 on a sunny day. When it comes to lenses, use a medium wide-angle setting for sweeping views and a medium telephoto for tighter shots.

Also, when you are shooting from a small plane, be prepared to shoot fast! Set your camera on rapid frame advance and be ready to shoot at a moment's notice.

Behind-the-Scenes Shots

We all love to zoom in on our subjects to get pictures with impact. But if we take behind-the-scenes shots, we add a personal touch to our slide shows and photo albums, giving the viewer the feeling of being there. I like to present these photographs because it shows that I was in a safari vehicle when I took the shot of the White rhino.

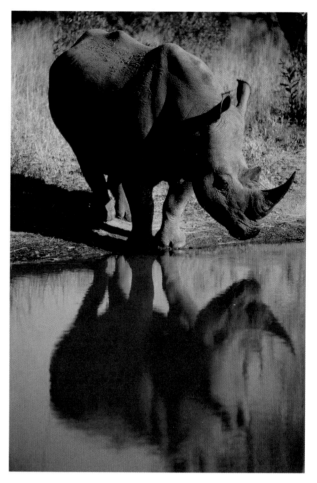

White rhino, South Africa

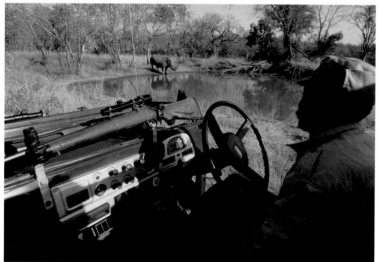

On safari in Exeter

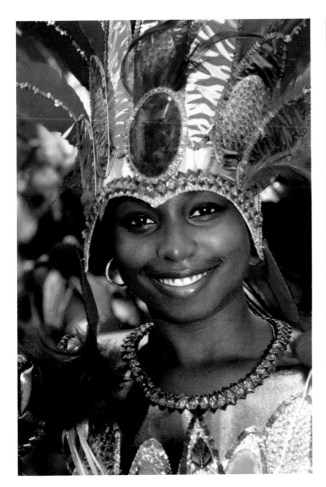

Performers, Carnival, St. Martin

Caribbean Carnivals

Caribbean carnivals are great fun and offer great photo opportunities. You'll find hundreds of people dressed in colorful costumes. The key to getting good photographs is to get into the slow-moving parades that pass through the streets and to walk along with the participants. To reduce harsh shadows caused by direct sunlight, use a flash for daylight fill-in flash photography (covered later in this book). If you don't have a flash that offers variable flash output (needed for daylight fill-in flash pictures), or don't want to use a flash, wait until the end of the parade (or get there early) and ask your subjects to move into the shade for a portrait. Keep in mind that carnivals are big, very loud parties. I use earplugs to reduce the volume of the music. To capture the mood of the event, you have to get in sync with the party.

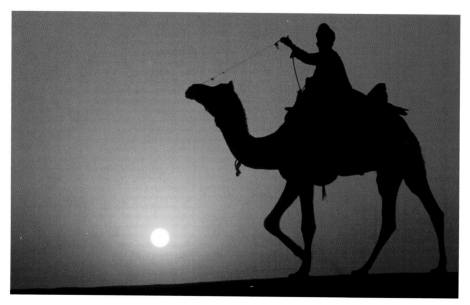

Sunset, Rajasthan, India

Deserts

Deserts, as well as beaches, offer major challenges for photographers: dealing with bright sunlight and lots of sand. When direct sunlight falls on the front element of a lens, it causes lens flare. At its worst, lens flare looks like a bright, glowing point in a scene. At the least, it can make a picture look soft and slightly out of focus. To help avoid lens flare, use a lens hood, or shade your lens with your hand or a hat.

As far as dealing with sand, which can get into the focusing and zooming rings of lenses, avoid it at all cost. Never place your camera bag down in the sand.

When changing lenses in the desert or at the beach, try to select a location that is protected from the wind. The last thing you want on your digital SLR's image sensor is even a single grain of sand, which will look like a large blob in your pictures. Also, change lenses very carefully. I was teaching a workshop on the beach one time when one of my students, while changing lenses, actually dropped one of his lenses in the sand! Carry a small can of compressed air for such emergencies, but never spray the image sensor with compressed air.

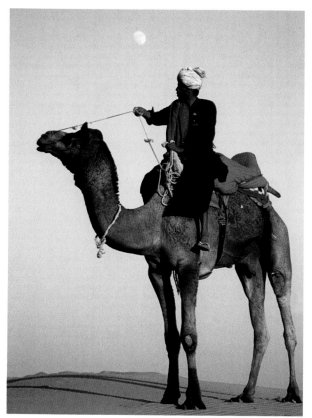

Shortly before sunset, Rajasthan, India

Island, Halong Bay, Vietnam

Island cavern, Halong Bay, Vietnam

Exploring a Location

Part of the fun of taking pictures is exploring a location. On our explorations, being prepared to capture unexpected sites is a key ingredient in getting the best shot. On a trip to Halong Bay in northern Vietnam, I packed a variety of lenses and accessories, including my flash. Without my flash, and fresh batteries, I would have missed capturing this quite unexpected view: a massive cavern inside the island that was discovered accidentally by a fisherman a few years before my 2003 trip.

Fun Shots

It's easy to get caught up with taking the best possible pictures when we're on location. However, if we try too hard, and don't have any fun, we may not get the best picture or even get a high percentage of good pictures. So, my advice is to have fun! And when you are having fun, record the moment. In later years, your fun shots may mean more to you than your serious photographs. A flash was used to lighten the faces in both of these pictures. For the shot of Susan, I held my camera out the car's rear window, pointed it at Susan and the giraffe, and shot blind. I missed the first few shots, but eventually got a keeper.

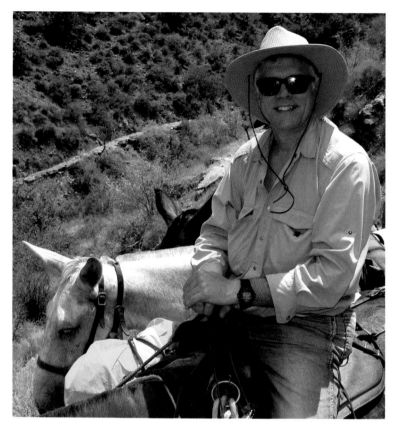

Your author before painful saddle sores, mule ride, Grand Canyon, Arizona

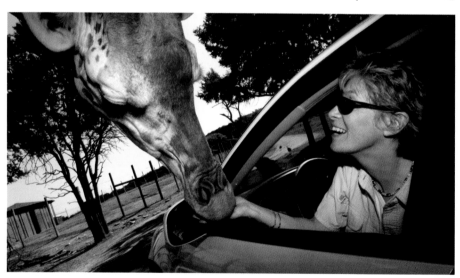

Susan Sammon hand-feeding a giraffe at Fossil Rim Wildlife Center, Glen Rose, Texas

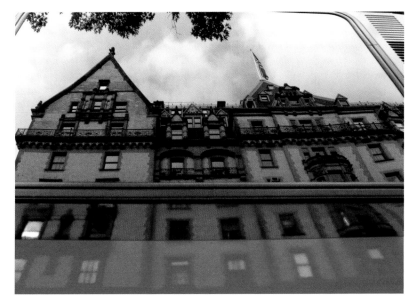

The Dakota, New York City

Glare on Glass and Water

The screw-on filter you asbsolutely need for outdoor and travel photography is a polarizing filter. A polarizing filter can reduce or even eliminate reflections on glass and water. It can also make outdoor pictures look sharper, because it can reduce reflections in atmospheric haze. Polarizing filters are most effective when the sun is at a 90-degree angle to the subject. Screw-on warming polarizing filters (with a built-in warming filter) are also available. Nik multimedia (www.nikmultimedia. com) offers a polarizing filter in its Photoshop Plug-in, Color Efex Pro 2.0.

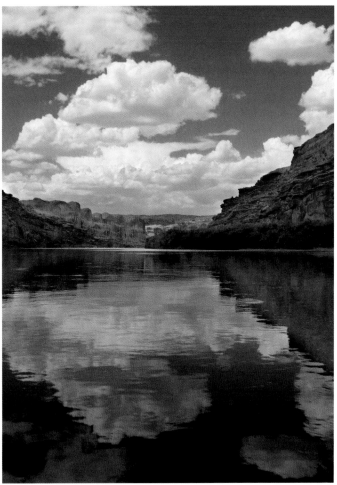

Colorado River, Moab, Utah

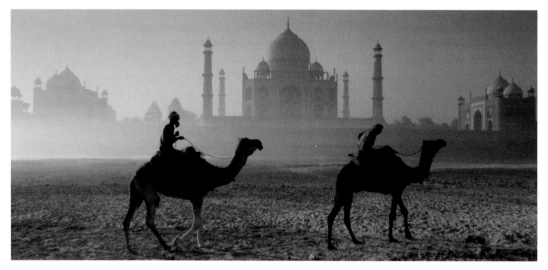

Taj Mahal, India

Gatun Lake, Panama

Heat and Humidity

Digital cameras don't like heat and humidity. When an image sensor heats up, colors may not be accurate. And when it comes to humidity, if you have a digital SLR, don't change lenses when you go from an air-conditioned area into humid conditions. If you do change lenses, condensation can build up on the filter over the image sensor and fog your pictures. If your lens and viewfinder fog up, you can wipe them clean with a lint-free cloth or wait until they clear up.

Indoors

Whenever possible, try not to use a flash for indoor shooting. The harsh light from a flash will make your pictures look—you guessed it— harsh. If you do have to use a flash, "bounce" it off the ceiling. For that technique, you'll need a flash with a swivel head. Bouncing the light will spread and soften it for a more even and flattering effect. The bedroom photograph is a natural-light shot, taken with my camera mounted on a tripod. The barbershop photograph is a flash shot, taken with bounce flash lighting.

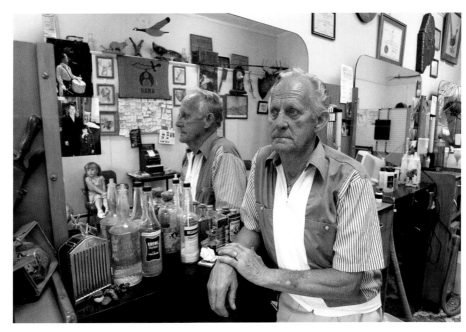

Kief's Barbershop, Belfast, Maine

For indoor, natural low-light photography, a tripod is sometimes a must. For hand-held pictures, you'll need to use a high ISO setting (maybe 400, 800, or even higher).

To help steady my indoor shots, I use a Canon 28-135mm image stabilization lens. This lens, because it reduces the effect of camera

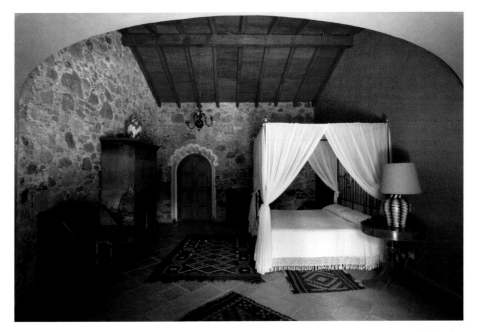

Ville de Santa Monica, San Miguel de Allende, Mexico

shake, lets me shoot at a slower shutter speed than is usually possible for hand-held photography. The general rule for hand-holding a lens is this: don't use a shutter speed slower than the focal length of the lens. That is, when using a 28mm lens, don't use a shutter speed below 1/30 of a second.

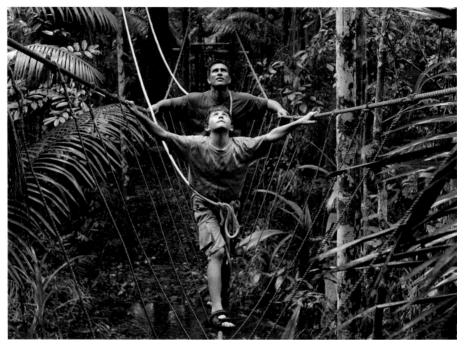

Survival camp, Ariau Towers, Amazonas, Brazil

Jungles

Deep in the jungles, we have to deal with dim lighting conditions. Be prepared to shoot at relatively high ISO settings, maybe even as high as ISO 800. Using a flash is another option if you plan to photograph people and close-up wildlife.

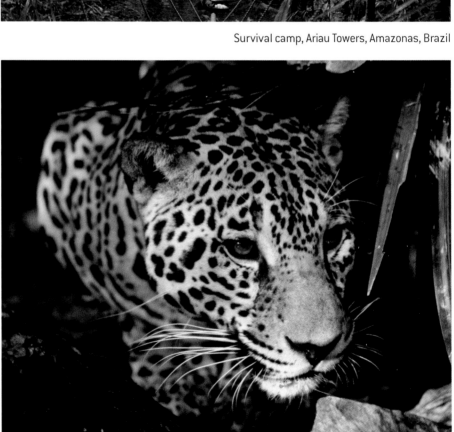

Jaguar, Belize Zoo, Belize, Central America

Boy with cat makeup, Ybor City, Florida

Young clown, Tampa, Florida

Kids

When photographing kids while traveling, keep in mind that silence is deadly. During an impromptu photo shoot, keep talking to the kids, even if you are using a guide/translator. The feeling and attitude you project will be reflected in your subject. Another tip is to "see eye to eye"—that is, get down to the child's level when you take the picture, rather than standing up and looking down at the child.

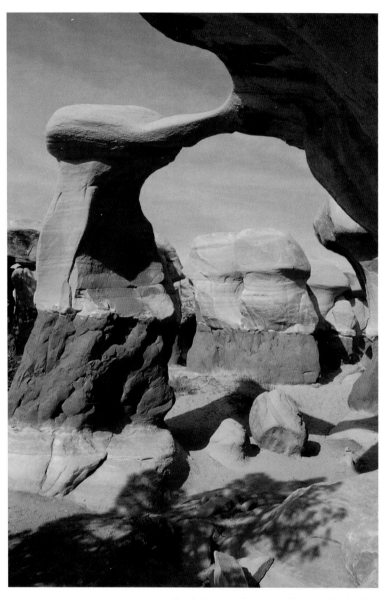

Devils Garden, Escalante National Park, Utah

Landscapes

Landscape photography is usually wide-angle photography, because wide-angle lenses, when set to small apertures, produce good depth of field. I like to use the 20mm to 24mm settings on my 16-35mm zoom lens when photographing landscapes. My aperture is usually between f/11 and f/22. Small apertures can mean shooting at slow shutter speeds, which in turn means that we often need a tripod to steady our camera to prevent blur caused by camera shake. A good rule to follow for maximum depth of field is to set a small aperture, focus one-third into the scene, lock in the focus, then recompose and shoot.

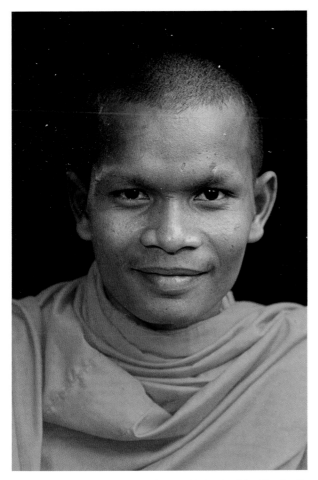

Buddhist monk, Angkor Wat, Cambodia

Street performer, Guanajuato, Mexico

Mind Your Manners

When we travel, we need to respect our subjects and be respectful of local customs. When we respect our subjects, they will respect us, helping us get the kinds of pictures we are seeking. Reading about local customs and religions gives us an understanding of what to expect on site. I have found that most people will pose for a portrait if I ask their permission with a genuine warm smile. I also respect the person's right to say no.

Nighttime Shooting

Cities come alive with lights after the sun sets. This is a great time to get dramatic photographs. To capture the lights, I recommend setting your camera to ISO 400 and the white balance to Automatic (due to the different light sources). To add drama to nighttime city photographs, use a slow shutter speed (perhaps as long as 30 seconds) to get taillights streaking through a picture. Those long shutter speeds will require a tripod. Check your camera's LCD monitor to make sure that bright lights are not overexposed. If they are, use your camera's +/− Exposure Compensation control and reduce the exposure accordingly. Finally, remember what your mother told you: Wear white at night for safety.

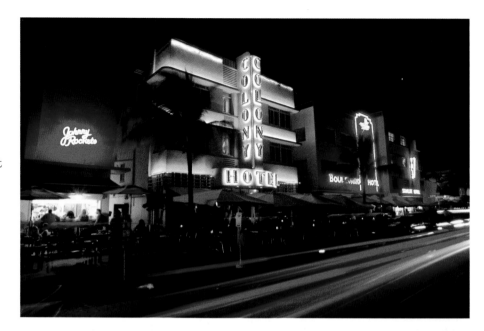

Miami Beach, Florida

Owls and Other Birds

For close-up shots like these of feathered friends in the wild, you'll need a telephoto lens. As a basic "bird lens," I'd recommend a 100–400mm zoom. To get an even tighter shot of a faraway bird, use a 1.4× or 2.4× teleconverter, which effectively increases the focal length of the lens by 1.4 times and 2.4 times, respectively. Keep in mind that 1.4× teleconverters often produce sharper images than 2.4× teleconverters. To light subjects in the shade and to add some catch light to a subject's eyes, use a flash with a flash extender, a device that fits over the flash head and increases the possible flash-to-subject distance.

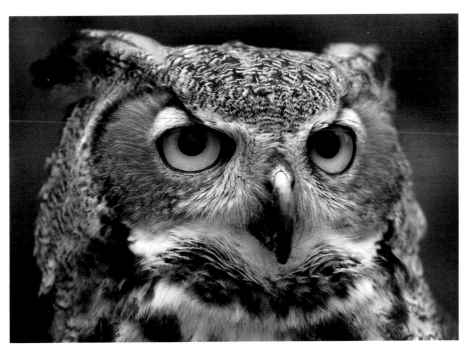

Screech owl, Anna Maria Island, Florida

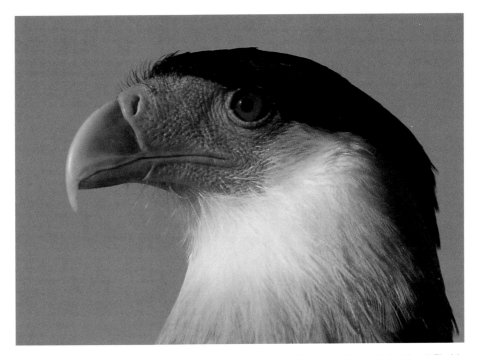

Cara cara, Anna Maria Island, Florida

Practice at Home

When we go on location, we often see photo opportunities that can be gone in the blink of an eye. If we have to fumble around with camera settings, we might miss the shot. I've seen that all too often on my workshops. If we practice at home, to the point where making camera adjustments becomes second nature, we'll get a higher percentage of keepers when we travel. Practicing, however, goes beyond technical camera adjustments. If you have not photographed strangers for a while, photograph your family, friends, and neighbors to start. If your travels will be taking you to a foreign city, make a trip to your local big city and shoot throughout the day. If close-up nature photography is your passion, spend time experimenting with lighting to see how best to light your subjects. Taking pictures on location is like jazz piano improvisation: Knowing what to do next becomes almost automatic.

Rick practicing at home

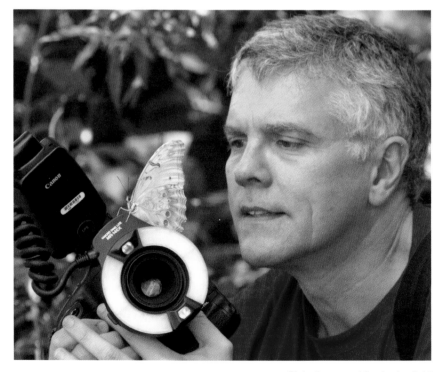

Rick photographing in the field

Quality Control

Novice digital photographers often think that getting a camera with the highest number of megapixels and shooting in the RAW mode will give them the highest-quality image. Well, those factors do affect image quality. However, they are not the only things to consider. The quality of the lens not only affects the sharpness of an image, but it can affect how much light reaches the corners of the image sensor. When light is reduced in the corners, the image will look darker in those areas. How a digital file is processed in-camera also affects the quality. Usually, more expensive cameras have higher-quality image processors than relatively inexpensive cameras. How you process an image in your image-editing program also affects the quality. For best results in the digital darkroom, save and work on your pictures as TIFF (Tagged Image File Format) files, which saves pictures, including any editing you created on Layers. If your imaging program can open 16-bit files (Adobe Photoshop CS can, Adobe Photoshop Elements cannot), go for it. You'll get less "banding" in shadow areas and you'll have a file with maximum color depth. Also, when sharpening an image, always sharpen as a final step.

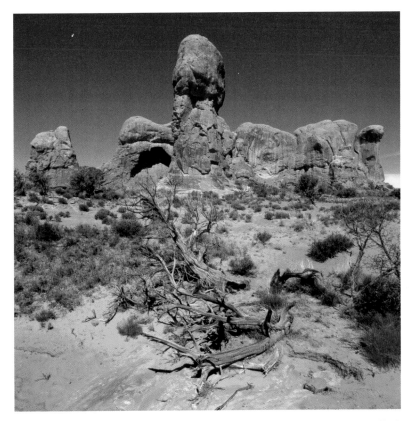

Crowned pigeon, San Diego Zoo, California

Arches National Park, Utah

Rainy Days

To protect your gear when shooting in the rain, travel with a camera bag with a water-repellent foldout cover. For in-the-rain shooting, use large sandwich bags or plastic bags with openings cut out for your lens and viewfinder. For serious waterproof protection, check out the waterproof plastic housings from EWA marine (www.rtsphoto.com/html/ewamar .html). In any case, be careful that your camera does not get wet! Digital cameras don't like moisture.

View from a roadside restaurant, Anganguero, Mexico

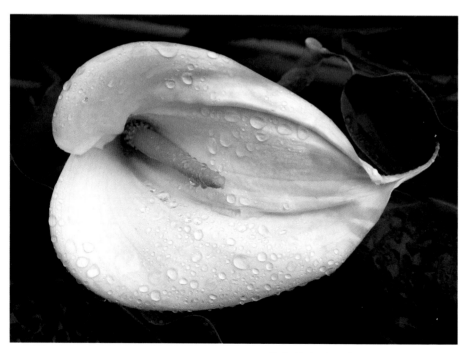

Calla lily in the rain, Anganguero, Mexico

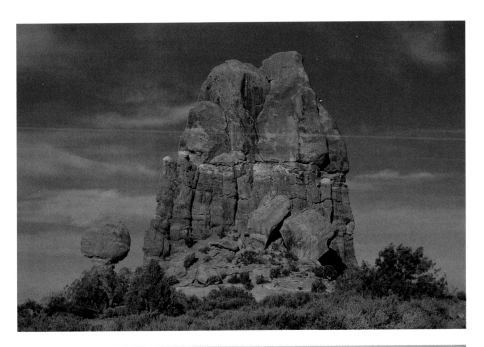

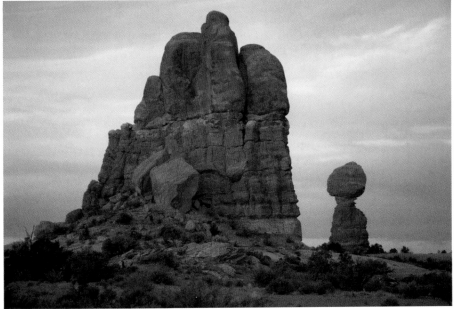

Arches National Park, Utah

Shadows

Shadows add depth and dimension to our pictures. Without shadows, our pictures look flat. Overcast days and scenes before sunrise and after sunset have few if any shadows. Sunny days offer strong shadows, with the most dramatic and flattering shadows in the early morning and late afternoon. For the most dramatic outdoor pictures, shoot during these hours, when the light is warm and shadows add contrast to our pictures.

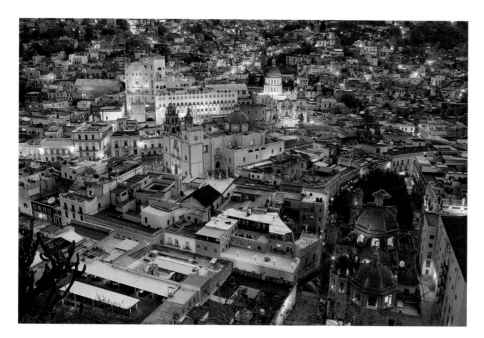

Guanajuato, Mexico

Twilight

Twilight is a wonderful time to photograph cityscapes. The mix of soft skylight and city lights produces pictures that seem to glow. When you arrive in a foreign city, ask the hotel manager when the sun sets and where most people go to photograph the sunset. Get there early, set up your tripod, and compose your picture. Slightly underexposing your pictures will give you slightly more saturated colors. Set your white balance on Auto due to the mixture of light sources. To help prevent camera shake, use your camera's self-timer for "hands-off" shooting with a tripod.

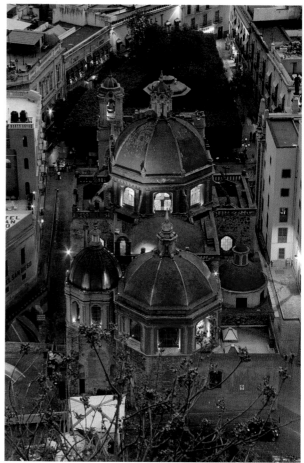

Underwater Photography

Many books have been written on underwater photography, and I've actually written five of them. Shooting beneath the waves requires waterproof cameras or waterproof housings for topside digital cameras. A Google search for underwater housings will help you find a housing or camera that meets your needs. Basically, wide-angle lenses are ideal for beneath-the-waves seascapes. Lenses longer than 50mm for that purpose are relatively useless. However, to capture the wonders of the close-up world, you need a macro lens. To bring out the color of marine creatures, you'll need a flash (or two), because water filters out color selectively. The deeper you dive, the more colors you lose.

Chain moray eel, Maldives

Long-nose hawkfish, Maldives

Vertical and Horizontal Shots

How we hold our cameras, vertically or horizontally, and how we compose our pictures in each position, dramatically changes the view of a subject. What's more, having both a vertical and horizontal picture of the same subject increases the chance of getting published. When I am out shooting, I usually take both vertical and horizon photographs of the same subject.

Zion National Park, Utah

Waterfalls

Three technical factors to consider when photographing waterfalls are exposure, filtering, and shutter speed. Because water reflects light, you'll often see "hot spots" in waterfall scenes. To avoid these areas being washed out, slightly underexpose your picture, perhaps by a stop. With your digital image-editing program, you can usually "pull" data from shadow areas, but it's usually impossible to bring back washed-out highlights. To reduce reflections in-camera, use a polarizing filter. Digital polarizing filters can darken a blue sky, but they really can't reduce harsh reflections. Use a slow shutter speed (from 1/30 of a second to several seconds) to blur the movement of the water. The longer the shutter speed, the more the water will be blurred. If it's sunny, use a neutral density filter. It reduces the amount of light entering the lens, and therefore lets you shoot at a slower shutter speed. Slow shutter speeds require a tripod for a sharp shot. The unacceptable picture of this waterfall was taken at 1/30 of a second at f/2.8 with the ISO set at 800. No tripod was used. The much more pleasing photograph was taken at 1-1/2 seconds at f/22 with the ISO set at 100 (a setting that offers minimal digital noise, as opposed to ISO 800, which has increased digital noise). For the second image, I used a tripod and neutral density filter. Both images were taken with my full-frame digital SLR and my 17-35mm zoom lens set at 50mm.

Small waterfall, Croton-on-Hudson, New York

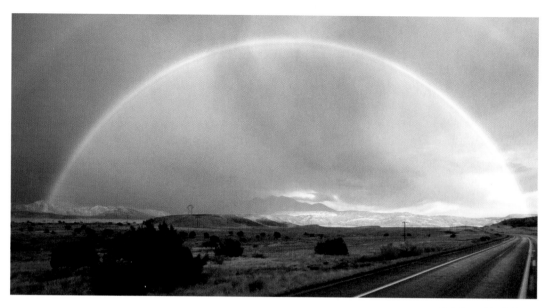

Rainbow, Moab, Utah

"X" Marks the Spot

"Being there" is one of the key ingredients of good travel pictures. Travel as much as you can and get inspired to take great pictures as often as possible. Also, sometimes moving just a few feet to the left or right can make the difference between a great shot and a snapshot. When looking through your camera's viewfinder, think about the best possible spot from which to take the picture. For these two pictures, I placed myself in what I thought was the exact right spot for the picture. The photograph of a lion eating a baby zebra was taken at night. I converted the dramatic color image to a sepia-toned image in Photoshop for a less gory effect. For the double rainbow image, I framed the shot so the right end of the rainbow was aligned with the yellow line in the road.

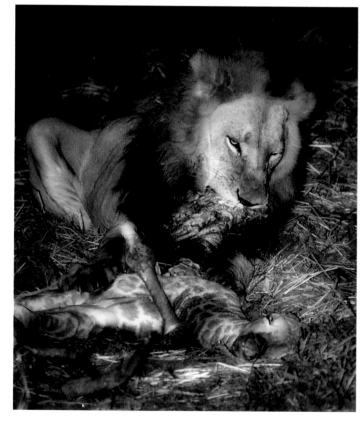

Lion kill, Botswana

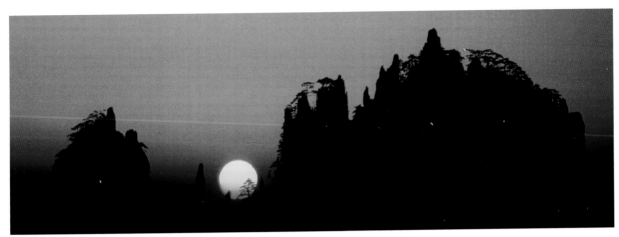

Sunrise, Danxia Mountain, China

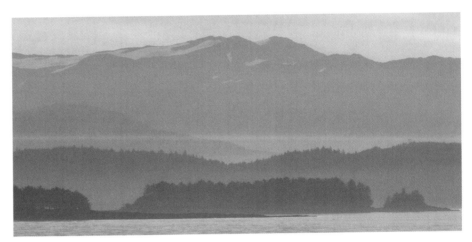

Before sunrise, Glacier Bay, Alaska

You Snooze, You Lose

Simply put, get up early and stay out late when traveling. In the early morning and late afternoon hours, you'll get deeper shades of red, yellow, and orange, what professional photographers often call the day's golden light. What's more, long shadows will add a sense of depth and dimension to your photographs. Likewise, pictures taken around midday will look "cool" and flat. If you really want to get a moody photograph, shoot an hour or so before the sun rises or after it sets. You'll need a tripod and need to use long shutter speeds, which require a cable release or the use of the camera's self-timer to prevent camera shake. Long shutter speeds often result in an increase in digital noise in pictures. Some cameras offer a noise reduction feature, which you manually activate. Noise reduction does work, but the noise reduction process increases the time it takes for a picture to be written to the camera's buffer, which can prevent you from taking another picture in rapid succession. Because you can reduce noise in the digital darkroom (using a noise reduction filter or a blur filter), I think it's best not to use the camera's noise reduction feature.

Zoos and Wildlife Parks

All professional photographers started out as amateurs. It's true. As amateurs, we can practice our wildlife photography skills at zoos and wildlife parks. When taking pictures, try to imagine what it would be like to shoot in the field. Get to know what your camera and lenses can do, so that when you do shoot wild animals, making camera adjustments becomes second nature. A telephoto lens will help you isolate subjects from distracting background elements.

Proboscis monkeys, Bronx Zoo, Bronx, New York

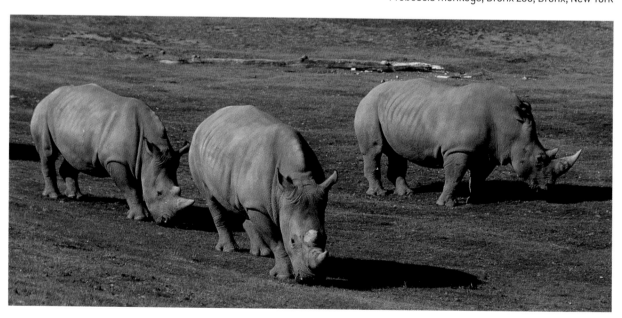

White rhinos, San Diego Wildlife Park, San Diego, California

Travel Smarts

In my travels around the world, I've gained a few "travel smarts" the hard way—usually by making mistakes.

Getting sick, not having the right gear, displaying poor manners, wearing the wrong clothes all can ruin any photographic adventure.

You can learn from some of my mistakes, and realize that being prepared will make your venture more pleasant and more productive.

Having travel smarts has helped me to come back with a high percentage of good pictures from fairly exotic locations, including Botswana, Brazil, Cambodia, and Nepal. It has also helped me when shooting in fairly difficult conditions closer to home,

including the national parks in the American Southwest, where the temperature can climb to over 100°F, causing possible dehydration in a relatively short period of time. Even when I am only going an hour away, I plan ahead: "Be prepared," as the Boy Scouts of America say.

Be Flexible

Traveling is a great experience and a wonderful education. Visiting and photographing new places, such as Monument Valley, Arizona (pictured below), is invigorating. However, unexpected bad weather, airport delays, and other travel-related challenges can arise. When traveling, the key to maintaining a good

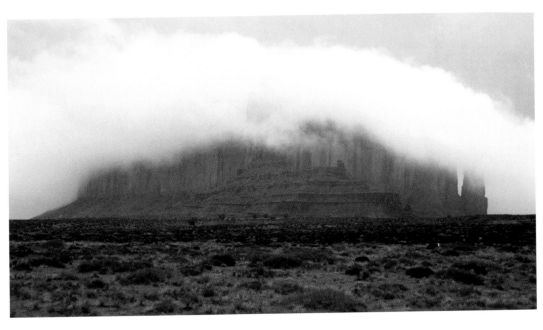

attitude is to be flexible. Looking at unexpected situations as opportunities, rather than as problems, will help you maintain a positive attitude.

Choose Your Shoes

If you plan to take pictures in Buddhist temples, as I did in the Temple of the Reclining Buddha in Bangkok, Thailand, you'll want sandals or shoes that slip on and off very easily, so you don't have to lose time untying and tying shoelaces. I learned this tip from photographer Lou "Boston" Jones. Footwear is also important when shooting in the field and in the city. For example, if you're shooing in the rainforest, waterproof hiking boots will help keep your feet dry and comfortable. When you are photographing in the mountains and canyons, high-end hiking boots will guarantee sure footing. If you plan to shoot in the water—at a lake or river or by the shore—consider fisherman's waders or scuba diver's booties.

Copy It

When traveling to foreign countries, your passport is perhaps one of your most valuable possessions. Lose it, and you could get stuck for days waiting for a new one. You can speed that process if you have a copy of your passport's identification page. Keep the copy in a separate place, perhaps in a suitcase. As for your actual passport, I'd recommend leaving it in a safe deposit box at your hotel or lodge.

Dining Out

Being careful about what you drink and eat may make the difference between feeling great and feeling really, really bad. Avoid the drinking water, and don't even brush your teeth with tap water when traveling in a foreign country. Don't have a salad, because the lettuce and tomatoes may have been washed in tap water. What's so bad about the tap water? Tap water elsewhere contains different kinds of bacteria and organisms than your body is used to. It's the bacteria

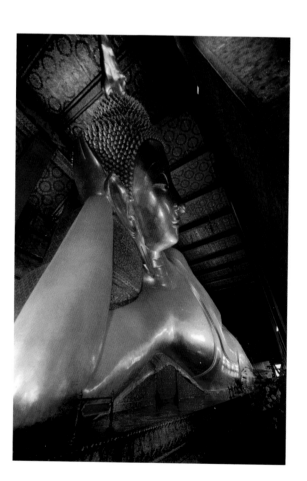

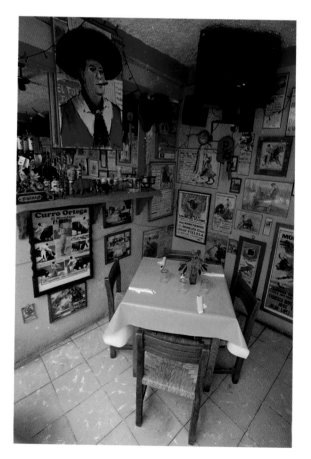

that can make you sick. When traveling, do what I do when I travel: Stock up on bottled water. It's also a good idea not to drink milk or ice cream that has not been pasteurized. And, remember to eat hot food hot. (See "Stay Healthy," on page 76, for information.) By the way, if you find yourself in San Miguel de Allende, I highly recommend having lunch and dinner in Olé! Olé!, pictured on the previous page. Great food, great price!

Do It When You Can

My dad has a great philosophy: When traveling, eat when you have the opportunity. That's pretty good advice for on-the-go photographers. I actually ate some of the watermelon pictured on the right during a trip on the Celebrity cruise ship *Constellation*, helping to hydrate myself before going out into the hot and humid weather. My friend Pat Stevens adds to my dad's suggestion. She says, "Shop when you can."

Dress for Success

What's wrong with this picture from Exeter National Park, South Africa? As I am sure you noticed, the woman in pink has not dressed for a photo safari, where green, tan, and brown clothes are recommend to provide some camouflage from wildlife. What's more, the woman is wearing sneakers, which don't protect your feet from sharp thorns that can poke through

the soles. (Our safari guide is trying to remove a thorn from her sneaker.) If you go on a safari, dress for success, and for protection from the animals. Speaking of dressing, photo vests and jackets not only make us look like professional travel photographers, but they are practical. All those pockets are great for giving us fast access to photo accessories, such as filters, memory cards, a flash unit, and even lenses. In addition, photo vests and jackets can act as an extra carry-on bag, letting us take extra gear on

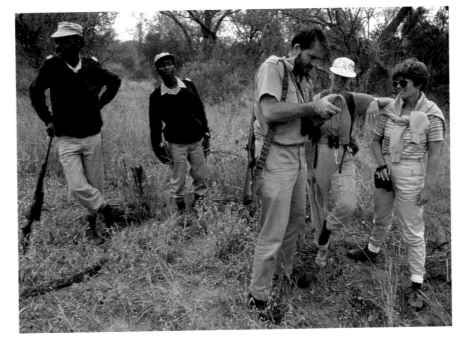

a flight. Wide-brim hats are important, too, shading face, neck, and ears from the bright sunlight that can cause sunburn. In my opinion, sunglasses are a must.

Fly Weekends

Weekday flights are usually packed with business travelers. Packed planes mean less carry-on room for our fragile camera gear. If possible, fly on the weekends to avoid the crowds. Also try to hand-carry all your camera gear with you to avoid having to send any of it through baggage. I sometimes overnight my extra gear to a location to avoid traveling with checked luggage.

Follow the Music

Photo legend Burt Keppler gave me some good advice before I took off for a tip to Bali, Indonesia. "Follow the music," he said. Burt was suggesting that when driving around the country, we should listen for music coming from local celebrations. We did, and found a celebration for the full moon. I also followed the music in Queretaro, Mexico (pictured here), and found a once-a-year celebration of local residents dressed in traditional costumes.

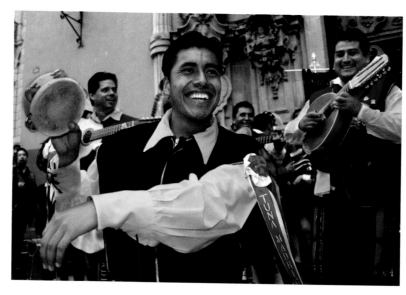

Get a Good Guide

Guides and translators are most helpful when traveling in foreign counties. Not only can they actually save you time in searching for a particular photograph, but they also may be able to help you see places and people you normally would not have the opportunity to see. If you don't arrange a guide through a travel agent, you can usually get one through your lodge or hotel. I know for sure that I would not have seen and photographed as many animals as I did in Botswana if it had not been for my expert guides, who spotted this lion resting in the shade from a distance of about 300 yards—while we were driving over a bumpy road. A good guide is worth what is often the least expensive part of an exotic trip.

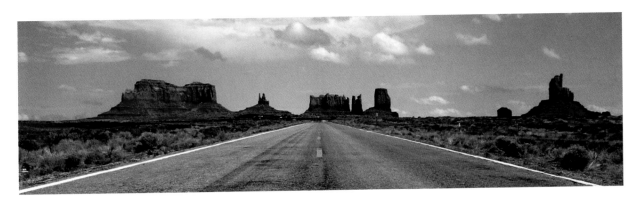

Keep On Searching

Perhaps the best source of information for travelers is the World Wide Web. Well in advance of leaving home, do a Google search on your destination, as I did before I ventured off to Monument Valley, Arizona. Check for weather, sites, photo restrictions, religious considerations, special events, festivals, holidays, local currency, local power (AC), and so on. The more you know about a destination, the better prepared you'll be photographically. If you plan a driving trip in the United States, join the AAA American Automobile Association (AAA). The organization offers detailed maps and other useful information for "road warriors." The AAA "Trip Tiks" was very helpful for me when I was driving throughout the American Southwest. For international travel, I rely on the Lonely Planet (www.lonelyplanet.com) travel guidebooks. They contain honest and practical advice on destinations. W. W. Norton (www.norton.com) also publishes well-respected guidebooks, for national and international destinations, that I have found most useful.

Make a Donation, If Possible

When I travel, I often pay adults a small fee ($1–$5) in exchange for taking their picture. I feel that if I'm getting something out of the photo session, so should the subject. However, when

photographing a child or a group of children, I try to find out if I can make a donation to a local school or charity, rather than pay the kids. That's what I did when I was photographing in Khajuraho, India. I recommend this later approach especially when traveling in countries such as India, where poverty is rampant, and you could get mobbed if you take out your wallet on a crowded street.

Read All about It

Read your camera manual and know what all the buttons do before you leave home. Know what your camera can and can't do. If you wait to read the manual on site, you'll not only miss photo opportunities, but you may make mistakes in camera settings, such as setting the

ISO, JPEG, or White Balance incorrectly. Pack your camera manual in your gear bag just in case you forget how to activate a camera's feature.

Salt and Water

When I was shooting in the deserts of Morocco, I almost died of heat stroke. I was shivering, sweating, and delirious. What was causing my symptoms? I was dehydrated. In hot climates, such as in Arches National Park in Utah, where I was shooting in June 2004, you can become dehydrated quickly if you don't drink a lot of water, at least a gallon a day. Salting your food will help you retain water.

Shape Up

If your travels include backpacking or hiking, you need to be in good physical shape for your trip. If you're tired in the field, you will not have the energy or enthusiasm to take good photographs. Several weeks

before a trip, start to do exercise that will help develop muscles and stamina for your trip. Make exercise a daily event.

Shooting above Sea Level

As I write this, I'm near Bryce Canyon, Utah. I'm about 8,000 feet above sea level, where the air is much thinner than it is at my home in New York, which is just about at sea level. Only a short hike into the canyon this morning took my breath away. I'm in fairly good shape. When traveling, shooting, and hiking at high altitudes, take it easy. Rest, and don't push yourself. If you are serious about getting good pictures at high altitudes, arrive a couple of days early and get accustomed to the thin air, especially if you will be hiking with a backpack filled with camera gear. A "baby" aspirin a day will help prevent altitude headaches in some people.

Shoot on the Move

Sometimes, group travel is the only way to see a site. If that is going to be the case, try to sit next to the driver so you can shoot out the open passenger window while you are moving. Better yet, ask the driver to slow down so you can take a picture. Actually, you may want to practice this "on-the-move" technique at home while a friend drives you around, which is what I did.

My at-home practice sessions helped me get this picture—taken while I was driving down a road in the Dominican Republic—of a sugar worker taking a crop to a transport station.

Sign 'em Up

A signed model release is required if you plan to use a photograph of a person for commercial purposes. The release has to say specifically that the person gives you the right to use the picture for commercial purposes. It should have space for the person to print his or her name, be signed by the person, and include the date. You may also need a release for a building if you plan to use the picture commercially. I lost a photo sale because I did not have a release from an art-deco building in Miami Beach. Even though I am friends with model Chandler Strange, I still get her to sign a release.

Stay Healthy

A visit to your doctor before a trip can help you stay healthy when traveling. He or she can recommend medicines and remedies to use when traveling to exotic locations. You can also do a search on your destination at the Web site for the Centers for Disease Control: www.cdc.gov. That will give you an idea in advance of what health problems you may run into in an area, such as malaria deep within the

Amazonas rainforest. On site, you might find indigenous people, like this Taraino chief and his daughter, who have natural remedies of their own, which they use to stay healthy.

Tag It

Many luggage bags look alike. You've seen those words at airport luggage carousels, and it's true. To distinguish your bags, place a brightly color tag on the handle. Make sure you write your name and phone number on the tag. Don't include your address. If you do, anyone reading it will know you are out of town, with your valuables at home unattended.

Take Notes

Take notes (or use a digital camera's voice recording capabilities) when traveling to help you remember facts when sharing your pictures. I used my camera's voice recording capabilities while I was visiting several different totem pole parks in Alaska. Had I not used it when I was photographing the fourteen totem poles at the Totem Bight State Historical Park in Ketchikan, I probably would have forgotten the name of the park. Accurate facts make a story more entertaining and factual. Speaking of keeping a record, if you plan to write off all or part of your trip (if you are or plan to be a professional travel photographer), you'll need to keep all receipts for Uncle Sam.

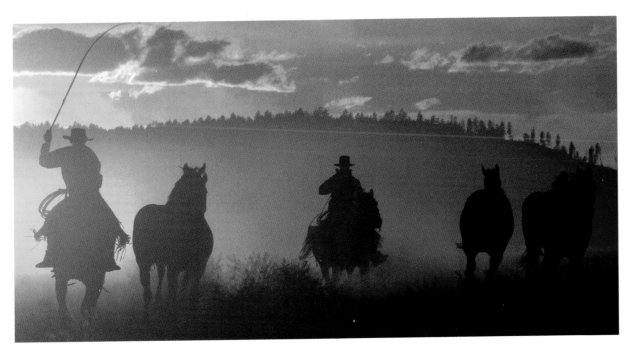

Time Is of the Essence

When most of us travel, our time is limited. Therefore, we need to maximize our hours in the field. Planning our trips before we leave home means we don't waste hours or days on location. Once on site, we need to plan each day carefully to take advantage of the light. At a workshop on the Ponderosa Ranch in Oregon with photographer Darrell Gulin, we planned the final shoot of the day so that the cowboys and their horses were perfectly silhouetted by the setting sun. Our window for this photo shoot at dusk was less than half an hour.

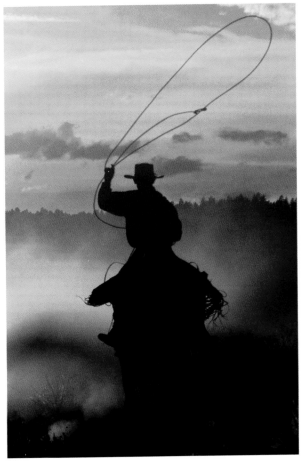

Tourist or Traveler?

My guess is that you are a traveler rather than a tourist. The difference is that tourists follow the group. Travelers go out and find their own photography opportunities. If you have the option and if it's possible, get out on your own. Out on your own you'll find unusual photo ops. With a group, you'll probably get the same old shots, riding from site to site in a bus. What's worse, you'll spend a portion of the tour at predetermined shopping stops. Finally, most of the group, I am sure, will not be as serious about photography as you. You'll quickly learn why these jaunts are called sightseeing tours and not photography tours. Yet traveling with a group in a foreign destination does offer a feeling of comfort. Doing so for a day can give you a good overview of the location and ideas for return visits. These two pictures, taken at Emerald Pool, Dominica, illustrate the difference between traveling with a group and traveling alone. To get the alone shot, I had to go back the next day, before the entrance to the pool was open, because this is one of the most mobbed places on the island. I added the vignette to the more creative photograph in Adobe Photoshop CS for, well, a creative touch.

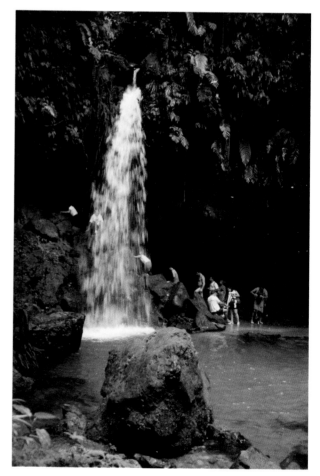

Watch It!

When you are shooting in a city and put your camera bag down to take a shot, place it between your feet or with a foot through the camera strap. That will help prevent it from "walking away" when you are concentrating on your photographs. You should also watch your wallet and passport, if you have them with you. Keep them in a money belt or zipped inside a pocket in travel pants or a travel shirt.

Work Hard, Get Lucky

When some people see a photograph of mine that they like, they say that I'm lucky to get to do what I do. I usually respond, "The harder I work, the luckier I get." So, work hard at your photography and your travels and you might get lucky, too, as I did at Big Cat Rescue, Tampa, Florida.

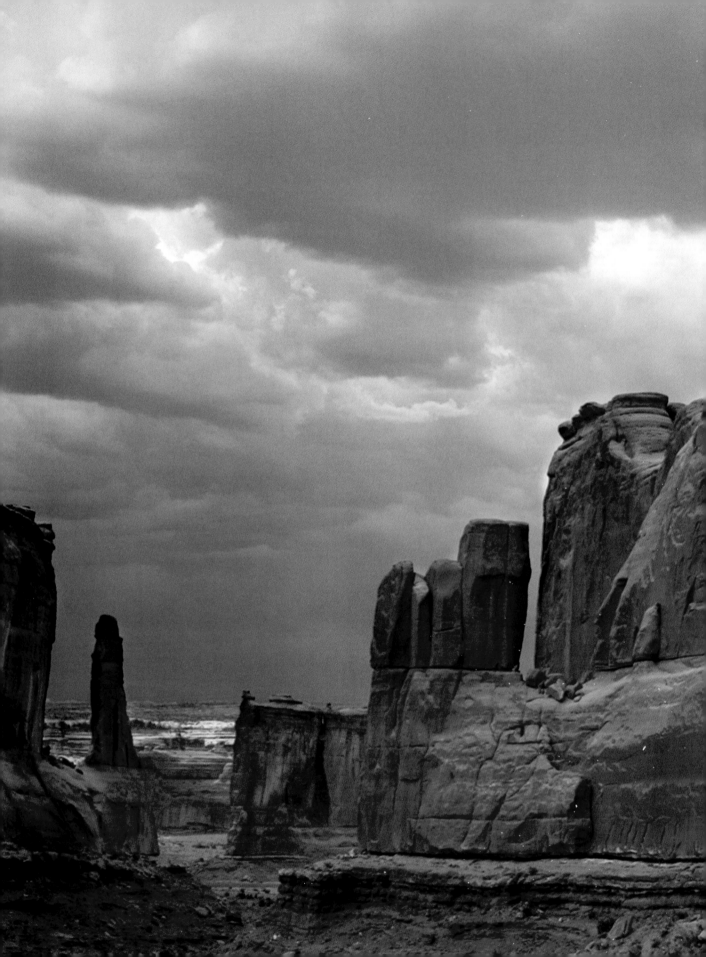

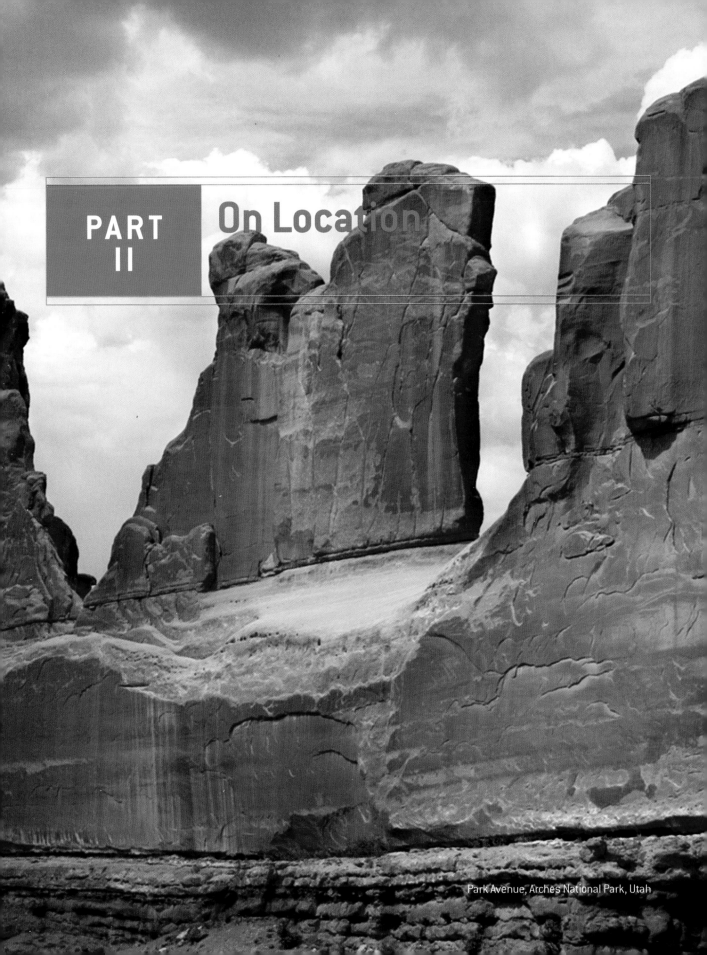

PART II

On Location

Park Avenue, Arches National Park, Utah

Little cowgirl, Montana

Grizzly bear, Triple D Game Farm, Kalispell, Montana

Common rose butterflies mating, Butterfly World,
Coconut Creek, Florida

As photographers, we all have our own special interests—people, wildlife, landscapes, seascapes, close-ups, and so on. My workshop students ask me about *my* special interests. I say that my specialty is not specializing; that I like to photograph everything. In reality, however, my favorite photographic subjects are people. I think people make pictures come alive. What's more, I enjoy the challenge of going to a foreign country, meeting strangers, and getting them to accept me. Yet after visiting places like Arches National Park, I've recently grown to love landscape photography. I have also traveled thousands of miles to shoot close-ups of the world's most magnificent butterflies and moths.

As travel photographers, we need not specialize to make satisfying and meaningful pictures. However, we do want to come home with pictures that tell a story of our destination.

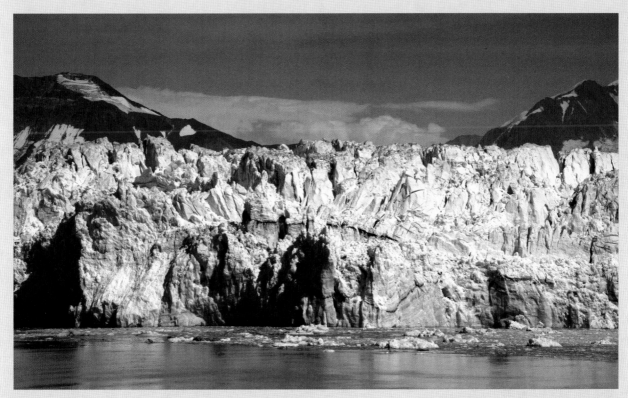

Hubbard Glacier, Alaska

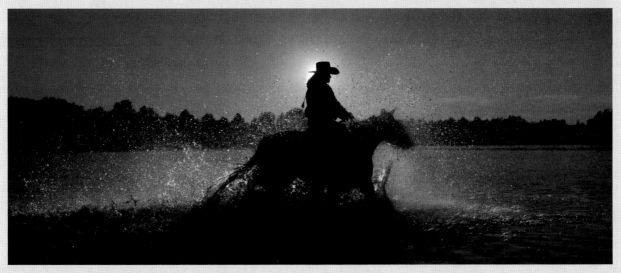

Double JJ Ranch, Rothbury, Michigan

The next set of lessons is the heart of this book. In them, I offer advice on photographing different kinds of subjects and scenes when traveling.

This spread displays some of my other photographic interests: people, animals, seascapes, and close-ups.

People

For wider-angle images (like the pictures shown later on in this lesson of three schoolgirls, the boy chopping nuts, and the man sweeping in Angkor Wat), I use a Canon 16-35mm zoom, set to 35mm when working close to the subject, and near the 16mm setting when working farther away.

Learn about a Subject

One of the real joys of travel photography is learning about other cultures and sharing that new world with others back home.

⇒ Here is a natural-light portrait of a man I met in Alaska. He was giving a lecture on Alaska's indigenous people. Most of the people who saw him simply snapped his picture and walked away. I took the time to find out a bit more about him. What I learned gives the photograph much more meaning to me, and to those who read about this native culture.

His American name is David Ramos and his native Alaskan name is Aaskuwat'eesh. He is Raven, of the Gineixkwaan clan of the Owl house. His owl headdress is made of abalone shells, ermine fur, rabbit fur, and sea lion whiskers. To signify the Owl house, David is wearing a sewn beaded owl around his neck. He is also wearing a copper necklace. David's clan is called the Copper Digging Clan because he comes from the Copper River. The clan used copper for money.

I took this picture in a bar on a cruise ship. By carefully framing David in front of a plant and a wooden wall, and by using a Canon 28-105mm zoom set at 100mm to slightly blur the background, and by placing David near a window for flattering side-

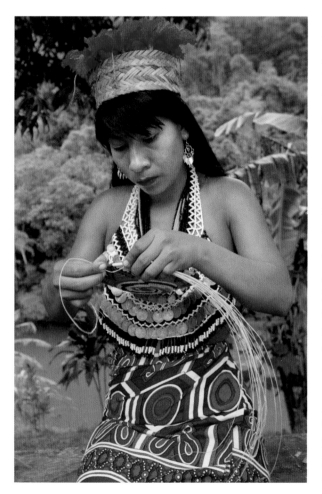

Embera woman, Panama

⇑ For many of my portaits, including the picture of the Embera woman, I use a Canon 28-105mm zoom set near 100mm. That lens and focal length let me work relatively close to the subjects, with them filling most of the frame.

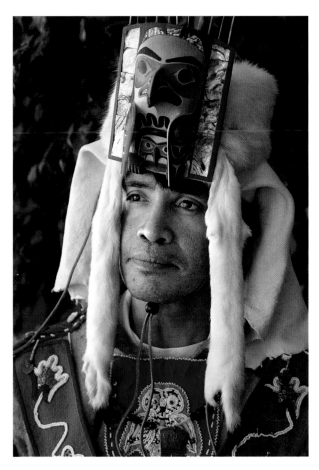

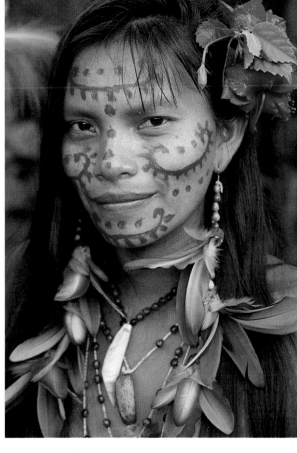

lighting, I was able to create the effect that the picture was taken on location in a village, and not on a ship with 2,000 passengers.

As a way of saying "thank you" for posing for my picture, I e-mailed the photograph to David, which he greatly appreciated. When you photograph a stranger, sending a photo to him or her is not only a nice gesture, it's very important, especially if you promise to do so.

↗ Here is another example of how learning about a subject makes a picture more interesting. I am sure you have seen pictures of Indians in the Brazilian rainforest with their faces painted, but do you know why they paint their faces? They believe that face painting helps the gods and spirits of the rainforest recognize and protect them from harm. I learned this interesting fact from our local guide, who was invaluable in getting us into the village to photograph the tribe.

See the Light

Our eyes are incredible light receptors. They can see a much wider brightness range than any digital sensor (or film). That wide brightness range is one reason why people are disappointed with their pictures. The camera simply can not capture the range of shadows and highlights that they saw when they took their picture.

The example on the next page illustrates that point. I photographed this man selling flowers in San Miguel de Allende, Mexico. My camera was set to the Program mode.

To my eyes, the man's face had the same brightness value in both scenes: I could see his face clearly. However, as you can see in the picture of the man standing by the white wall, his face is darker than in the picture of him standing by the orange wall. What

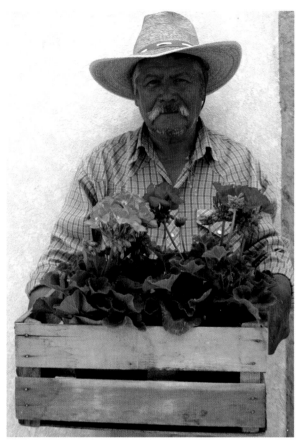

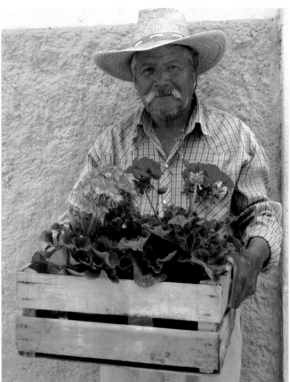

happened in-camera? The white wall "fooled" the camera's exposure meter into thinking that the scene was brighter than it was, and therefore underexposed the man's face, which only takes up a small portion of the frame. One way to compensate for this underexposure in the Program mode is to increase your exposure by +1 using the camera's +/− Exposure Compensation control. Another way would be to use the camera's spot meter and set the spot (metering zone) on the subject's face. Another way would be to use a flash, which we'll get into in bit.

When composing a portrait, look for light, and watch how the background can affect the exposure.

A side note: Look how the portrait taken from a slight angle is more pleasing than a straight-on shot. Also note how the orange wall is more pleasing then the white wall. As is often the case, a colored background is more pleasing than a white background.

Hard Light vs. Soft Light and Cool Light vs. Warm Light

To see the light is to see the quality of light. Direct sunlight is hard light with strong highlights and shadows. Overcast days create soft light. Warm light, with deeper shades of red, yellow, and orange, is produced when the sun is low in the sky. Cool light, with a blue cast or tint, is produced around noon.

All these types of light produce pleasing pictures and can create different moods.

Sunlight reaches our eyes and cameras after passing through the Earth's atmosphere. At midday with the sun overhead, the light travels down to us through the atmosphere, nearly perpendicular to the surface. Think of poking a knife into the skin of an orange. The atmosphere scatters some of the short blue wavelength light, but much of it reaches us. The shorter the wavelength, the more likely atoms in the atmosphere will bounce such waves away. At

sunset or sunrise, think of sliding a knife across your orange in order to peel it. Now, on this longer journey through the atmosphere to reach you, more of the short blue light waves have been scattered by atmosphere. The longer, redder light waves are less prone to being scattered by atoms in the atmosphere. Less blue light reaches us at sunrise and sunset, and as a result red, orange, and yellow predominate at those times of long shadows.

These cowboys were photographed at the Double JJ Ranch in Rothbury, Michigan. The cowboy in red was photographed in the direct, warm light of early morning. The cowboy in black was photographed in the shade, which produces soft, cool lighting.

In soft lighting conditions, shadows are softened or even eliminated, so we don't need to use a flash or a reflector or diffuser (covered later) for a more pleasing picture.

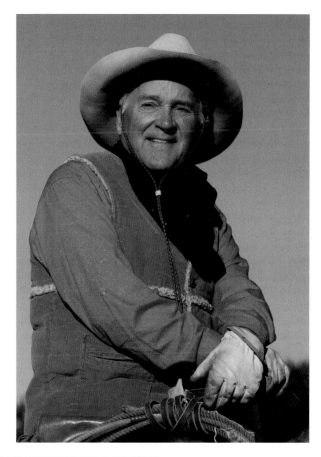

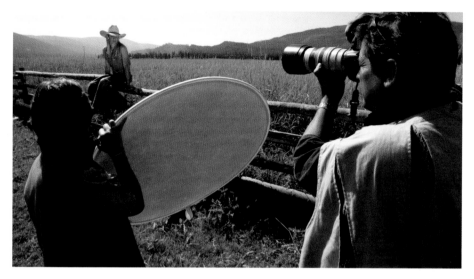

Controlling Light

In direct light, we can use a reflector or a diffuser or a flash (to fill in or to soften shadows) if the subject is toplit or backlit. In this situation, an assistant is holding a reflector to bounce sunlight onto the subject's face.

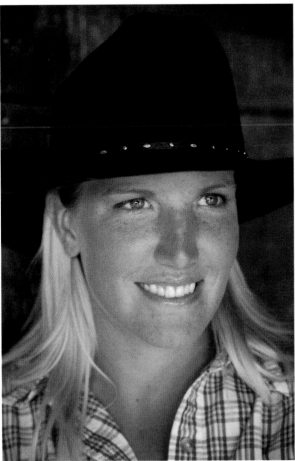

Bouncing Light into the Shade

Here is another example of how using a reflector can enhance a portrait. No reflector was used for the dull shot of the cowgirl, who was standing in the shade. Notice how her hat is lost in the background. Look what happened when a gold reflector, held in the bright sunlight, was used to bounce sunlight onto her face. It's much brighter and "warmer." What's more, now we can see the cowgirl's hat more clearly.

When using a reflector, keep in mind that the bright, reflected light can cause the subject to squint and actually hurt his or her eyes. Be considerate. Ask the subject if the bright light is too annoying. If so, position the reflector further from the subject, which will lessen the intensity of the reflected light.

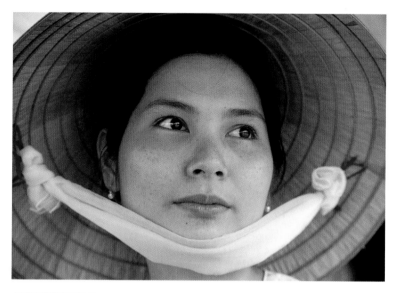

Try a Digital Reflector

Another way to warm up a subject is to use a digital filter to create the effect. In this example, I used the Gold Reflector in Color Efex Pro, a Photoshop Plug-in from nik multimedia.

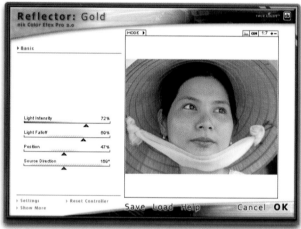

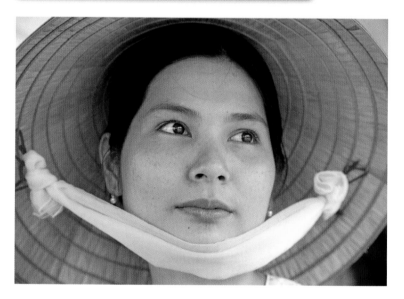

Diffuse the Light

A diffuser looks like the reflector in the preceding example, but it is translucent. This pair of pictures dramatically illustrates how holding a diffuser above the subject can make a big difference. Notice how the harsh shadows created by direct sunlight are completely eliminated.

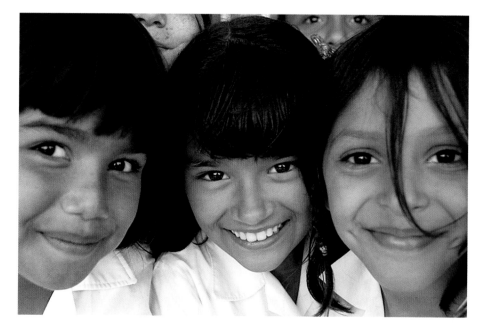

Taking vs. Making Pictures

Professional photographers know that there is a big difference between taking a picture and making a picture. Taking a picture means photographing what we see, without moving the subject or any of the elements in the scene. Making a picture means that we move subjects and elements for a more pleasing picture or one with greater impact.

Here are two examples of making a picture. For both pictures, the schoolgirls in Costa Rica and the monk in Cambodia, I moved the subjects, who had been standing in direct sunlight, into the shade. The girls are standing under an overhang of their school looking into the bright schoolyard, and the monk is sitting on his bed, which was positioned near a doorway.

The two pictures have something else in common: light caught in the subjects' eyes brightens up their faces. You see, I simply did not move the subjects into the shade, I positioned them so that they were looking into a bright light source.

When you need to make a picture, consider how you can pick a location that adds some catch light to the subject's eyes.

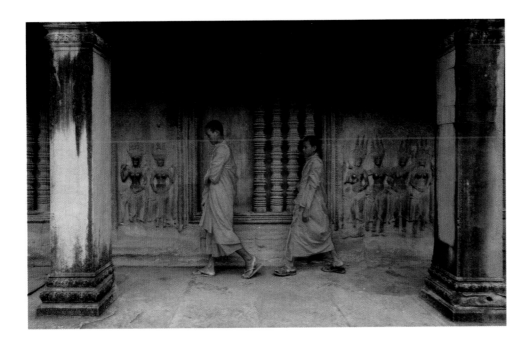

Here are two more examples of making a picture. For the photograph of the monks, I asked them to walk back and forth several times in the temple at Angkor Wat, Cambodia. For the picture of the boy cutting nuts in Brazil, I asked him to move closer to the edge of the hut, which had more light, so I could shoot at a smaller f-stop for more depth of field.

Daylight Fill-in Flash

Compare these two pictures taken in Queretaro, Mexico. One has more "pop" than the other; it has more contrast. The catch light makes the girl's eyes sparkle. Yet, the brighter picture does not look like a flash picture, which is the goal in daylight fill-in flash photography. Here's one technique for reaching that goal.

1) First, you'll need a flash with variable flash output control—that is, +/− exposure control.
2) Turn off the flash.
3) In the Manual mode, set the exposure.
4) Turn on your flash and make an exposure with the flash set at −1 1/3. If your picture looks too much like a flash shot, reduce the flash output to −1 1/2. If it's still too "flashy," continue to reduce the flash until you are pleased with the results.

 This technique works because even in the Manual mode, the flash will operate in the Automatic mode. I suggest that you master this technique. It is an essential tool used by most of my nature and travel photography friends.

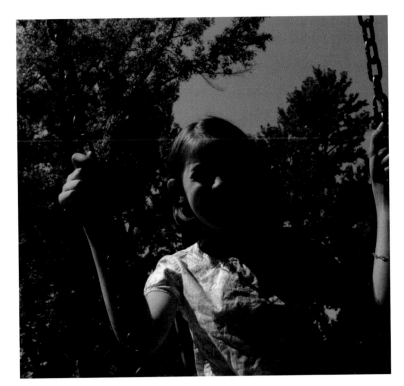

More on Fill-in Flash

The aforementioned fill-in flash technique is especially useful when a subject is backlit, which, in most situations, causes a subject to be underexposed. Here is a before-and-after example that shows the effectiveness of daylight fill-in flash photography.

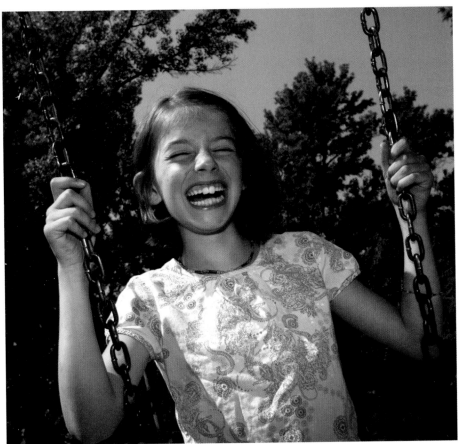

Fill-in Flash Perfection Is Not Always Possible

Sometimes we can't exactly balance the light from the flash with the existing light. You have to experiment and make a compromise. In this situation, had I set the Manual exposure for the sky, the sun would have been grossly overexposed. The Manual exposure is a bit darker than it should be, which created shadows (one under the neck of the guitar) in the pictures. Still, without a flash, we could not have seen Marco's face.

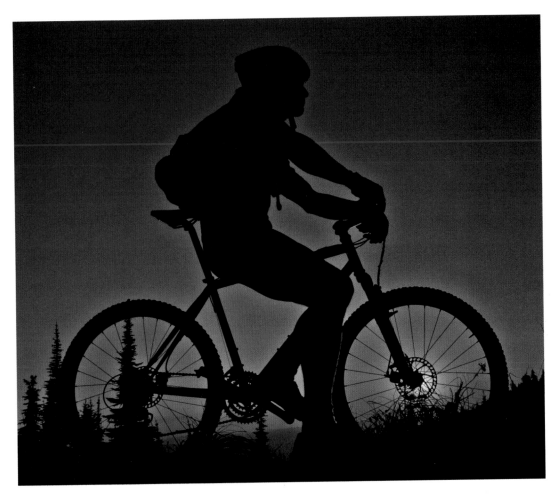

Shooting a Silhouette

The reason we could not see Marco's face in the nonflash shot on the previous page is because he was basically facing the camera. If he had been looking off to the right side of the frame, we could have seen his profile. He'd be recognizable.

In this example of a mountain biker resting on a mountaintop in Montana, we can see the subject's profile, as well as the strong silhouette of his bike.

Very careful composition (getting down very low to the ground and placing the sun directly behind the hub of the front wheel), directing the subject to hold his head so I could see his profile, and underexposing the camera's suggested Automatic reading by one stop (for more vivid colors) produced a dramatic photograph in which friends of the subject can recognize him. It's also a photograph that captures the mood of the setting. In this example, I think using the daylight fill-in flash technique would have destroyed the mood of the breathtaking setting.

So remember, daylight fill-in flash is a great technique to use on people pictures. But when you are shooting a silhouette, go natural, as long as you can see the subject's profile.

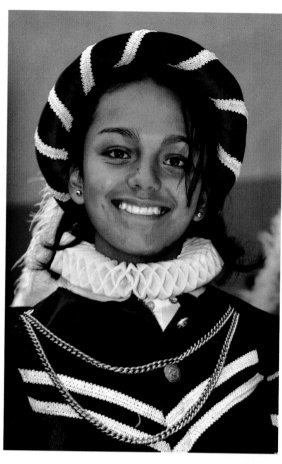

Only the Shadow Knows

We need to be aware of where the shadow from the flash falls. In the picture of the smiling street performer in Guanajuato, Mexico, we can see (if we look very, very closely) the shadow of her white collar on the bottom left side of her chin. That was caused because the camera was held in the vertical position, which put the flash to the right of the lens. Using a flash bracket and coil cord, and positioning the flash off camera and above the lens, would have prevented the shadow. In the picture of the dancer in Cambodia, we can't see the shadow because the subject is standing several feet away from the background. The closer the subject is to the background, the more prominent the shadow will be in the picture.

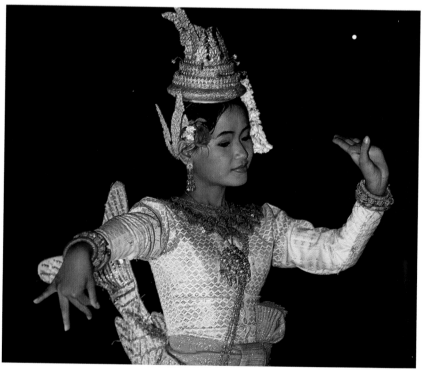

Go Natural When Possible

Compare these two pictures, which I took during the tropical outdoor show *Kandela* during my visit to the Dominican Republic. The closer picture of the singer is a flash picture, and looks a bit harsh. For the full-length picture, I turned off my flash and worked with the available light for a softer picture that, I feel, captures the mood of the evening.

The natural light picture was taken with the ISO on my Canon EOS 1D Mark II professional digital SLR set to 1250. That's considered a very high ISO setting, one that would result in lots of digital noise with most compact digital cameras. As you can see, however, the digital noise is hardly noticeable in the picture, which is one reason digital pros use high-end digital cameras.

Create a Sense of Disequilibrium

Here's a technique that adds an extra sense of interest to a picture of a person. It's called creating a sense of disequilibrium. All we have to do is tilt our camera down to the left or right and then take the picture. The "off-balance" feeling of disequilibrium draws extra attention to a picture. The technique is not effective for landscape photography.

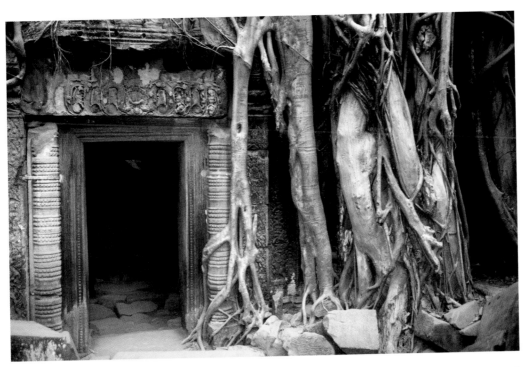

Picturing People in a Scene

Compare these two pictures, taken in Angkor Wat, Cambodia. To me, the picture without the man sweeping looks boring. The next picture is much more appealing because there is a person in the scene. Whenever possible, try to include a person in the scene.

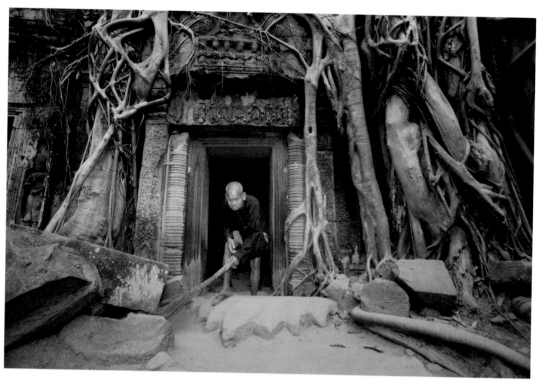

Vary Your Position

In this picture, we can see more of the man's face than in the previous example. I like both pictures. When you are out shooting, move your camera up and down and move your position to the left and right to see how just a slight change in camera angle can affect your pictures.

Compose in Thirds

This is not only a very basic technique but a solid one. When possible, compose in thirds—that is, imagine a tic-tac-toe grid over a scene. Place the main subject outside the dead center of the image. Shift your main subject left, right, up, or down to where the lines intersect. This composition technique causes the eye of the viewer to wander around the frame and to look for other objects in the picture. The two pictures on the opposite page are illustrations of composing in thirds. The monk was photographed in Cambodia, and the woman was photographed in Vietnam.

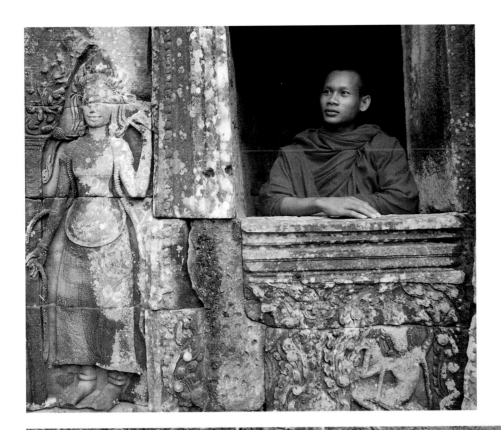

Looking Away

Subjects don't always have to be looking at the camera or to be aware that you are photographing them. For these photographs, one of a woman in San Miguel de Allende, Mexico, and the other of a Buddhist monk in Angkor Wat, I used my 100-400mm zoom lens. With that lens I was able to work at a distance from the subjects without being noticed.

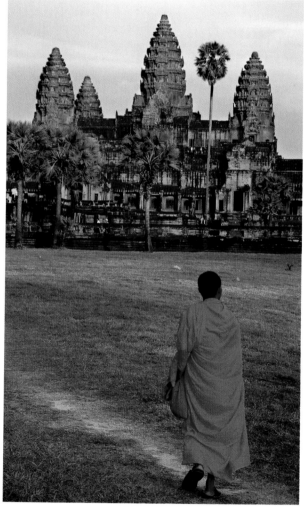

Respect Your Subject

One of the most important aspects of photographing a person is to respect your subject. Young and old, close to home and far away, if we respect our subject, he or she will respect us. The old woman was photographed in Angkor Wat, the young girl was photographed at the Double JJ Ranch in Rothbury, Michigan.

Watch for Lens Flare

Compare these two photographs of the "sheriff" I took in Nevada City, Montana. One looks crisp and the other looks dull. The reason? Direct light falling on the front element of the lens caused lens flare, which reduces contrast. To avoid lens flare, use a lens hood or shade the front of the lens with your hand or hat.

Extreme Lens Flare

Here is a more extreme example of how lens flare affects a picture. In this example, I was shooting more directly into the sun than in the previous example.

Take Lots of Pictures, and Share Them

Expressions change in the blink of an eye. To capture what you feel is the best expression of a subject, you need to take a lot of pictures. In this series of pictures, I have two favorites: the girl sitting on the horse looking away and the close-up of the girl showing her broad smile. The photo session lasted about a half hour. Sharing the pictures with the little girl via the camera's LCD screen made the photo session interactive and more fun for both of us.

Shooting Sports Action Sequences

When it comes to sports photography, taking lots of pictures is the name of the game. Set your camera on rapid frame advance and start shooting before the peak of action. That way, you'll be able to get a picture with impact. If your camera has a bit of shutter lag (a delay between the time you press the shutter and the time the picture is actually taken), press the shutter a few seconds in advance of the start of the action.

Also keep in mind the number of pictures the camera's buffer can handle before the camera "locks up" and waits for a sequence to be written to a memory card. If you can only shoot three to six pictures before your camera locks up, you'll want to time your shots to capture the peak of action.

Another factor to consider is the writing speed of a memory card. Memory cards, such as the SanDisk Ultra II cards, offer a fast writing speed and let you keep on shooting—only if your camera offers a fast writing speed. Mid-range to high-end digital SLRs usually offer a fast writing speed. Low-end digital point-and-shoot cameras usually do not let the camera write as fast.

Freeze or Blur Action

When photographing sports action, we have the choice to either freeze or blur the action. Freezing the action is fairly easy. Select a shutter speed of 1/500 of a second or higher. I used a shutter speed of 1/1000 of a second for this photograph of a rider dashing off into the setting sun. \Rightarrow

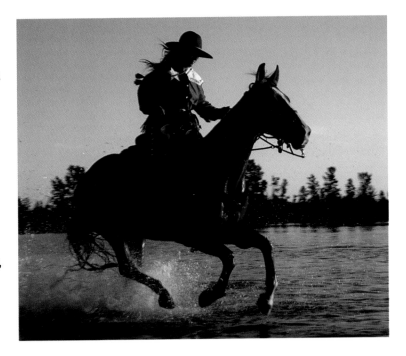

To blur the action, which can create a greater sense of speed, we need to shoot at slower shutter speeds, but the shutter speed we choose depends on how fast the subject is moving, the direction in which the subject is moving, and the effect we want to create. Considering these factors, we need to experiment with different shutter speeds for a successful blur.

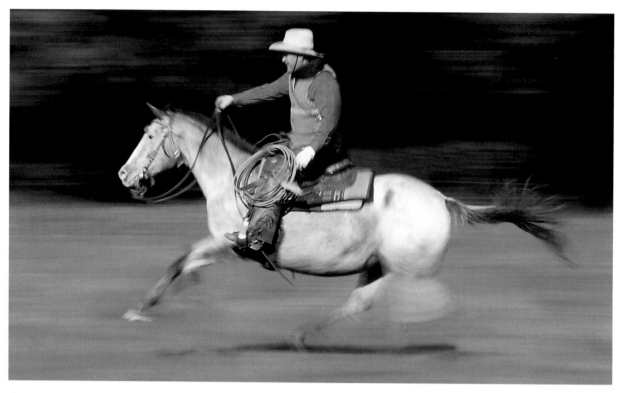

⇑ For this picture of my friend Wally (who was seventy-two years old when the picture was taken!), I used a shutter speed of 1/30 of a second. You will notice that the background is blurred. I also used a technique called panning, for which I moved the camera to track Wally and his horse. Panning kept Wally relatively sharp, but blurred everything else.

Here is the panning technique: Select a slow shutter speed (between 1/60 and 1/15 of a second), start to follow the action of subject moving horizontally in front of you, take the picture when the subject is directly in front of you, and then keep following the action for several seconds. Again, take several pictures to get the desired results.

Panning is a hit-or-miss technique. To get this successful pan, I had several failures, due to my moving the camera too slow or too fast. We can digitally create the panning effect, with a 100 percent success rate, in the digital darkroom. I cover that technique in my book *Rick Sammon's Complete Guide to Digital Photography*.

Hand Over Your Camera

When traveling, there is one people picture you really should not miss: a photograph of yourself. Before I hand over my camera, I first photograph a person in the setting and set my exposure. Then, when I hand over my camera, all someone has to do is compose and shoot for a good picture, if, that is, I explain the composition I want. (Photograph by Allison Hickey.)

⇓ Look what happened when I handed over my camera and forgot to tell the picture-taker at the San Diego Wildlife Park not to crop off any joints. You can see that my hand is cropped at the wrist. Generally speaking, when composing people pictures, we don't want to crop off people at the joints—photographically amputating their knees, ankles, elbows, wrists, and so on.

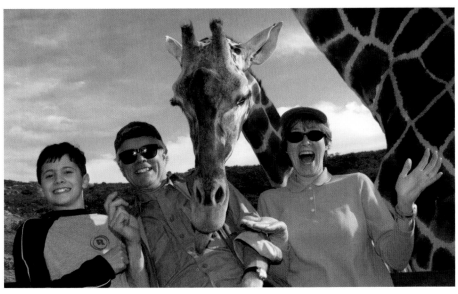

Here is a very important "hand over your camera" story.

I was riding in a helicopter on a tour of St. Thomas and the surrounding islands. As usual, I handed over my camera to a fellow traveler to get a shot of me in action. While handing the camera back to me, the passenger accidentally flipped the Autofocus switch on the lens to the Off position. Had I not checked my camera settings before taking the next picture, all my pictures with that camera would be out of focus. The moral of this story: When your camera is handed back to you, check all your settings.

EVOLUTION OF TWO PHOTO SESSIONS

Photo Session in Mexico

I'm often asked how many photographs I take to get the one shot I like. Well, photographing a subject or scene is actually a process, one that starts with snapshots, so my subjects and I can get comfortable with each other. To illustrate this process, I'd like to share a series of photographs with you.

While driving down a street in Queretaro, Mexico, I noticed a large crowd out of the corner of my eye. I also heard some festive music. I literally jumped out of the car and ran toward the crowd, leaving my wife and driver in the car to try to find a parking space, and me!

I share these shots, some admittedly snapshots, to show you how the photo session evolved,

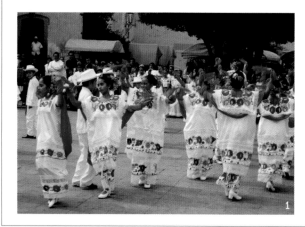

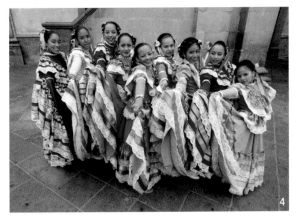

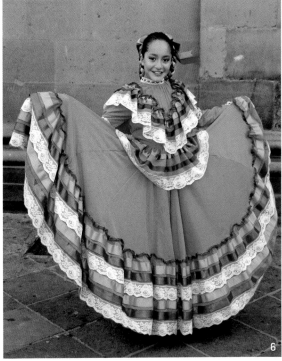

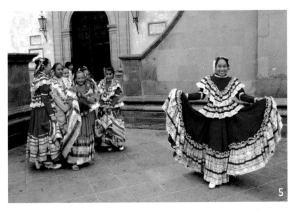

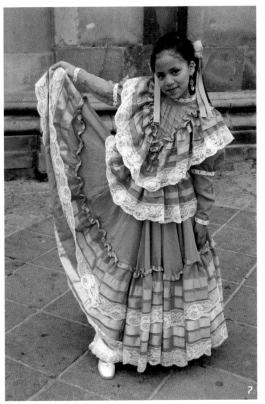

resulting in some nice portraits. I also share them to show some behind-the-scenes pictures and to illustrate a point: Shoot everything. After all, you have a digital camera and you can delete all your outtakes, if you like. However, think carefully before you delete those outtakes; although they may be only snapshots, they may bring back fond memories some day in the future.

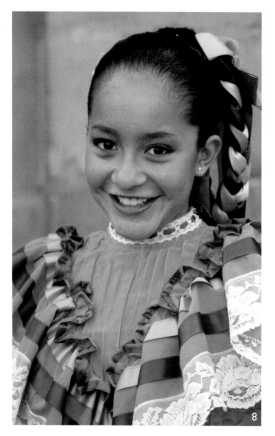

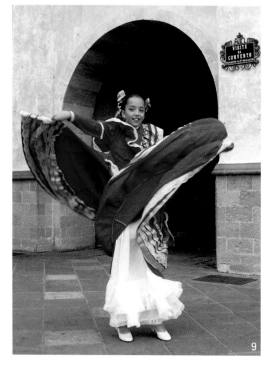

As you see, I'm in the last picture in the sequence, interacting with my subjects. Many of my people photo sessions end up like that.

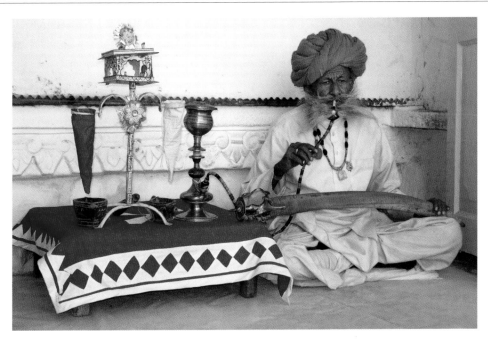

Photo Session in India

Here is another example of the evolution of a photo shoot. First, I photographed the man in his surroundings for an environment portrait. Then I zoomed in for a tight headshot. Finally, as in the previous example, I posed with my subject, which ended the photo session on a happy note for both of us. Making yourself join your subject for a final photo puts you on equal ground.

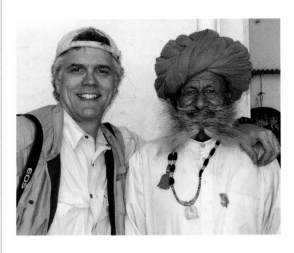

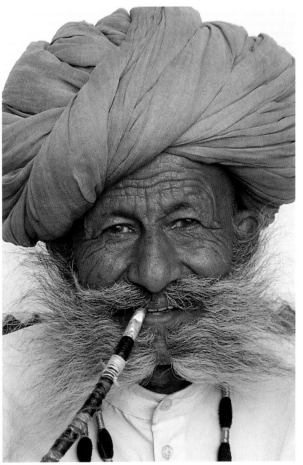

Strangers in Strange Lands

As I finish writing this lesson (perhaps my favorite in this book), and after reviewing my photographs on the contact sheets, I feel a bit melancholy. Looking at all the faces of the wonderful and accommodating strangers I have met in strange lands reminds me of the exact split second I took each picture, the feeling I had and the goal I was trying to accomplish with each and every shot.

From a technical standpoint, I can tell you that a split second either way would have or did result in a picture with which I was not pleased. Timing is a key component in people photography.

From an emotional standpoint, which plays a big part in how a picture turns out, I can tell you that I was filled with a sense of joy and enthusiasm when I looked at my camera's LCD screen and was pleased with the results.

But right now, I am a bit saddened to realize that I will never see most of these subjects again, the woman in Brazil, the monks in Cambodia, the beautiful girls in Mexico. These people let me into their lives for a few minutes, and I have probably been forgotten. But for me, the memories of my encounters will always be strong, especially when, through the magic of photography (and I still consider it magic), I can visit with them again and again.

Practice Your On-Location Portraiture Close to Home

Before you set off for some exotic destination, perhaps a rainforest in Brazil or a jungle in Cambodia, it's a good idea to practice your on-location portraiture techniques close to home. That's what I did, and that's what I do, whenever I get a new camera, lens, or flash, or when I am going to a new destination, just to keep in practice.

A wonderful place to practice is at a zoo or wildlife park, outdoors and in the enclosed exhibits, especially ones that simulate the conditions in which you will be shooting, such as a rainforest or jungle. What's more, you'll have fun practicing and you'll probably get some good pictures.

To make your job of testing and experimenting easier, bring along a friend who can pose for you, so you don't have to ask a stranger to help you out.

The pictures in this lesson of my friend Chandler Strange were all taken at Jungle World (an enclosed, natural-looking habitat with large skylights) at the Bronx Zoo in New York before I set off for my trip to the rainforests of Panama. I was experimenting with the following techniques and camera settings.

I knew it would be relatively dark in the rainforest, so I was seeing how my camera would handle the high ISO settings (400 and 800) at which I'd be shooting. Remember, high-end digital SLRs have less digital noise at high ISO settings than low-end point-and-shoot digital cameras.

(TTL) mode (fully-automatic), the flash performed beautifully, adding some detail and contrast to my subject, as well as adding a bit of catch light to her eyes.

I hate to end a lesson with a bad picture, but I will to illustrate an important point. This is what could happen if you don't practice your flash techniques at home, especially when the subject does not fill the frame. The subject could be overexposed. If you have time to reshoot a subject, that may not be a problem. However, oftentimes when traveling you don't get a second chance, so you really should have your camera set up to get a good exposure on the first shot.

Bear in mind that skill comes with practice.

I also wanted to see how steady I could hold my camera at low ISO settings and still get a sharp natural-light shot. This is really a good exercise, and I highly recommend it.

I was trying to see how the light would fall on a subject, too. Knowing that I'd be shooting under the rainforest canopy, which diffused the light from above, I asked Chandler to tilt her head upward, so the light evenly illuminated her face. I also experimented to see how shadows on a subject's face could add to or detract from a portrait. Learning how to see the light is one of the keys to getting a good picture.

In the picture of Chandler with the camera, we see soft, even lighting on her face. In the headshot, we see stronger shadows, which make the picture perhaps more dramatic.

I was also testing my new flash to see how it would handle daylight fill-in flash photography, which is covered earlier in this lesson. In the through-the-lens

Landscapes

Earlier, I mentioned one of my favorite books, *Zen & the Art of Motorcycle Maintenance*. I mention it again here, while writing in Alaska, for a good reason: so you are not disappointed with some of your landscape photographs.

In Mr. Pirsig's book, one of the main characters, John, is talking about the beauty of a landscape. He's saying that you need a 3-D, 360-degree camera to capture the beauty of a landscape. He goes on to say that as soon as we put a border on a picture, the scene is gone. John sums up, saying that he has photographed beautiful landscapes, but that when he gets his pictures back, he has tears in his eyes, because there is nothing there.

John is disappointed with his landscape pictures, as are many photographers, because two important elements are not accurately captured in their work: the true depth of the scene and the emotion the photographer felt at the time the picture was taken.

We see the world in three dimensions: height, width, and depth. But our cameras see only two: height and width. It is hard to have the same emotion we felt when seeing a sweeping landscape on a

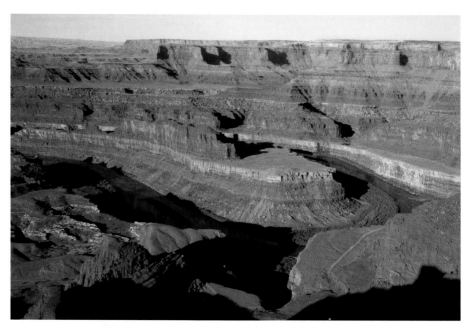

Dead Horse Point State Park, Utah

beautiful summer day when we are looking at a picture on a computer monitor on a winter day while wearing a heavy sweater at night. But if we add visual depth to our pictures, we may also have captured some of the emotional depth that we felt.

Before we get to some specific examples, here are three tips that apply to all landscape pictures.

Go for Maximum Image Quality

First, for the highest-quality image, we should set our camera to High or Fine if we shoot JPEG images, or to RAW if we shoot RAW files. RAW files offer a bit more exposure latitude, which is helpful in scenes with dark shadows and bright highlights.

One might be hard pressed to see the difference between a RAW file and a High or Fine JPEG file in a book or magazine or even in an 8 × 10-inch inkjet print. But the difference is noticeable in larger prints.

In addition to the image quality setting, we should set the ISO, or camera's light sensitivity, as low as possible to avoid digital noise. Noise is more noticeable in the shadow and dark areas of a scene, and is also more noticeable in lower end digital cameras. Low ISO settings, especially with low-light conditions, usually require the use of a tripod.

Compare these two versions of a picture I took in the Okavango Delta, Botswana. The original picture, showing fairly sharp detail, was taken at ISO 100 with my camera set to RAW. The pixilated picture simulates what the same scene might have looked like if I had taken it at ISO 1200 with my camera set to low JPEG resolution.

Keep the Horizon Level

In landscape photography, we need to keep the horizon level. Believe it or not, when I review portfolios, a tilted horizon line shows up more than one might think.

Keeping the horizon line level is especially hard when shooting from a boat, as was the case when I photographed the scene on the next page in the Okavango Delta, Botswana.

If you have trouble with the horizon line, small bubble-levels are available that fit into a camera's hot shoe. Bubble-levels are basically miniature versions of the levels carpenters use to ensure level lines.

If you don't have a bubble-level, you can bring the bottom of your viewfinder up until it is level with the horizon line. Now, carefully tilt your camera up or down, keeping a keen eye to see that the horizon line stays level.

Finally, if the horizon line is tilted in a photograph, it can easily be leveled in the digital darkroom, a technique discussed in my *Compete Guide to Digital Photography*.

Cut the Clutter

Often, we are so overwhelmed by the beauty of a scene that we try to capture the "big picture" with our camera. Well, it is possible to capture an entire scene. Sometimes, however, big-picture images look cluttered, with too many different subjects competing for our attention. In composing a picture, any picture, we need to select a main subject.

⇒ I took this picture on a hilltop in Antigua. The entire hill was covered with dense foliage. With careful composing, and by using one palm tree as an anchor point, I was able to cut the clutter from the busy scene.

Shoot during the Golden Hours

Professional landscape photographers prefer to shoot early in the morning and late in the afternoon. Pros call these times "the golden hours." During these beautiful hours, the quality of sunlight is "warmer," making pictures look more pleasing than pictures taken at midday, when the light is "cooler." What's more, long shadows in the early morning and late afternoon add a sense of depth and dimension to landscape photographs.

We can warm up our digital pictures in our camera by using the Cloudy white balance setting, the setting I used for these photographs, one taken at the Grand Canyon in Arizona and one taken of a lone tree in Zion National Park in Utah.

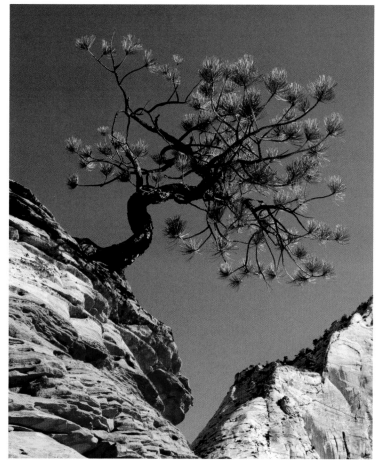

Use a Digital Filter to Simulate the Golden Hours

We can also warm up our pictures in the digital darkroom by adding a warming filter. Adobe Photoshop CS2 and Adobe Photoshop Elements 3.0 offer digital warming filters.

Here's the effect of a digital warming filter on the waterfall we saw earlier in this book.

Try Cooling Off a Scene

Digital cooling filters are also available in Adobe Photoshop CS2 and Adobe Photoshop Elements 3.0. Here's the effect of using a cooling filter on my waterfall photograph.

Even though I began this lesson by talking about the "golden hours," I like this cool effect, too.

Try warming and cooling filters on your photographs. You'll see that they can quickly and easily change the mood of a picture.

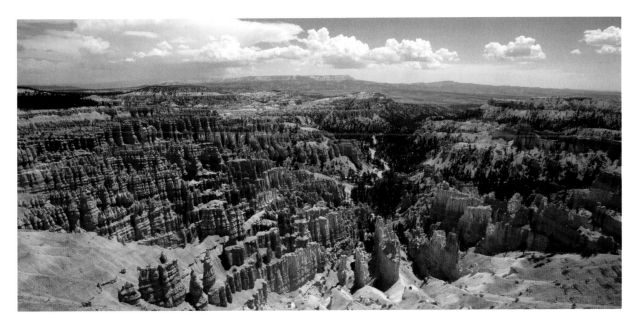

Go Wide and Shoot Small

Landscape photography is often about capturing the wide view. To capture the wide view, we need a wide-angle lens, usually in the 16-28mm range of effective focal length. For maximum depth of field, we need to shoot at a small aperture, usually at or smaller than f/11. That may require using a tripod, because as we decrease the aperture we also decrease (lengthen) the related shutter speed. Even if you don't like using a tripod, they are helpful in landscape photography, if for no other reason than they slow you down and help you live in the moment.

For this picture of Bryce Canyon National Park in Utah, I used my Canon 16-35mm zoom lens set at 16mm on my Canon EOS 1Ds. The digital SLR camera features a full-frame image sensor, or the same size as a 35mm film slide or negative would be. So, the effective focal length of using a 16mm lens is 16mm. My aperture was set at f/11. As you can tell, I cropped off the top and bottom of the frame for somewhat of a panoramic picture, something I had envisioned when looking through the viewfinder. When composing landscape pictures, it's a good idea to visualize how simple cropping can enhance a scene.

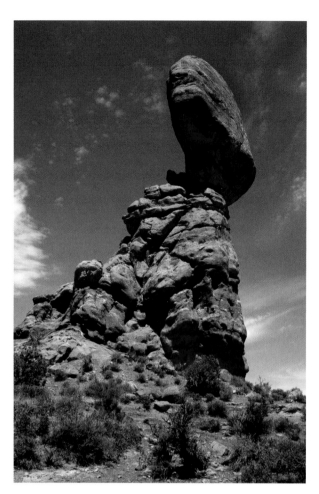

Shoot When It Is Sunny and When It Is Not

Most of us love to shoot on bright, sunny days, when the sun is warming our mind, body, and soul. If we have an interesting subject, we can surely get dramatic pictures on sunny days. However, we can also capture interesting landscapes when it is overcast or misty or foggy.

I took this photograph of Balanced Rock in Arches National Park in Utah on a sunny day, and I photographed this scene near a hot spring in Yellowstone National Park in Montana early one misty and overcast morning. Each picture has a different feel, capturing the feeling of the moment.

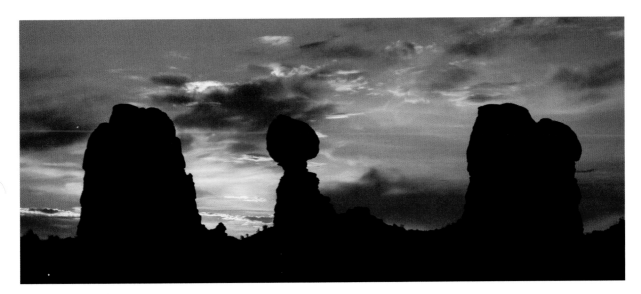

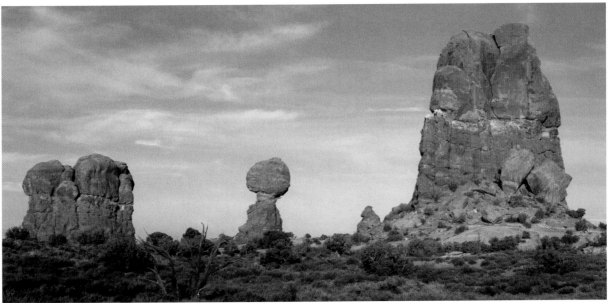

Take Your Time, Shoot a Lot

When it comes to landscape photography, we need to think about all the technical aspects: lens selection, aperture, shutter speed, and so on. However, it's also a good idea to shoot a lot. Take pictures of the same site or at the same locations at different times of day. Throughout the day, the color of light in the sky and on the landscape changes, and shadows grow and shrink. The more we shoot, the more variety we'll have in our digital slide shows, and the better chance we'll have of getting the most dramatic image of a particular scene.

Both of these pictures were taken at Arches National Park.

Get Movin'

When I travel, I like to shoot a set of pictures that illustrates how simple techniques can improve a picture. In this set of pictures, taken at Zion National Park, Utah, we can see how moving a few feet sideways can make a big difference in the composition of a picture. In the first picture, the small rock formation is in the center of the frame, creating a less than pleasing composition. By moving a few feet to my left, the same rock formation is now off to the side of the frame for a much more pleasing composition. Notice how your eyes move around the bottom image, taking in the foreground and background subjects.

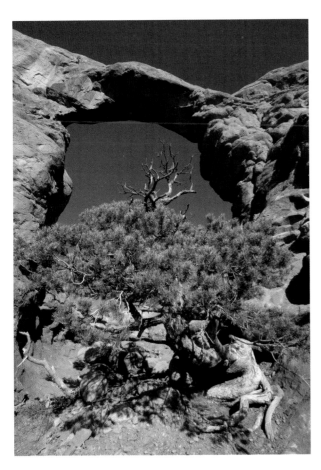

Move On Up, or Down

Here is a set of pictures taken in Arches National Park that illustrates how moving just a bit can dramatically change the picture. In this example, after taking the first picture, for which I was crouched down on the ground, I stood up straight. In this case, I like both photographs.

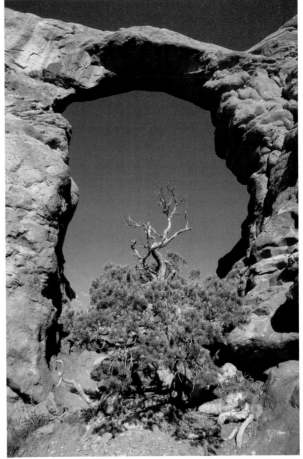

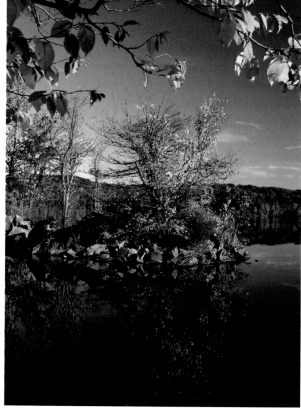

Pack a Polarizing Filter

Perhaps the most useful screw-on filter for landscape photography is a polarizing filter. A polarizing filter can continuously vary the amount of polarized light that passes through it. In doing so, it can (but will not always) darken a blue sky and make white clouds appear whiter.

A polarizing filter can also reduce reflections on water to the point where you can see through the water. Basically, a polarizing filter is most effective when the sun is off to our right or left. A polarizing filter is not effective when the sun is directly in front of or behind us.

Polarizing filters rotate in their mount so you can dial in (select) different amounts of polarization, from maximum to minimum. When the maximum effect is achieved, the light reaching the image sensor may be reduced by up to 1 1/2 stops. When shooting in an automatic exposure mode, the camera automatically compensates for that reduction. When shooting in a manual mode, you will need to make the appropriate compensation. (Except on rare occasions, I usually shoot using some form of automatic mode.)

I used a polarizing filter to take the darker and more saturated picture of this scene at the Croton Reservoir, not too far from my home. The lighter picture was nonfiltered.

Digital Polarizing Filter

A digital polarizing filter is available in nik Color Efex Pro 2.0, a Photoshop Plug-in from nik multimedia. This filter simulates the effect of using a polarizing filter on a lens, to a degree. It does a good job of darkening a blue sky and making clouds stand out, but it can't help us see through water.

Here I used the nik Polarization filter on the nonfilter picture of the Croton Reservoir. Notice the difference in the tree's reflection on the foreground water.

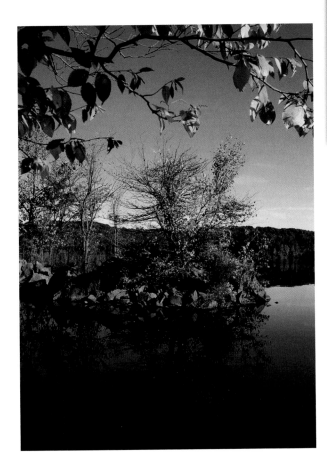

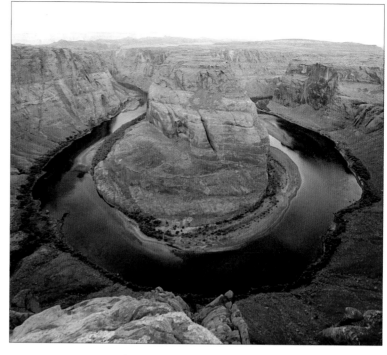

Digital Graduated Filters

I always travel with several graduated filters that fit over my lenses. These filters are colored on the top and gradually become clear on the bottom (or vice versa, if you hold them upside down). These days, I also use digital graduated filters, found in nik Color Efex Pro 2.0. The nik graduated filters are available in any color you desire (included gray for a neutral density effect) and can be moved strategically into position in the frame while working in the digital darkroom.

Here I used a nik Color Efex Pro Graduated Dark Blue filter to add color to the washed-out sky in a picture of Horseshoe Bend near Page, Arizona.

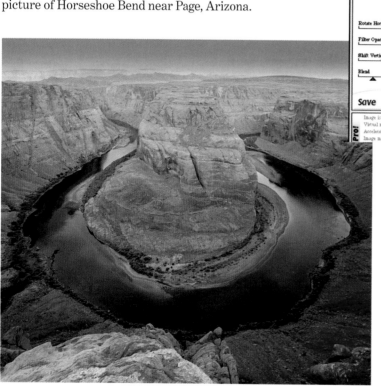

Add a Foreground Element and Focus Carefully

As we saw in the first picture in this lesson, shadows can add a sense of depth to a picture. Another way to create a sense of depth is to include a foreground element in the scene. In this example, I framed the Grand Canyon with the trunk and branches of a tree on the rim of the canyon.

When there is a very near foreground element, having all the elements in the scene in focus is important, if not essential. We already talked about using a wide-angle lens and setting a small f-stop. In addition to those techniques, we need to know where to focus for maximum depth of field. Generally speaking, if we focus one-third of the way into a scene with a wide-angle lens/small f-stop combination, we should attain sharpness throughout the scene. Keep in mind, however, that if elements are just a few inches from the lens, it may be hard to get the foreground and background in sharp focus.

Choose the Foreground Element Carefully

In this picture, taken in Zion National Park, the huge boulder in the foreground clearly dominates the scene. From an artistic standpoint, the rock may not have been the best choice for a foreground element. However, from a scientific and perhaps from an interest standpoint, the foreground does show the sheerness of how the bounder was cut by nature; the surface facing the camera is almost perfectly smooth and flat. As with the previous example, the entire scene is in focus, thanks to carefully focusing one-third into the scene.

This boulder is sedimentary rock. It dates back to when the area was covered with an ocean. Heat and pressure from the shifting continental plates pushed the old sea bottom upward. Erosion of millions of years created this marvelous natural sculpture.

Look Up

Sometimes we are in such a rush to get to a specific location that we don't look around—and up—for other picture opportunities. Both of these pictures, the pine tree scene photographed in Montana and the sunset scene photographed at the Grand Canyon, illustrate what can happen when we look up and photograph what we see.

Be a Storyteller

Good photographers tell a story with their pictures. How much of the story we tell is up to us. Sometimes it's a single picture, other times it's a series of pictures.

When we are out shooting, it's important to think about the story we want to share with our family, friends, or readers.

Here are three pictures that I feel help to tell the story of the Lower Antelope Slot Canyons near Page, Arizona.

The first picture shows the very narrow slot that visitors have to shinny down on a ladder to get into the canyon. The second shot, taken in the canyon, shows the beauty of the inner canyon walls. The last shot shows the scale of the canyon. Combined, the pictures give a look at what someone visiting the canyon might expect.

More to the Story

There is always more to the story, if we have pictures that show a comparison, a closer or wider view, or simply a different view.

These two pictures were taken at the Upper Antelope Slot Canyons, across the road from the Lower Antelope Slot Canyons. One shows the walk-in entrance and the other offers an interior view. So keep shooting once a story hits you.

Exploring Color Modes and Options

In the digital darkroom, we can explore color modes (which change the overall color of a scene), in addition to increasing and enhancing the color of a scene, as we saw with my pictures of Double Arch in the Introduction. We can also, if our camera permits, choose the black-and-white, infrared, or sepia mode.

 I photographed the ruins of an old country club by my home in Croton-on-Hudson, New York, with a point-and-shoot camera set on color, then on sepia, and then on black-and-white. Each version of the scene creates a different mood and feeling.

Digital Darkroom Black-and-White and Sepia Pictures

If your camera does not have a black-and-white mode, you can create a black-and-white picture from a color file in the digital darkroom. The Photoshop Plug-in I mentioned earlier, nik Color Efex Pro, offers a black-and-white conversion filter that allows complete control over the tone, brightness, and contrast of a picture. Other options include converting a color file to a black-and-white file in the digital darkroom by desaturating it and converting it to a gray scale image.

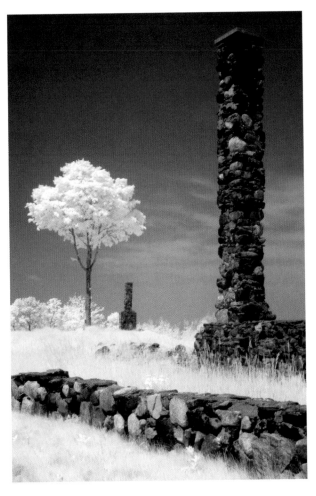

Infrared Options

Some digital cameras offer an infrared (IR) mode that produces pictures that look as though they were taken with infrared film.

Astronomers use the infrared spectrum to make photographs of distant subjects. Infrared measures light emitted by a subject; the more heat, the lighter the object is in the image. Notice that this IR view shows the leaves as almost white. Since heat radiates, IR images often capture that by depicting a white glow around the hotter elements in a picture, in this case the grasses.

I use a Canon D60 camera that has been modified to take only infrared pictures. My camera was converted to IR-only by the "IR Guy," who can be reached at www.irdigital.net. The IR Guy also converts Canon D30 and Nikon D100 cameras for infrared-only photography.

Here is the effect of photographing the country club ruins with my IR camera.

Seeing in Infrared

I took my IR-only camera on a trip out west in 2004. After a while, I actually began to see landscapes in infrared. Training our eyes to see in IR, or in black-and-white or color or sepia, can help us to see more creatively and capture dramatic landscapes.

My infrared picture of a lone tree in Bryce Canyon, Utah, illustrates what a difference color can make in a picture. In this case, I feel the infrared image looks much more dramatic than the color picture.

Shoot the Signs

When we are traveling, it's natural to get involved with trying to take the best pictures of the most interesting subjects we find. That's okay. However, photographing signs, as I did in Arches National Park, can help us remember the exact names and locations of each site. That's important when traveling to several locations on a single trip, especially if you plan to market your work.

Photographing Sunsets

Sunsets (as well as sunrises) often evoke emotion, especially when there are clouds to make the scene more dramatic.

When I shoot a sunset, I often look for a foreground element, a tree in this case, to hide the sun, which reduces the contrast range between the bright sun and the dark shadows.

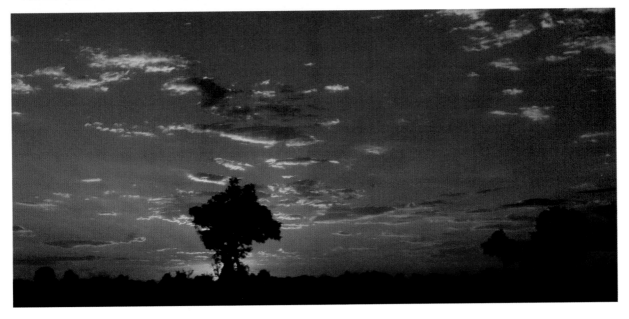

Push the Clock Ahead

As it gets later in afternoon, sunsets usually become more colorful. With our digital cameras, we can, as my friend Doug points out, "move the clock ahead by underexposing the scene." When I photograph a sunset, I usually underexpose the

scene by one stop, sometimes up to three stops, when shooting in an automatic mode.

I almost always underexpose the scene by at least one stop, which increases color saturation.

I also take vertical and horizontal pictures, because sometimes I am so overwhelmed at the time that I don't know which picture I will like best.

I use both wide-angle lenses (as I did here) and telephoto lenses (as I did for the elephant pictures in "Lesson #4: Wildlife"). But don't get so caught up in photography that you miss the magic of a sunrise (or sunset).

Explore Botswana

Shoot a Title Shot

Sharing our pictures in digital slide shows is part of the fun of being travel and nature photographers, whether we are professionals or dedicated enthusiasts.

When you are out shooting, look for scenes that would make good "openers" for a slide show, scenes in which you have clear space in which to add your title text.

Go for a Cover

While you are framing a shot for the opener of a slide show, also try composing a picture for a cover of a magazine. It's fun and a challenge. Who knows? If you ever decide to go pro, you may have just the shot an editor wants.

Finally, if you want to turn pro, keep this saying in mind: All professionals were amateurs at one time.

Savanna

Where humans first walked

COLD WEATHER SHOOTING

I've just come inside after shooting in the snow for an hour on a December day, when the wind-chill factor made it feel like 5°F.

What the heck was I doing outside in the freezing cold? I was taking pictures for this section of the book.

Following are some important tips on shooting in the cold.

First, it's important to keep warm. Wear layers of clothes and a hat to help retain body heat. Waterproof boots help keep our feet warm and dry. Gloves are very important, too (see "Lesson #10: Gear for Travelers," for details). Touch a cold metal tripod with your bare hands and you'll feel as though you are touching an icicle. So, dressing for the weather is the first step in taking pictures in the cold.

Second, charge your battery fully before you go outside. In addition, keep an extra battery tucked inside your coat. If you are shooting outside in very cold conditions, your battery will lose its charge sooner than you think. When you are not shooting, keep your camera inside your coat to preserve battery power.

Third, start your cold-weather shooting session with a fresh memory card. That way, you'll have lots of capacity, and you will not have to take off your gloves to change cards in the cold.

Fourth, if there is snow or ice in a scene, it may fool your camera into thinking that it is brighter than it really is. Overexposed, washed-out snow and ice in your pictures are nearly impossible to rescue in Photoshop.

Croton Reservoir, Croton-on-Hudson, New York

When bright snow and ice are in a scene, compensate by setting the +/− Exposure Compensation control at +1. I know this sounds backward, but it's actually the correct exposure compensation technique.

To ensure a good exposure, check your camera's LCD monitor. If any areas of the scene are washed out, you'll need to reduce the exposure compensation.

Okay, let's move on to some creative photo tips.

Previously, you saw how to change the overall color of a picture by changing the White Balance and applying the Photo Filter in Photoshop. I suggest you check out those sections if you missed them.

I mention color here because getting "good" color is in the mind of the beholder. Let's take a look at two pictures to illustrate this point.

The picture with the whiter snow, like all the

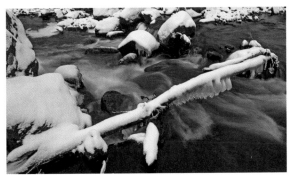

darkroom into a black-and-white picture. Here is another example of that process. I share this technique again so you can compare a black-and-white picture to a Duotone, which offers more creative options for photographers.

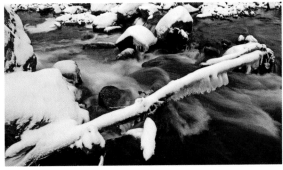

pictures in this sidebar, was taken in Croton. Because the day was cloudy, I had my White Balance set to Cloudy for accurate color. However, by applying the Cooling Photo Filter in Photoshop, I added a blue cast to the scene, which may be more pleasing to some viewers because it has more color than the picture with accurate color. Experiment with the White Balance setting on your camera and with Photoshop's Photo Filters to see how they can produce different effects.

⇈ In Photoshop CS, a Duotone is made by combining a color or colors with black. Photoshop groups Tritones and Quadtones (used for this image) with Duotones. You find Duotones in Image > Mode > Grayscale > Duotones. Duotones are not available in Photoshop Elements.

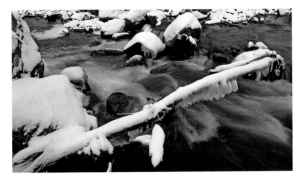

⇈ Earlier I gave an example of what happens when a color picture is transformed in the digital

⇈ Here is an example of the Duotone Dialog Box for the previous image. As you can see, Cyan, Magenta, and Yellow are combined with Black to produce this Duotone effect.

For those of you who like black-and-white and sepia-toned images, check out Duotones.

Whenever we have a picture up on our monitor, it's a good idea to play around with the Crop tool in Photoshop—looking for pictures within a picture.

Here is a picture within my original picture. I prefer the square-format image over the original rectangular image.

⇘ This dramatic winter scene was taken at the New Croton Dam. It was the last picture I took

when I was outside one morning, and one of the last pictures I took for this book. Just looking at the picture makes me shiver!

To blur the water, I used a shutter speed of two seconds. My camera was mounted on a tripod and I used the self-timer to prevent camera shake during the relatively long exposure.

I am pleased with the picture. But, as you have read in this book, I feel that a photograph is never totally finished. There is always more work to do—and more fun we can have—in the digital darkroom.

While I was taking this photograph, I wondered what the dam might look like at night, when it is

really cold, and when the "cool" light makes the scene look even colder.

⇑ Rather than freeze in the dead of night, I adjusted the Color Balance and Curves in Photoshop to create an image that looks as though it might have been taken on a moonlit night.

Here is the result of using those powerful effects in Photoshop.

Okay, now I need to have some tea and warm up.

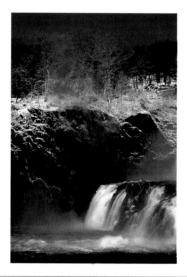

Captive Animals

In this lesson, I'll share some basic tips for photographing captive animals, using pictures taken at zoos and wildlife preserves in America and one in Botswana to illustrate my points.

In the next lesson, we'll journey to the open plains of Botswana, and I'll offer some advice on photographing animals in the wild. In that lesson, we'll cover a bit more tech talk, such as specific settings for digital cameras. Whether you are shooting close to home or on the other side of the planet, and whether your subject is captive or wild animals, the first tip is to know your camera.

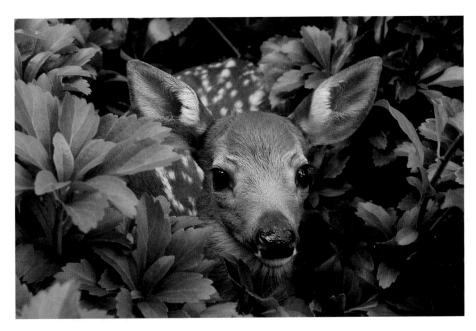

Practice at Home

Photographic opportunities don't always wait until we're ready for them. Before we set off for a zoo or wildlife park, we need to be familiar with our camera's settings. We don't want to fumble around pressing buttons and adjusting dials when we see a subject that we actually want to photograph.

Of the utmost importance is knowing how different focal length lenses and different f-stops and shutter speeds can affect a picture. Successful wildlife photography also requires knowing how a flash can help a picture, and how a picture can be enhanced in the digital darkroom.

Before a shoot, we should practice our photographic techniques around the neighborhood, photographing common animals such as squirrels, birds, dogs, and cats. For our practice sessions, we should set our camera the same way we would set it for an animal adventure. Our practice shoot should mimic the conditions of our serious shots as closely as possible.

I photographed this young fawn in our backyard garden with a 28-105mm lens set at about 35mm. I was only about three feet from the animal. Here I was practicing my composition techniques and getting the fawn's eyes in focus. Yes! Pros still practice to keep up their photo skills.

Fossil Rim Wildlife Center, Glen Rose, Texas

Eliminate Fences

By eliminating or erasing fences at zoos and wildlife parks, we can make our pictures look as though they were taken in the wild. In the first example, we can clearly see the fence between the cheetah and me. That's because I used a wide-angle lens set at a small aperture (f/16), and held the lens close to the fence. That wide-angle/small f-stop set-up put everything in focus.

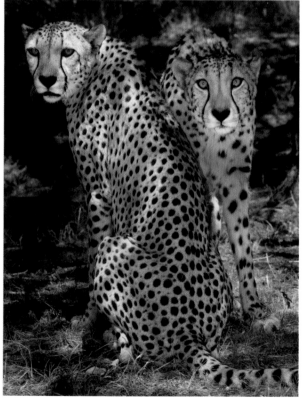

On the other hand, the portrait of the two cheetahs looks as though it could have been taken in the wild, perhaps on the plains of Botswana. That's because I used my 100-400mm lens set at 400mm, held the lens right up to the fence, and placed the lens directly in the center of one of the openings of the fence. I then selected a wide aperture (f/5.6). The telephoto setting of 400mm combined with the f/5.6 aperture put the fence so out of focus that it became invisible in the picture.

To fill in the shadows created by the surrounding foliage, I used my flash for daylight fill-in flash photography, a technique that is discussed in the next lesson.

If you have trouble remembering the difference between a cheetah and a leopard, remember the saying that "a cheetah can make you cry." Look for the black "tear drops" on the cheetah's face.

Blur the Background, Emphasize the Subject

Using the aforementioned recommendation of placing a telephoto lens directly in an opening in a fence and selecting a wide aperture to eliminate the fence from our picture is actually the fist step in blurring the background, too. We want to blur the background for two reasons: one, to "erase" a fence or wires; two, to make our subject stand out.

We can use several techniques to blur the background. One is to compose our picture so that there are no vivid fences or poles, or signs in the background. That may require shooting from a higher-than-normal position (as opposed to shooting at eye level with the animal) so that the ground is the background for the main subject. Another technique is to photograph the animal when it is a good distance from a background fence. The further the animal is from a background fence, the softer and less noticeable the fence will be, due to the short depth of field that telephoto lenses offer at wider apertures. Also, as the focal length setting of the lens increases, say from 100mm to 400mm, the sharpness of the background decreases, when you use the same f-stop.

This series of California condor photographs was taken with my 100-400mm lens. For the first shot, I was not close enough to the fence, and my lens was set at f/16 and 100mm. For the other two shots, I moved closer to the fence, and used a longer zoom setting and a wider aperture.

For the second shot in the sequence, I did something else. When I returned home and opened the picture in Photoshop, I applied the Gaussian Blur filter to the area around the magnificent creature, thereby making it stand out better from the background.

California condor, San Diego Wildlife Park

Use the Background

There is more to captive-animal photography than great animal portraits. Sometimes, we want to include the background.

When we take pictures, we should consider how the background could make or break a picture. Composition is important. So is aperture selection, which, as mentioned, gives us control over how much of the background (and foreground) will be in focus.

While my family and I were on a self-guided tour in Fossil Rim Wildlife Center, I happened to notice two axis deer resting in the shade. As our car came closer, one stood up and, by doing so, perfectly framed the deer in the background with his antlers. To capture this unusual photographic opportunity, I set my focus between the two deer and used a small f-stop. The result was that I got both animals in focus. The moral of this story: Always be prepared to shoot.

Keep Both Eyes Open

In captive-animal and wildlife photography, as in sports photography, keeping both eyes open is important when we are looking through the viewfinder, as Marco demonstrates in this picture. By keeping both eyes open, we can see what's happening in our viewfinder *and* what's happening around the main subject. In doing so, we can see if other subjects will be moving into the

Axis deer, Fossil Rim Wildlife Center, Glen Rose, Texas

Marco showing correct viewing technique

frame, or if our main subject may be moving out of the frame, perhaps toward a distracting fence.

Keeping both eyes open when shooting requires some practice. But after a few tries, I am sure you'll have it.

Get the Subject's Eyes in Focus

In animal photography, the subject's eyes must be in focus. If they're not, most professional wildlife photographers will tell us that we've missed the shot. Why? Because when we look at a picture of an animal (or person) our eyes go to the subject's eyes first. If they're soft, we have to

Flamingo, San Diego Zoo, and zebra, Fossil Rim Wildlife Center

strain our eyes to try to get them into focus, a frustrating and impossible task.

For the flamingo picture, I used the center focus point in the viewfinder of my digital SLR to lock in the focus on the animal's eye and then recomposed the scene and shot. For the zebra picture, I used the center focus point to lock in the focus on the background zebra's eye, recomposed, and shot. For that picture, I set my aperture at f/8 so I could get the eyes of both animals in focus.

Reduce Camera Shake

Telephoto lenses, like binoculars and macro lenses, exaggerate camera shake, which, if the shutter speed is too low, results in a blurry picture. The longer the lens and the slower the shutter speed, the greater the risk of a blurry picture.

To increase the chance of getting a sharp picture, Canon offers image stabilization lenses, Nikon offers vibration reduction (VR) lenses and Minolta offers an in-camera image stabilization feature on some of its digital SLRs. These lenses and systems let us shoot slower than the recommended shutter speeds for hand-held photography.

For example, when using a 125mm lens on a digital camera with a full-frame image sensor, we need to set the stutter speed to at least 1/125 of a second to prevent camera shake. If our camera has an image sensor with a 1.3x image magnification, our 125mm lens has an effective focal length of 162.5mm, so we'd need to use a shutter speed of around 1/200 of a second for a sharp shot.

IS and VR lenses—and the Minolta system—let us shoot up to two shutter speeds below the recommended setting. This is a major benefit in captive-animal and wildlife photography, especially when using a zoom lens, as I do; the zoom lens has a smaller maximum aperture than my equivalent fixed focal length lenses.

In addition, shooting at a slower shutter speed means we can use a lower ISO to reduce the digital noise in our pictures. These two pictures illustrate the difference between using a telephoto zoom lens with the IS feature and without.

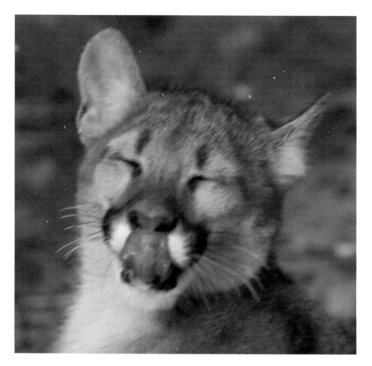

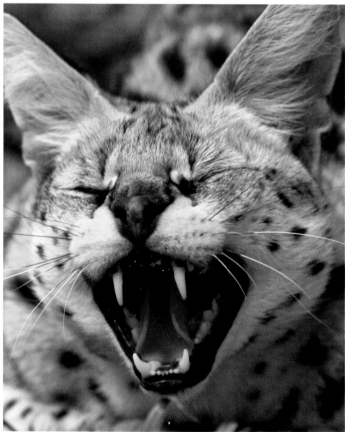

Bobcat, Triple D Ranch, Kalispell, Montana, and serval cat, Big Cat Rescue, Tampa, Florida

Consider a Macro Lens

A 50mm, 60mm, 100mm, or 180mm macro lens may not be the first lens that comes to mind when you think about photographing captive animals. However, a macro lens can come in handy when photographing small animals, because it lets us photograph closer than a zoom lens with a macro setting.

I used my 50mm macro lens for these two pictures of an iguana. Unlike most of my close-up pictures, these were taken using only available light. To get the most out of macro lenses, I recommend using a ringlight (see "Lesson #8: Close-ups" for more detail).

Iguana, Wildlife Inc., Santa Maria Island, Florida

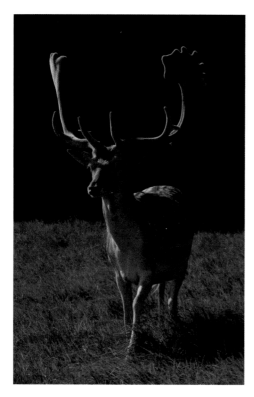

Fill In Shadows with a Flash

In "Lesson #1: People," we saw how using a flash outdoors can enhance our outdoor pictures. When it comes to photographing animals, especially when the sun is illuminating the subject from behind, from the side, or from above, a flash can fill in harsh shadows that hide a subject's features.

In the case of this deer, the sun was above and behind it, so the natural-light picture showed the deer's face in the shade.

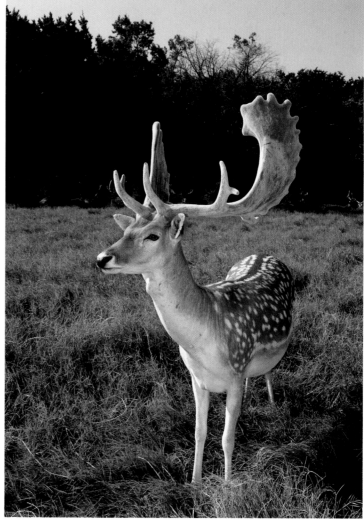

Fallow deer, Fossil Rim Wildlife Center, Glen Rose, Texas

Crocodile, crocodile farm, Kasane, Botswana

Shooting in the Shade

Using a flash outdoors can save the day when photographing animals in the shade. Here, too, it's a good idea to use the daylight fill-in flash technique. To get the desired result, you may want to take several shots until you achieve the balance of natural and added light that looks good.

When shooting in the shade, keep in mind that digital noise is most noticeable in shadow areas. Therefore, it's a good idea to use a low ISO setting when taking a flash picture in the shade, as I did for this crock shot. Without a flash, you'll need to use a higher ISO with the potential for digital noise in the darker areas.

⇒ Before we leave daylight fill-in flash, here is an example of what happens when the flash may overpower the natural light. The picture of a crowned pigeon looks like a harsh flash shot. Notice the flash shadow on the right.

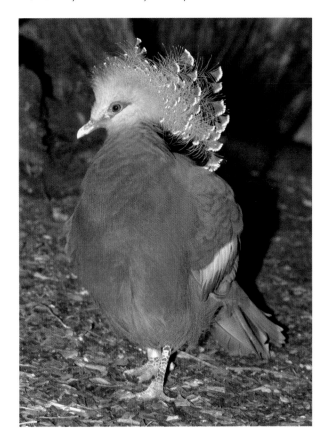

Choose the Time of Day

As a travel photographer, I like to shoot in the early morning and late afternoon, when the quality of light is warmer than it is around the midday hours. We can enhance the color of our pictures in the digital darkroom. We can also choose the Cloudy white balance setting on a sunny day to warm up our pictures. But why not shoot during times of the day that offer a more pleasing quality of light?

The lighter-colored tundra wolf in this set was photographed in the cool light of midday. The darker-colored tundra wolf was photographed in the late afternoon. For both pictures I had my white balance set on daylight.

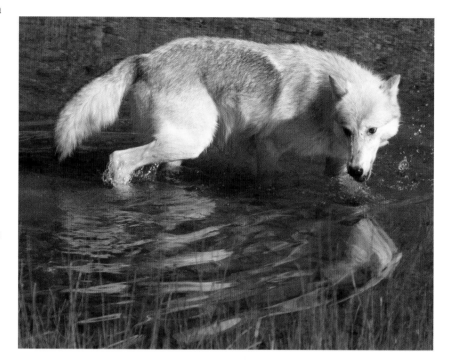

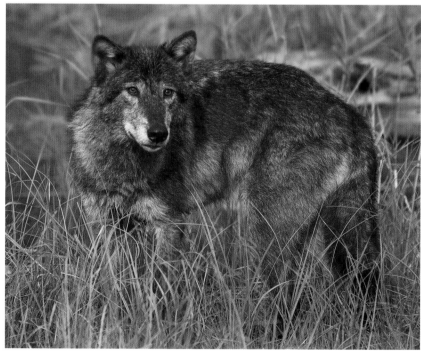

Tundra wolves, Triple D Game Farm, Kalispell, Montana

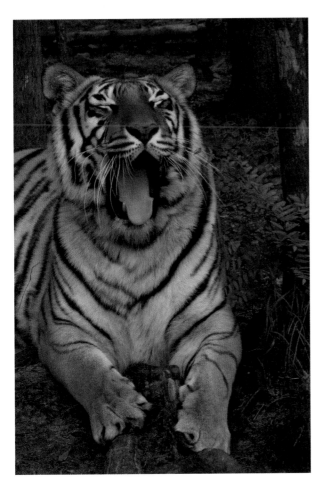

Shoot with Digital Enhancements in Mind

Adobe Photoshop has changed not only the way we make pictures in the digital darkroom but the way we take pictures on site, as well.

When I am out shooting, I am thinking about how a scene can be enhanced in the digital darkroom. For example, when I was photographing this tiger in the shade on an overcast day, I knew that I could boost the brightness, color, contrast, and sharpness of the image in Photoshop for a much more dramatic image.

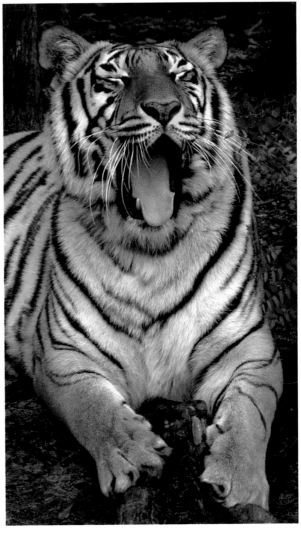

Tiger, Big Cat Rescue, Tampa, Florida

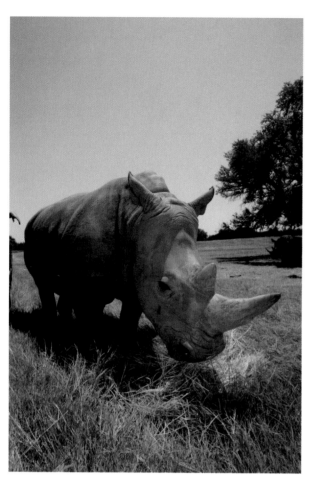

White rhino, Fossil Rim Wildlife Center, Glen Rose, Texas

Crop Creatively in the Digital Darkroom

When we can't follow the tip "The name of the game is to fill the frame," we can crop our pictures in the digital darkroom for a much more dramatic effect. This is often necessary when shooting captive animals, because we can't always get as close to the animals as we'd like.

Here, tightly cropping my original vertical image of the rhino, complete with a visitor's hand sticking into the left side of the frame, resulted in a much more dramatic horizontal image.

In the next lesson, we'll move on to some advice on photographing truly wild animals in their truly wild environment.

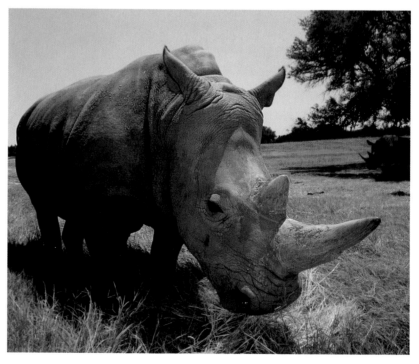

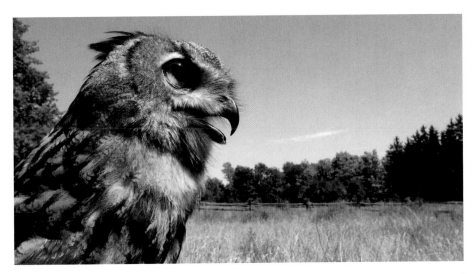

African eagle owl, the largest owl in the world, photographed at Talons Birds of Prey in Cazenovia, New York

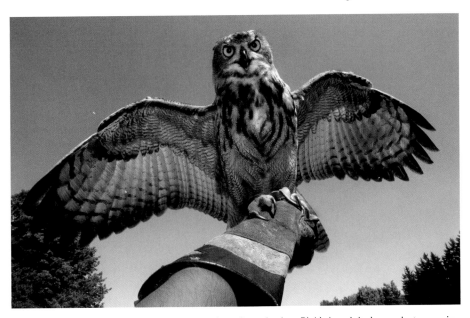

African eagle owl perched on Rick's hand during a photo session

A Gentle Reminder

Before we leave captive animals, please keep in mind that "honesty is the best policy" when it comes to publishing pictures of captive animals, as I mentioned in the introduction to this book. If you plan to publish enhanced captive-animal pictures, please tell the editor or art director of your shooting situation or image enhancements.

For more on this topic, which is very important to professional wildlife photographers, please see the Web site for the North American Nature Photography Association (www.nanpa.org).

Indoor Captive Animals

Previously, we've taken a look at photographing outdoor captive animals. Photographing indoor captive animals presents a few more challenges, most due to photographing in relatively low light conditions.

Here are some quick tips to help you get not only technically pleasing pictures but natural-looking ones, too. These monkeys were photographed at the Bronx Zoo in New York.

Steady As You Shoot

⇓ ⇒ These two pictures illustrate the difference between using an image stabilization lens (which helps reduce camera shake) and a non–image stabilization lens. Both pictures were taken with a 100-400mm IS lens set at 400mm. The shutter speed for both pictures was the same, 1/250 of second. As you can see, the image stabilization feature helped produced a sharp shot. The blurry picture suffers badly from camera shake.

If you don't have an IS lens, a tripod or a monopod is a good idea, if the facility allows them.

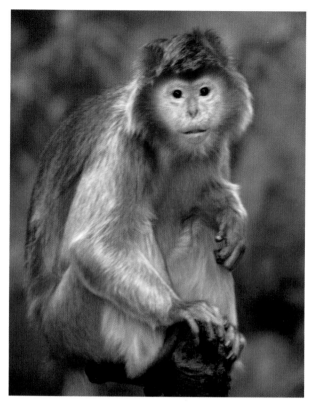

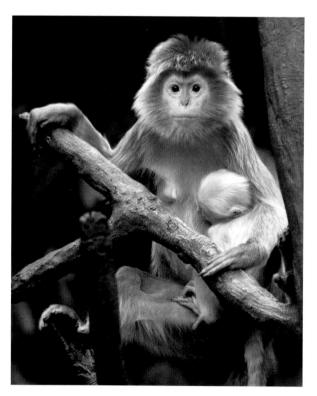

A Flash Is an Option

A flash can also help you get a sharp shot indoors. For best results, try the daylight fill-in flash technique outlined in "Lesson #1: People."

⇒ These two pictures illustrate the difference between a successful daylight fill-in flash shot (the mother with her young) and a harsh flash shot, the picture in which we can see the shadow cast by the flash on the background. That shadow, to the right of the monkey, is a dead giveaway that the picture was taken indoors.

Speaking of the background, the closer an animal is to the background, the more prominent the shadow from the flash. So, try to photograph animals that are some distance from the background.

One more thing about the background: it can make or break the photograph. When framing an animal, notice all the background elements and the brightness level of all the elements before you press the shutter release button.

We need to consider a few other factors when photographing captive animals indoors:

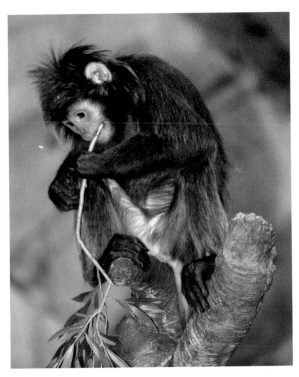

Plan Your Visit

If you plan your photo session for a Sunday morning, you'll avoid the crowds of Saturdays and the busloads of schoolchildren that frequent zoos and wildlife parks on weekdays. The kids are fun, but the sounds they make are usually distracting to the animals, sometimes to the point where the animals turn their backs on the kids, and you!

Even with skylights, the light level is usually low at the exhibits. For the most light, go between the hours of 10:00 A.M. and 2:00 P.M., when the sun is high in the sky.

In the Blink of an Eye

Animals, like people, blink. I have more than a few pictures of animals with their eyes closed. To ensure a picture of an animal with wide-open eyes, it's a good idea to take several pictures.

ISO Setting

Even at their brightest, lights are relatively dim at the exhibits. You'll probably need to use an ISO setting of 400 or 800 for natural-light, hand-held pictures with a zoom lens, with an f/4.5 or f/5.6 maximum aperture. If you have a compact digital camera, expect a bit of digital noise in your hand-held pictures. If you want to use a lower ISO setting, you'll probably need a tripod or monopod.

If you have a zoom lens with a maximum aperture of f/2.8, you'll be able to use lower ISO settings and higher shutter speeds, because the lens lets more light into the camera than an f/4.5 or f/5.6 lens.

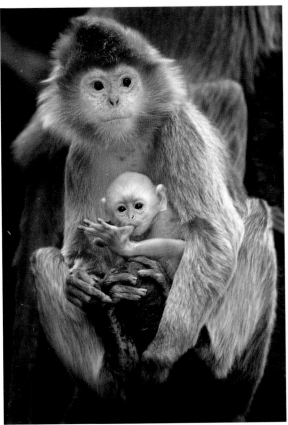

White Balance

Due to mixed light sources (skylight and artificial lights), your best bet is to shoot on Auto White balance. If you want to warm up a picture to simulate the light of early morning or late afternoon, you can shoot on the Cloudy White balance setting or boost the red and yellow tones in your digital image-editing program.

One final tip: Call the zoo or wildlife center before your visit and ask about any special additions to the exhibits. That's what I did before my visit to the Bronx Zoo, and that's why I have these pictures of the monkey mothers and their cute little babies.

Wildlife

Beryl Markham begins *West with the Night*, her wonderful and enthralling book about her adventures as a bush pilot in East Africa in the mid-1930s, with the question, "How is it possible to bring order out of memory?"

As I begin to write this chapter, I am halfway through an incredible photo safari in Botswana in the fall of 2004 with my photographer friend Doug McKague. I am beginning to understand how Ms. Markham felt about her experiences. Already, we have observed the lion's ritual of mating throughout an afternoon. We have observed a pride of lions hunting for hours through rugged terrain. We came upon a surprised male lion drinking from the lodge's swimming pool. We watched a pride of lions eating their recent kill, a young elephant.

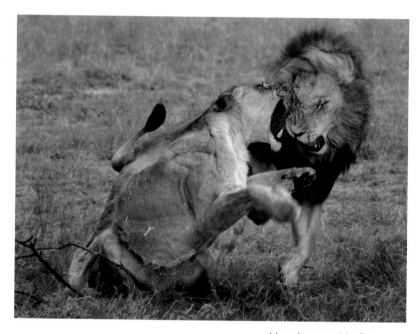

Lions in courtship, Botswana

Doug and I have been fortunate to see cheetahs basking in the late afternoon sun, leopards silently stalking prey, huge herds of elephants slumbering along the riverfront, giraffes peering at us from behind a treetop, zebras prancing in the late afternoon sun, and warthogs, kudu, sable, antelope, and impala darting away from predators.

We have witnessed here some of the most spectacular sunsets, sunrises, and moonrises I have seen in my twenty-four years of traveling around the planet. We shared good laughs the first day, when our guide had to chase an elephant off the dirt airstrip before takeoff.

As I review today's images on my camera's LCD monitor, I am trying to bring order to the experience of an African photo safari. I am also trying to organize the photographs, so I can share them with my family, friends, and you.

Writing about my Botswana adventures is for another time, in another book. For now, I'll share some of my favorite photographs from that trip, along with some tips for digital wildlife photographers.

As mentioned before, you can use most of the tips for photographing animals wherever you may encounter them.

Establish the Location

When we take wildlife pictures, it's important to show the location. If we don't, the people with whom we share our pictures will not have a good picture, so to speak, of the animals' habitat. As we'll see later, close-up shots of wild animals sometimes cannot be distinguished from pictures taken of animals in captivity. That's why we need to show the habitat.

I took this aerial picture from a light plane while flying over the Okavango Delta in Botswana, where many of my pictures, including the first series in this lesson, were taken. I took the moonrise shot from a winding river channel not far from the same location.

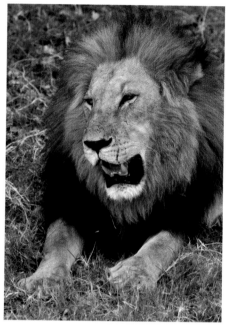

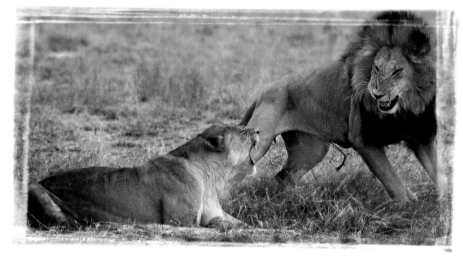

Main Ingredients for Wildlife Photography

These pictures of lions in courtship (the same pair pictured at the beginning of the lesson), taken over two days and selected from more than 100 images, illustrate the main ingredients needed for successful wildlife photography: an expert guide who can find the animals for you, luck, a good shooting position, a pleasing background and foreground, a knowledge of one's equipment, and patience—because sometimes we have to wait for days to get a perfect shot.

Almost all of the pictures in this lesson were taken with a Canon EOS 1D Mark II digital SLR and 100-400mm IS zoom lens. This is my prime lens for wildlife photography.

Some readers may ask why I did not use a much heavier and faster 300mm or 400mm f/2.8 lens and a tripod to steady my lens. The answer is simple: a zoom lens, which is lighter and smaller, offers much more composition flexibility when I am required to stay in the safari vehicle, out of harm's way.

Look for Other Photo Possibilities

When we focus our lens on a prime subject, it's important to look around for other photo opportunities, pictures that help us tell the story of the entire scene. Here we see cautious giraffes observing the actions of the lions from a safe distance. Do the giraffes know lions do not hunt while mating?

Carefully Choose the ISO Setting

Digital images contain digital noise, and as the ISO setting increases, so does the digital noise, which is most visible in shadow areas and sometimes in the sky. In most cases, point-and-shoot digital cameras have more noise at a high ISO setting than digital SLRs do at the same ISO settings.

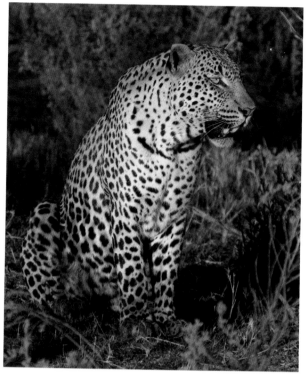

As a general rule, we should try to use the lowest possible ISO setting for the existing lighting conditions, because we usually want to minimize the noise in our pictures. On sunny days, we may be able to use low ISO settings, 100 or 200. As the light level gets lower, we often need to boost the ISO setting. On overcast days, we may need to shoot at ISO 400. When the sun gets low in the sky, we may need to shoot at ISO 800 or higher.

If we are shooting with a 300mm or 400mm nonstabilized telephoto lens on a sunny day, we may need to use a higher ISO for a faster shutter speed to avoid adding camera shake to our images, or a smaller f-stop, for more depth of field. Each situation should be evaluated separately.

When in doubt about the ISO setting, ask yourself this question: Would I rather have a noisy picture, which may be acceptable and which may be able to be enhanced in the digital darkroom? Or do I want to risk a blurry picture caused by camera shake? I really find blurred subjects unacceptable. You may also want to ask yourself if noise, which can be added with the Film Grain feature in Adobe Photoshop and Adobe Elements, can actually enhance a picture.

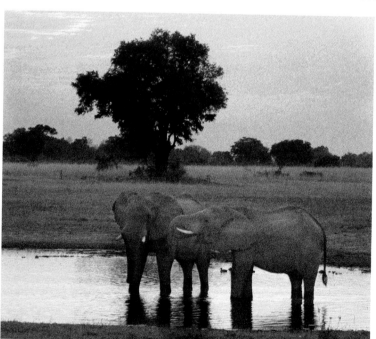

⇑ I set my ISO to 100 for the photograph of this leopard, which was hunting in the strong, direct sunlight of late afternoon. That lighting condition and the ISO 100 setting helped to produce an image with virtually no digital noise, an image in which you can see every whisker on the big cat's chin.

⇐ To illustrate how a high ISO setting affects digital noise in a picture, I set the ISO on my digital SLR to 1000 for this picture of two elephants at a watering hole. The picture has a fair amount of noise, especially in the dark areas. The noise, and the fact that the animals are backlit, makes this an "outtake" that I would not otherwise publish.

See the Light

When we take a picture with our digital camera, we are recording light on the image sensor. With no light, we would have no picture.

Sunny days and overcast days offer different types of lighting conditions. So as not to be disappointed with the lighting in our pictures, we need how to see the highlights and shadows in a scene. As a general rule, I expose for the highlights, so they are not overexposed.

⇒ On an overcast day, without any harsh shadows in the scene, pictures tend to look a bit soft, which can be pleasing, too. I photographed this resting male lion on

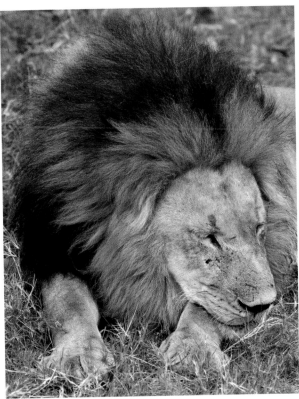

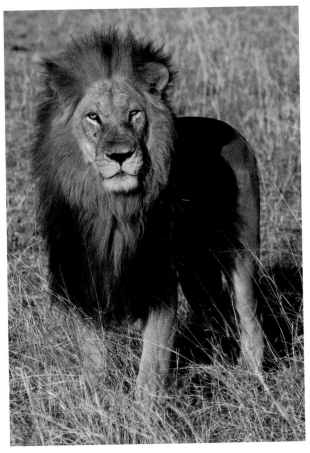

a slightly overcast day. Notice how the soft lighting contributes to the peaceful quality of this wildlife moment.

⇐ When we shoot on sunny days, our pictures have more "pop," due to the strong shadows and increased contrast created by direct sunlight. On sunny days, I try to compose my picture so the light is falling on the subject's face (unless I want a silhouette or unless I have a flash to fill-in the shadows). By the way, this is the same male lion we see resting in the previous example.

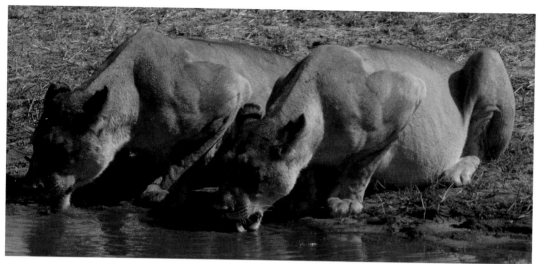

⇮ In addition to seeing the quality of light, we need to see the highlight and shadow areas of a scene—something our cameras can't see as accurately as our eyes can see. In this example, the lionesses' faces are shaded and therefore darker than their bodies, which may not be the most desirable lighting effect. But the lighting here does bring more attention to the powerful shoulders and legs of these magnificent creatures.

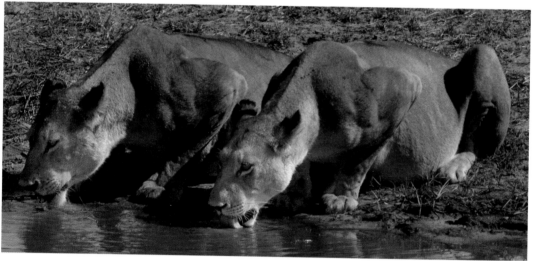

⇮ Of course, we can rescue the highlight and shadow areas of a scene (to some degree) in Photoshop. Here I not only lightened the animals' faces and darkened their bodies, but I also darkened the background to draw more attention to the animals.

Set the White Balance

Digital cameras allow us to set the white balance for the existing lighting conditions. When we set the white balance, we are telling the camera that we want white objects in the scene to be white. If the white is recorded white, then all the other colors in the scene should be accurately recorded. This is very important in commercial and scientific photography, where clients and scientists need to have their products shown with accurate color.

For the type of pictures we take, we don't have to be extremely fussy about color—because we sometimes are more interested in a pleasing picture than one that is scientifically accurate. We can even set the white balance on our cameras for different effects. Generally speaking, I don't use the auto setting, because the other white balance options offer more accurate or creative effects.

⇓ I photographed this elephant on a sunny day with my white balance set on Cloudy. I often use the Cloudy

setting on sunny days to "warm up" my wildlife pictures, which creates the impression that the picture was taken toward sunrise or sunset, when the light is "warmer" (having deeper shades of red, yellow, and orange). Before Photoshop was available, I used an 81A warming filter on my lens.

⇑ Because I mostly shoot RAW files, I can change the white balance of a given image in Photoshop's RAW Plug-in on my computer. Here I changed the white balance to daylight, which produced a more accurate color rendition of the scene. Still, I prefer the warmer image. However, there may be situations where the more accurate color would be a better choice.

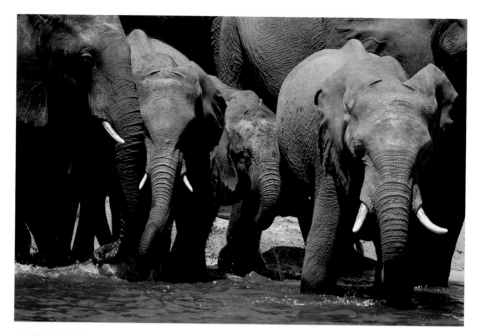

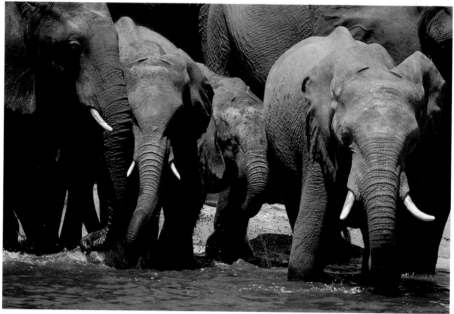

If you shoot JPEG files, you can warm up the tones in a picture with one of Photoshop's Warming Photo Filters, which are adjustable. In this set of pictures, we can see how I used Photoshop's 81A Warming Filter to change the white balance of the image.

Use Daylight Fill-in Flash

In "Lesson #3: Captive Animals," we see how using a flash outdoors can enhance our pictures. In that lesson I outline the easy steps for daylight fill-in flash photography.

A flash is also very useful for wildlife photography, because we often find subjects with back, side, or top lighting, or find the subject in the shade.

I strongly recommend that you master the basics of using daylight fill-in flash. The more you use it, the more you will value the results.

⇒ This baboon carrying her young is backlit. For a brighter view of the animals' faces, I could have set my exposure compensation to +1. However, that would have resulted in the background's being brighter and overexposed. In wildlife and people photography, we usually want the subject's face to be the brightest part of the scene.

⇒ Of course, we can use digital darkroom techniques, selectively lightening the young baboon's face in this example, for a more pleasing picture. However, it's always best to start with the best possible in-camera picture.

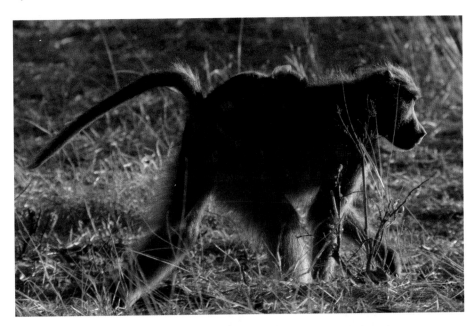

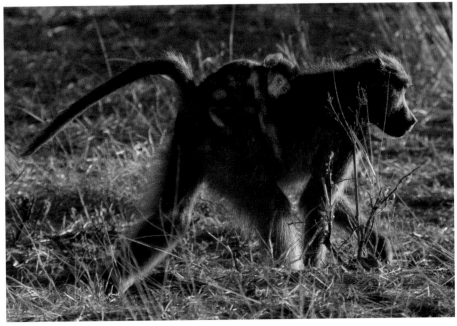

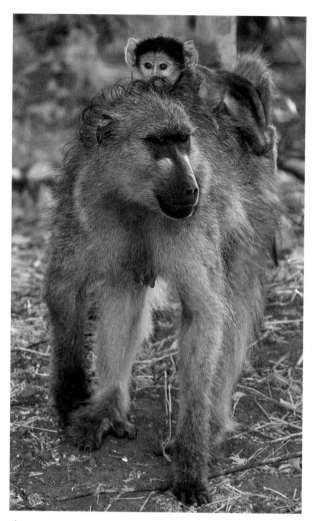

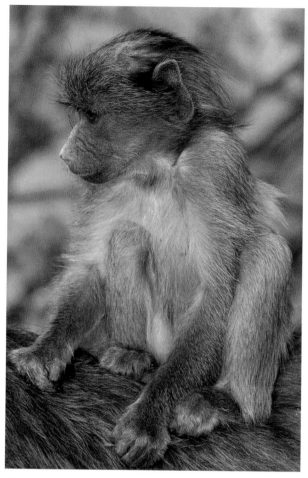

⇑ For this picture, which clearly shows the subjects' faces in a backlit situation, I used my flash. Because I did not want a harsh, flash photograph, I set the exposure compensation, which was on TLL (through the lens), to − 1-1/3. The resulting lowered flash output closely matched the existing daylight level.

⇑ Earlier in this lesson I mentioned that I use a 100-400mm IS zoom lens for wildlife photography because the zoom lets me change my composition in an instant. If I had had to fumble with changing fixed focal length lenses, I might have missed the close-up shot of the newborn baboon getting a ride on the back of its mother.

Take Sense-of-Place Photographs

When we are photographing wildlife, it's important to take photographs that capture a sense of place to help us with our storytelling. In addition to talking wide location shots that show the larger geographical features of a location, I like to make images that show the animal within its context.

⇓ I photographed this leopard with my 100-400mm zoom set at 400mm. A shot as tight as this could easily have been taken at a zoo. Switching to my 16-35mm zoom lens set to 35mm, I took a picture that shows the savannah habitat surrounding this magnificent animal. ⇓

⇒ Here is another sense-of-place photograph, one of my favorites. As you can see from the shadow created by the Land Rover in which my friend Doug and I were riding, the lions (the same pair pictured in the opening sequence for this lesson) came very close!

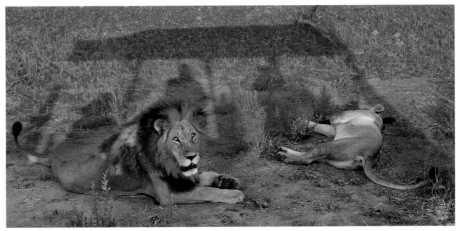

Watch the Background

In landscape photography, the foreground is important, because it can add a sense of depth to a scene. In wildlife photography, the background is important, because it can enhance or detract from the scene.

I like both of these pictures. The portrait of the giraffe showing the head framed against the sky was my first shot. However, as I studied the whole scene, I noticed the tree that may have been lunch for the giraffe. The picture framed with the tree in the background shows more attention to composition and tells more of a story.

Behavior Pictures vs. Portraits

Portraits of animals are fun to take. By portraits, I mean an image in which the subject is at rest. However, showing animal behavior is often more interesting. Admittedly, we often have to wait for an animal to exhibit behavior. The lioness giving the lion a "love bite" during courtship earlier in this lesson is one of my favorite behavior shots.

Here are two more examples of animals whose portraits appeared earlier in this lesson exhibiting behavior: the giraffe drinking and the elephant making a mock charge. The strong legs of the giraffe help us imagine how its rear legs are forceful enough to kill a lion with one swift kick. The elephant's mock charge reminds us that elephants can outrun a man and can easily flip over a safari vehicle in no time.

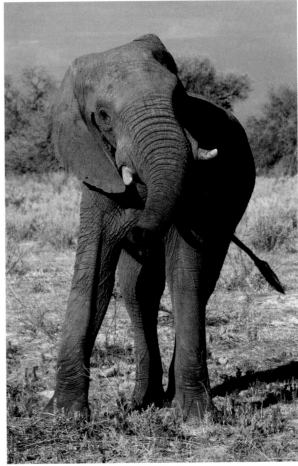

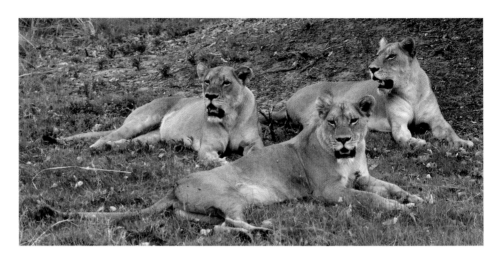

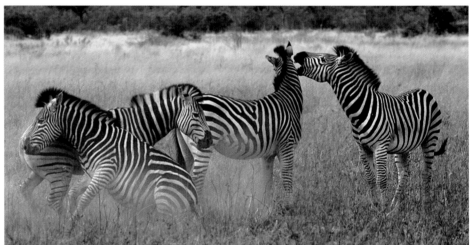

Crop Creatively

As you may have realized from flipping through this book, I am a nut about cropping. I seldom use the full-frame image that I captured in-camera. Rather, in the digital darkroom, I crop out areas that I feel don't add anything to the scene.

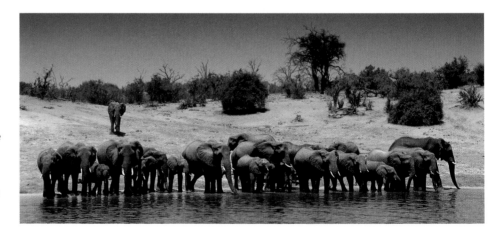

Here are three examples that illustrate my thinking on cropping. Each of the pictures had "dead space" on the top and bottom of the frame that detracted from the impact of the main subjects.

Silhouettes at Sunset

Sunsets offer a wonderful opportunity to take dramatic silhouettes of animals. The key is to frame the animal so the sun or part of the bright sky is behind the animal.

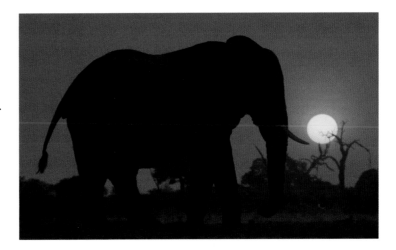

For dramatic sunset silhouettes, I recommend setting your camera on Aperture Priority and then taking pictures with the exposure compensation set at −1, then −1-1/2, and −2 (and in between those setting if you want to fine-tune your exposures). The reduction in exposure will give you more saturated colors and make the silhouette more dramatic. It also keeps the sun from becoming too overexposed in the scene, which can ruin a picture.

Setting the white balance to Cloudy (in-camera if you shoot JEPG files or in Camera Raw on your computer if you shoot RAW files) will also give you more dramatic colors than if you set the white balance to Auto.

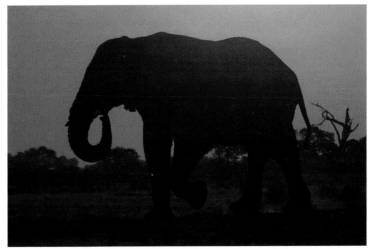

As the sun gets lower in the sky, it's necessary to increase the ISO setting. For these illustrations, I had my ISO set at 100.

Before you read on, can you find a mistake in the bottom picture? I was in such a hurry to capture the scene that I forgot to remove the skylight filter from my lens. That's a big mistake when shooting directly into the sun, because the light from the sun bounces off the front element of the lens and onto the filter, which results in a ghost image of the sun in the image. You can see that ghost image above the elephant's head in the middle of the frame. Oops. I could have fixed the mistake in Photoshop but left it here to show you that pros make mistakes, too!

One final tip on shooting sunsets: Wear sunglasses and don't look directly into the sun. You could cause damage to your retina.

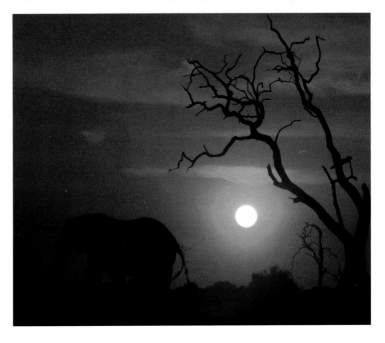

Witness to a Kill

I debated including this picture of two lions eating a young elephant after a kill. I also considered not including the picture of the lion kill of a baby giraffe in "Jumpstart #4: Travel and Nature Photography Basics from A to Z."

I am sure some readers and animal lovers will be turned off by these images, and I respect and appreciate that sentiment. However, I feel that it's important to share these pictures, because they accurately depict the circle of life in the wild. After all, lion and cheetah cubs need to eat and grow, too. If you have seen the Disney musical *The Lion King*, you'll see that a similar story is played out.

The other reason I share these with you is this: If you go to Africa or to other wild places, including the Galápagos Islands and the Brazilian rainforest, you'll most likely witness a kill. If you don't want to see it, you can always turn away.

I wish you the very best luck in finding the animals, getting close to them, and getting photographs that will make you roar with pleasure when you see them on your computer monitor.

My Botswana experience was unforgettable. I could not have a better, more enthusiastic traveling buddy than Doug. I am very pleased with my pictures and feel fortunate to have seen all that I have seen. Scrolling through my file browser, seeing the pictures you have just seen and more on a much smaller scale, I am thinking back to when my South African Airways flight took off from JFK Airport. As we lifted off the tarmac, I was listening to Joni Mitchell's "Circle Game" on my iPod. I was filled with anticipation and excitement and apprehension, not knowing what kind of photographs I'd come home with, and what experiences the trip would bring. I knew one thing for sure: I needed and wanted the pictures for this book in the worst way. The pressure was on. Self-inflicted. As things turned out, luck was with me. But, as the saying goes, "Work hard. Get lucky."

By the Sea

There isn't any symbolism. The sea is the sea. The old man is an old man. The boy is a boy and the fish is a fish.... What goes beyond is what you see beyond when you know.

—ERNEST HEMINGWAY

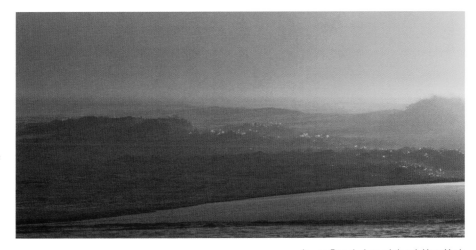

Jones Beach, Long Island, New York

Much of this book was written on my Apple Powerbook G4 while I was traveling to gather images. (Many photographers feel, by the way, that one of the reasons we like to take pictures is because we are basically hunters and gatherers.) Over the years, I have found that writing while traveling has two advantages. First, recording the experiences and details while they are fresh in my mind makes them easy to share. Second, writing fills my downtime while on the road, waiting for hours and even days for a flight, van, bus, boat, or ship to depart.

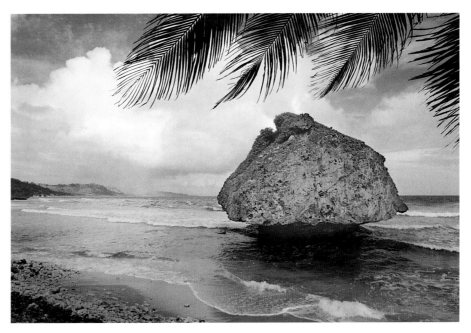

Bathsheba Beach, Barbados

I begin writing this lesson from the deck of my stateroom on board the Celebrity cruise ship *Constellation*. Not all my downtime is this luxurious. It's just past sunrise on day three of the seven-day cruise, and I've just finished reviewing my pictures from yesterday's stop, Barbados, to select the images for this lesson.

The opening picture for this lesson is my favorite photograph from Bathsheba, which is on the Atlantic side of Barbados. The image was taken with my Canon EOS 1D Mark II and one lens, my Canon 16-35mm f/2.8 zoom. I used a polarizing filter to darken the sky and reduce some of the reflection on the water.

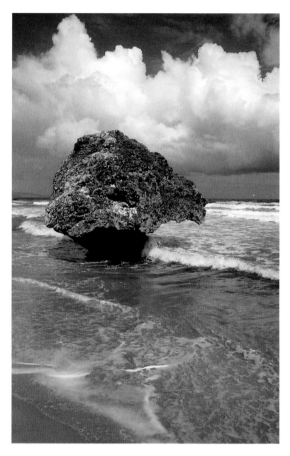

If I could recommend one zoom lens for scenery photography, it would be the 16-35mm zoom. When we use a small aperture (f/8 to f/11) and zoom the lens within the 16-24mm range and focus one-third into the scene, we can get the entire scene in focus, unless we have a foreground element very close to the lens.

I like the picture, over the others from the same trip that follow, for several reasons. One, it creates a sense of depth, because I composed the beach scene with the palm leaves in the foreground. Second, it captures the mood of the peaceful setting. Third, it tells a story. Looking in the left side of the frame, we can see an isolated rainstorm. So the picture also gives us a glimpse of the weather possibilities in this tropical setting.

Now I'd like to share with you a few more pictures from Bathsheba, each to illustrate a photographic technique.

Near or Far?

An important consideration is how close we want the main subject to be. How much of the scene do we want the main subject to fill? And how much of the surroundings do we want to include in our photograph?

Both of these pictures, also taken with my 16-35mm zoom, tell a slightly different story and give us a slightly different view of the section of the beach. Decisions, decisions, decisions! They are ours to make.

Horizontal or Vertical?

Simple as it sounds, holding our camera horizontally or vertically can make a big difference in the impact of a seaside picture. When we think a seaside scene can work both ways, we should shoot it both ways. That gives us a choice for making a decision when we get back home, when we are not overwhelmed or enthralled with the beauty of the sea. What's more, having both horizontal and vertical images helps in stock photo sales, which is a nice sideline for anyone who has the photographs, time, and patience for it.

We see that the horizon line curved in these two photographs. For that effect, I use the Canon EF 15mm f/2.8 fisheye lens.

Hubbard Glacier, Alaska

Three months have passed since I photographed in Barbados. I am now writing this part of this lesson on the last day of a weeklong Royal Caribbean Alaskan cruise on the *Serenade of the Seas*. It's been a wonderful learning and growing (and eating) experience for my family and me. Being up close to Hubbard Glacier is one of the cruise highlights, and this photograph (slightly underexposed to bring out the beautiful blue color in the ice) is one of my favorites from the trip.

A floatplane ride was another highlight of our Alaskan adventure. Toward the end of the aerial tour I snapped a picture of our ship. We can see a reflection in the plane's window. A photograph does not necessarily have to be technically perfect to be a meaningful shot. See "Aerials" in "Jumpstart #4: Travel and Nature Photography Basics from A to Z" to learn how to reduce this type of reflection.

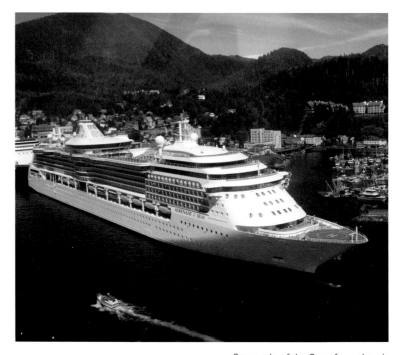

Serenade of the Seas from the air

Misty Fjords, Alaska

Dead Center Is Deadly

As I write this lesson, the seas are calm and the snow-capped mountains in the distant horizon are fading into the mist. A few moments ago, I took my last shot of the trip, a picture of a coast guard boat bringing a local pilot onto our ship for its navigation through this very narrow waterway. To make this photograph, I followed the photo tip "Dead center is deadly," being careful not to compose my picture with the main subject in the dead center of the frame.

But wait! In the second horizontal picture of Bathsheba Beach, I placed the huge limestone rock almost smack dead in the center of the frame. Yes, I broke the "dead center is deadly" rule. In that case, I felt like breaking the rules worked.

Keep It Clean

When I am traveling by ship, I am extra careful to wipe off the salt spray on my lens with a lint-free cloth, and to wipe down my camera with a soft cloth after a day of shooting. In addition, I never change lenses on my SLR camera while on the moving boat or when it was misting. A tiny drop of salt mist on my camera's image sensor would look like a big blob in my pictures and would require my cleaning the sensor. When necessary, I carefully clean the sensor with Eclipse cleaning fluid and Sensor Swabs from Photographic Solutions (www.photographicsolutions.com).

Place the Horizon Line Carefully

Where we place the horizon line in the frame affects our pictures. Generally, if the sky is more interesting than the foreground, we should try composing a picture with the horizon line near the bottom of the frame. If the foreground is more interesting, as it was in this Provincetown sunset scene, trying placing the horizon line near the top of the frame.

Sunset, Provincetown, Massachusetts

Don't Get Locked In

The rectangular ratio of height and width of a camera's digital image sensor does not need to lock us into that frame format. When I shot this sunset scene, I envisioned cropping out the dead space for a picture with greater impact.

Sunset, Provincetown, Massachusetts

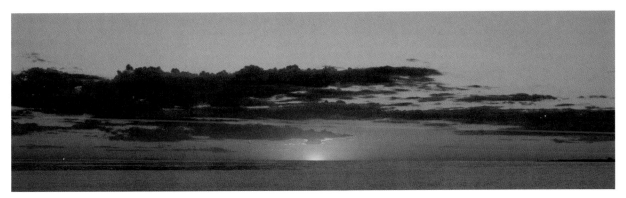

⇑ Here I cropped out some of the top and bottom of the frame in the digital darkroom for a panoramic image.

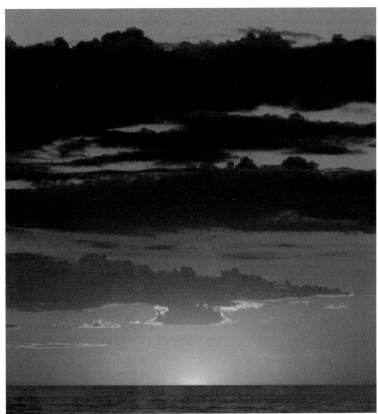

⇒ And looks what happens when the image is cropped square.

The moral of this story: When composing a picture, think about how simple cropping might enhance it.

Lobster buoys, Provincetown, Massachusetts

Look for Creative Composition

Always try to see how moving and/or tilting your camera can produce a more
creative picture. Also experiment with how a different lens can improve a
photograph. Compare these two pictures. The boring shot was taken horizontally
at eye level from a standing position with a 50mm lens; the more creative shot was
taken from a kneeling position looking up with a 16mm lens.

Coronado Hotel, San Diego, California

Lifeguard stand, Miami Beach, Florida

Add a Sense of Depth to a Scene

We see the world in three dimensions: height, width, and depth. Our cameras only see height and width. Therefore, we need to create a sense of depth in our pictures. We can do that by shooting in the early morning and late afternoon hours, where shadows add a sense of depth to our pictures. We can also create a sense of depth by composing our pictures with a foreground element in the scene. In my picture of the Coronado Hotel, the seagulls add a sense of depth. In the lifeguard stand picture, the words on the structure add a sense of depth to the scene.

Lifeguard Stand, Miami Beach, Florida

Experiment with Different Lenses, Positions, and Angles

We all look for pictures with our eyes. However, as simple as it sounds, looking for pictures while we are actually looking through a lens will provide us with even more photo opportunities. That's because wide-angle lenses, for example, take in more of a scene than telephoto lenses, which crop out part of a scene. Telephoto lenses can also blur distracting background elements, while wide-angle lenses, especially very wide-angle lenses set at small apertures, can get the entire scene in focus.

These two pictures of a lifeguard stand in Miami Beach were taken just minutes apart. The first picture, the silhouette, was taken with my 16-35mm zoom set at about 20mm. The front-lit photograph was taken with the 100-400mm zoom lens set at 200mm.

While looking for pictures, vary your shooting position, using sunlight to create different effects, as illustrated by these two pictures, in which I shot from both the seaward and landward side.

And as far as varying our angle, we can shoot standing straight up, as in the silhouette photograph, or squatting, as in the other picture.

In a word: experiment. Your experiments may just result in new photographic discoveries for you.

Use the Disequilibrium Effect

We can tilt our cameras down to the left or right for what's called the disequilibrium effect. This effect can add interest to some subjects. You may not want to use this technique when taking a landscape photograph, because your image will look as though you did not pay attention to keeping the horizon line level.

Breakwater Hotel, Miami Beach, Florida

Pack a Polarizing Filter

If we plan to shoot by the sea, we must have a polarizing filter. A polarizing filter enables us to "dial out" reflections on water and can also darken a blue sky and whiten white clouds. Polarizing filters are most effective when the sun is off to our side; and not effective at all when the sun is directly in front of or behind us. If we have a skylight filter on a wide-angle lens, it's a good idea to remove the skylight filter when shooting with a polarizing filter. If we don't, we may get some vignetting (darkening) in the corners of our pictures.

For newcomers to SLR photography, a skylight filter is an important filter to have on your lens. Designed for film cameras to reduce the blue tint in slides, these days it mainly protects the front element of the lens from scratches and dings. Replacing a skylight filter is much less expensive than having the front element of a lens repaired.

Dockside, Bahamas

Seagulls, Jones Beach, Long Island, New York

Look Out for Lens Flare

Direct sunlight striking the front element of our lens (or a filter) can cause lens flare, which at its worst can look like this, and at its best makes pictures look soft and flat (as illustrated in "Lesson #1: People"). To avoid lens flare, we should use a lens hood. When using wide-angle lenses, which have short lens hoods, we may need to shade our lens further with a hand or a hat.

Capturing Seashore Life

In most locations, we need a telephoto lens to capture skittish seashore creatures. However, in places like the Galápagos Islands, where most of the animals are not afraid of humans because they have not been hunted for generations, we can get up-close shots with wide-angle lenses.

When possible, we should try to use a blue sky or blue water background to enhance our photographs. If the subjects are off center, as they are in my seagull photograph, we can use our camera's autofocus lock and lock the focus on the main subject, recompose the photograph, and shoot. Be extra careful to ensure that the horizon line is level in your picture.

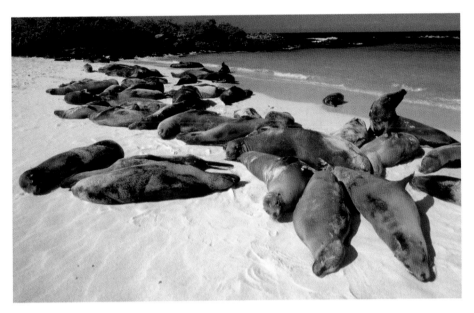

Sea lions, Galápagos Islands

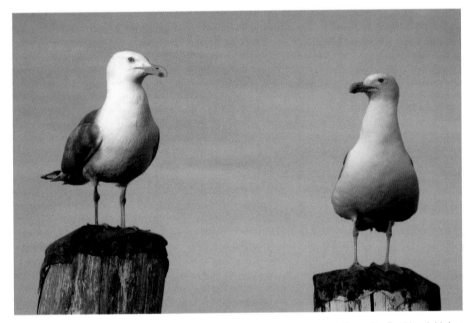

Seagulls, Rockland, Maine

Now I'd like to share a few "postcards" with you. These are some of my favorite Maine pictures that I've taken while teaching my yearly digital photography workshop at the Maine Photographic Workshops (www.theworkshops.com), based in scenic Rockport.

During the workshops, I stress the importance of starting with the best possible in-camera image, rather than relying on Photoshop to "save the day." In between teaching and eating as many lobster rolls as possible (I had seven in five days), I was able to take a few photographs of my own.

Rockport and neighboring Camden are good as a home base. Both towns have plenty of motels and bed-and-breakfasts, but you need to make a reservation well in advance, due to the popularity of the area and the number of festivals, including the July Lobster Festival.

All of the following photographs were taken with my Canon EOS 1Ds, and all were adjusted slightly in Adobe Photoshop CS.

⇒ Pemaquid can be a one-hour or a several-hour drive south of Rockport (the latter if you take your time, as we did, and photograph along the way). In Pemaquid, the main attraction is the Pemaquid Lighthouse, surrounded by spectacular granite rock formations, which also make wonderful photographic subjects. For this photograph of the lighthouse, I composed my picture with a large rock in the foreground to add a sense of depth to the scene. I set my 16-35mm lens to 16mm and selected a small aperture to get everything in focus. A polarizing filter helped to darken the sky, which I darkened even more in Photoshop.

⇓ Rockland is a fifteen-minute drive north of Rockport. Go down to the fishing dock in the early morning and you'll find fishing boats unloading their catch—if the catch was good and the boats are in. If the boats are still out, as they were the first time I was there, focus your camera on the harbor scenery. I took this shot with my 28-105mm lens set at 105mm.

An important safety note: Be careful where you step and shoot. On my most recent visit to the dock I was so wrapped up in the shooting that I was actually hit and knocked down by a truck backing up. In fact, I was almost killed.

⇒ Camden's harbor is filled with wonderful sailboats, which make nice subjects. When the water is calm, try to capture a boat's reflection. Underexpose a reflection picture just a bit to bring out the colors in the scene. For this shot, I used my 28-105mm lens set at 105mm, because the boat was some distance from me and I wanted to include only the water in the reflection.

⇘ Why not end a day with a sunset cruise? Several boats cruise from Camden. Our group took a cruise on the Windjammer *Appledore* (not the boat in the picture) and sailed on the calm seas for two hours. We photographed the harbor and passing boats. I took this picture with my 28-105mm lens set at 105mm.

⇘ Sea captains make great subjects. For this photograph, which I took in Rockland, I asked the captain to stand by the hull of his boat, which provided a nondistracting background. The pillar on which he is leaning, the porthole, and the yellow hawser (technical name for the yellow rope in the photo) are all elements that add to this "environmental portrait." For most of my portraits, I like to shoot on overcast days, when the soft light is flattering to the subject. My lens for this shot was my 28-105mm set at about 50mm.

As you may have noticed, I only used two lenses while shooting in Maine: a 16-35mm zoom and a 28-105mm zoom. These two lenses give me a nice lens range, from wide-angle to medium telephoto. When traveling, I find that less is more: I don't miss shots hunting through my camera bag looking for lenses. Travel light with the right equipment and you may be

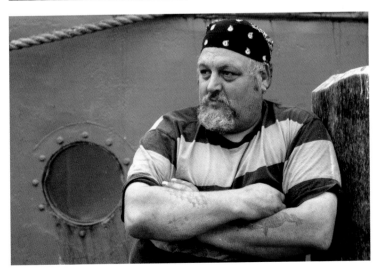

surprised at how many good pictures you can get without a ton of gear.

In closing this lesson, I'd like to share with you a favorite seaside picture, a photo tip, and a joke. Here's the joke: What's the difference between an amateur and a professional photographer? A professional does not have to show his or her bad pictures.

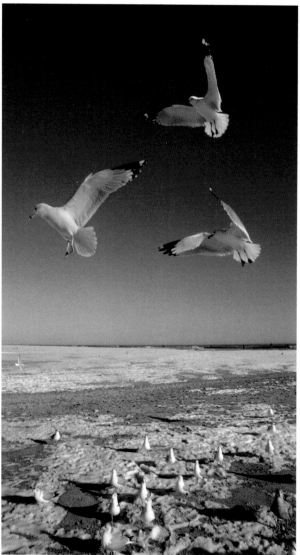

These pictures of seagulls in flight are two of more than 100 I took during an afternoon at Jones Beach. Most of the pictures did not have tack-sharp focus, had the bird's wings or feet cut off, or had a touch of lens flare, as we saw earlier. Here's the tip: When photographing fast-moving birds, take a lot of pictures to ensure a few keepers. See "Lesson #4: Wildlife" for more advice on photographing birds in flight.

SEASIDE DIGITAL EFFECTS

For those of you who are interested in image enhancements, which I cover extensively in my two other W. W. Norton books, *Rick Sammon's Complete Guide to Digital Photography* and *Rick Sammon's Digital Imaging Workshops*, here are just a few fun ideas of what we can do with our seaside pictures.

⇓ Oftentimes, simple enhancements can make a picture look more creative. Here I first used the Aged Photo effect in Photoshop CS2. Then I applied

the Watercolor frame in a Photoshop Plug-in called Extensis PhotoFrame.

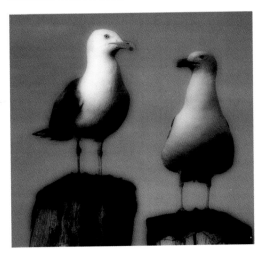

⇑ These are the same two seagulls we met earlier, from the same pictures. With some cutting and pasting, I was able to get the seagulls closer together. Then I applied the Midnight Sepia filter in the Photoshop Plug-in nik Color Efex Pro 2.0.

In looking at the picture, I had the idea to create a reflection. First I increased the canvas size of my document. Then I duplicated the original image and flipped it vertically. Next I dragged the flipped

image (the reflection) into my original document (the topside shot) and lined up the two images. You'll find out how to do this in *Rick Sammon's Complete Guide to Digital Photography*.

⇓ Increasing the saturation and contrast of a picture, and reducing its brightness, can often turn an okay beach scene into a more vivid image.

In the digital darkroom, we can transform our vertical pictures into horizontal images by increasing only the width of a picture. My original vertical image has a width of 4.31 inches. By increasing the width to 12 inches, I have a picture that looks like it would fill the screen of a high-definition television. The super-wide image was the result of increasing the width to 25 inches.

City Life

As travel photographers, we all enjoy photographing in cities around the world and being inspired by the people and sites. However, I encourage you to spend some time shooting in your own city, or a nearby large city. It's a great way to spend the day and feel creative at the same time.

If you are new to city shooting, the following are some tips to get you going. To illustrate these points, we'll begin by using some photographs taken in New York City.

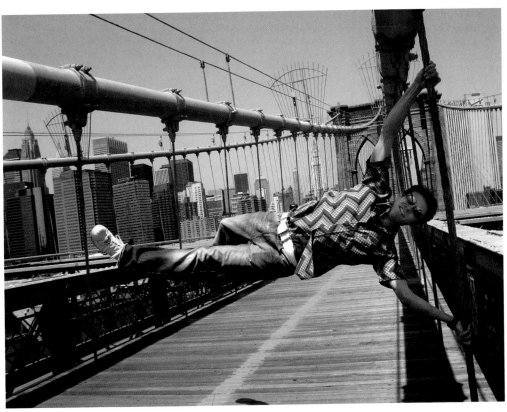

On the Brooklyn Bridge

Have Fun

Sure, we are serious about our photography, but we should try to have some fun with our photos. It's fun to work with a subject to create a picture that will bring a smile to someone's face.

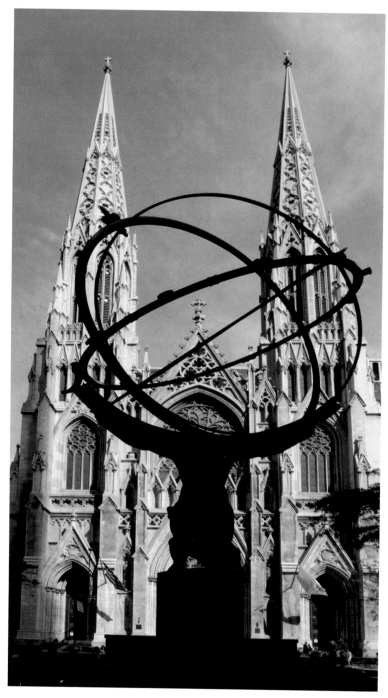

St. Patrick's Cathedral

Go Wide

You'll need a wide-angle lens to photograph buildings or statues at close range. For this shot I used my 16-35mm zoom set at 16mm. Notice how the foreground element adds a sense of depth to the photograph.

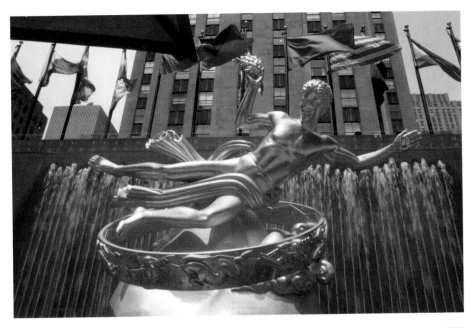

Rockefeller Plaza

Add More Interest to a Picture

Create a sense of disequilibrium in a picture by tilting your camera to the side. This is a popular effect in music videos and television commercials.

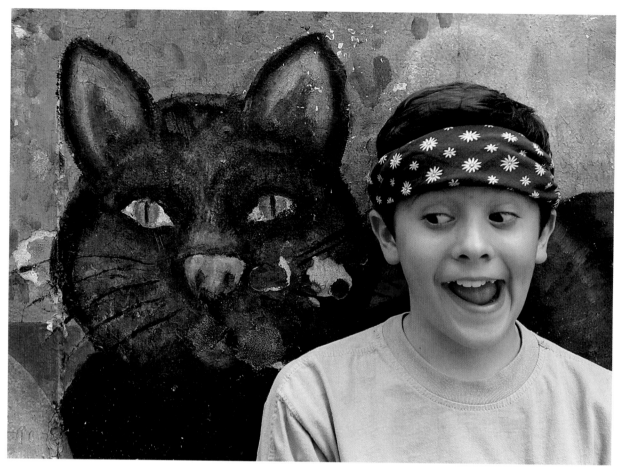

Marco by mural near Central Park

Look for Urban-Style Backgrounds

Many cities have building walls painted by local artists. Use these outdoor canvases as a backdrop for your photographs. Here I used my 28-135mm zoom set at about 100mm. For people pictures, a zoom setting around 100mm will provide a nice camera-to-subject working distance.

Slow It Down

To capture the hustle and bustle of a city, use a slow shutter speed (1/15 of a second or slower) to create a sense of motion. At slow shutter speeds, you'll need a tripod to steady your camera. To prevent camera shake, use a cable release or your camera's built-in self-timer. Keep in mind that long shutter speeds often result in increased noise in a digital picture.

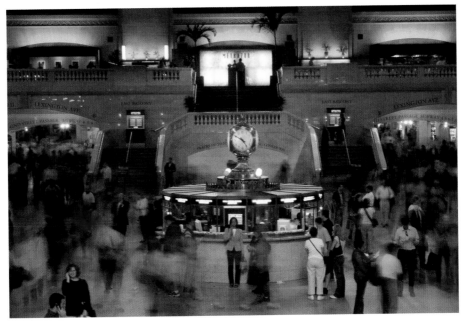

Grand Central Station

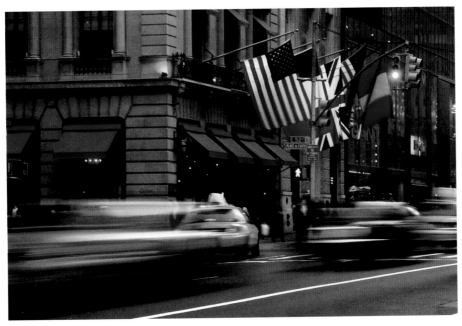

Fifth Avenue

Bring a Flash Outdoors

Shadows created by buildings and trees can darken a subject's face. Use a flash to reduce or eliminate the shadows. I took this shot with my camera set on Program and my flash set at − 1-1/3. The reduced flash output filled in the shadows for what's called a daylight fill-in flash photograph. Because the flash output was reduced, it balanced the natural light, and therefore this does not look like a flash picture. Read more about daylight fill-in flash techniques in "Lesson #1: People."

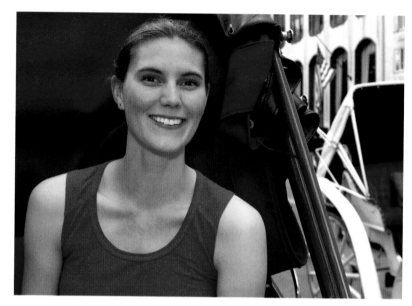

Brooke in horse-drawn carriage

A softer Brooke

Soften a Subject

I used to use screw-on soft-focus filters to soften the features of a subject, as well as the elements in a scene. These days I use the Classical Soft Focus filter in nik Color Efex Pro, a Photoshop Plug-in from nik multimedia. Try this digital filter on your people shots, your street scenes, and even on landscapes.

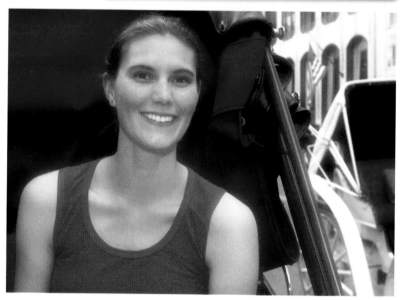

Get Closer

Most people don't get close enough when they frame a subject. When composing a picture, think about how moving in or zooming in can improve a picture. In this case, I actually like both pictures, but Brooke prefers the closer shot.

Brooke by the LOVE sculpture

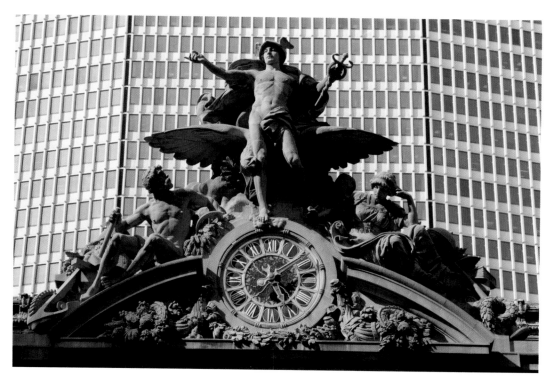

Clock, Grand Central Station

Look Up

As simple as it sounds, looking up for pictures will help you see more picture opportunities. You'll find this to be true in many photographic situations.

Get It All in Focus

Photographs of city scenes work well when most, if not all, of the scene is in focus. To achieve that goal, use a wide-angle lens and a small f-stop and focus one-third of the distance into the scene. For this picture I used a 16-35mm zoom lens set at 20mm, set my f-stop to f/11, and focused on the red part of the carriage.

Horse-drawn carriage, Central Park

Young boy, Central Park

Crop Creatively

Which one of these pictures has more impact? My guess is that you'll choose the one in which the boy fills more of the frame. Well, as you can see, you are looking at the same picture, but one is cropped tighter. When you can't get close enough to a subject, think about how creative cropping in the digital darkroom can enhance the picture.

Thai Temple Photo Shoot

I wrote the next part of this lesson at 30,000 feet, returning from another wonderful city, Bangkok. Besides showing you my pictures, I thought I'd tell you a bit about Bangkok, surely one of my favorite cities to photograph. Bangkok is a popular tourist destination, but it's also a starting point for tours of northern and southern Thailand. For adventurous travelers, the city provides a short layover when you're on your way to other places in Southeast Asia, including Vietnam and Cambodia.

The exotic, magical, and enthralling city is filled with dozens of Buddhist temples, the Emerald Buddha Temple (Wat Phra Keo) being the most elaborate. Upon seeing the Emerald Buddha Temple, one immediately appreciates the temple's name: It seems as though every inch of the temple is inlaid with jewels (actually pieces of colored glass). The temple is magnificent, but it's only a small part of the stunning Grand Palace complex, which comprises many throne halls and stupas (sacred sites for religious relics), all seemingly decorated with jewels and gold leaf.

The Grand Palace complex offers unlimited photo opportunities. Here are just a few.

⇓ You will not be alone in the palace complex. In fact, there may be hundreds of people sharing your experience! You can avoid getting people in your pictures by getting down low and shooting at an upward angle. I used my Canon 16-35mm lens set at 20mm for this photograph.

⇓ Use a telephoto zoom (my Canon 70-200mm lens was set at 200mm) for a tight shot that reveals the intricate inlays on the statue. For added impact, sharpen your pictures in the digital darkroom. I use nik Sharpener Pro! (a Photoshop Plug-in) as my sharpening tool.

The Giant Guardian, Emerald Buddha Temple

Grand Palace Complex

Temple of the
Reclining Buddha

Throne Hall, Grand
Palace

⇑ The outer walls of the Temple of the Reclining Buddha are lined with hundreds of statues set against an intricate background of carvings and colored glass. To convey the depth and scale of the walls, shoot from a corner with a wide-angle lens set at a small f-stop. I used my Canon 16-35mm lens set at 16mm and f/11.

⇒ In the early morning and late afternoon, shadows drape many of the buildings in the Grand Palace, creating high-contrast situations. More contrast is added when you frame the white and gold buildings against a blue sky. To ensure a good exposure, check your digital camera's LCD monitor for "washed out" areas and make "−" (minus) exposure compensation adjustments accordingly.

The Temple of the Sun is across the river from the Grand Palace. It's worth the five-minute boat ride. Dozens of Buddha statues line the inside walls of the temple. Take telephoto and wide-angle shots. Each shot tells a different story. Slightly underexpose your pictures to avoid highlights being washed out.

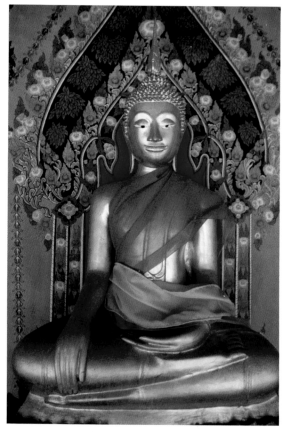

Temple of the Sun

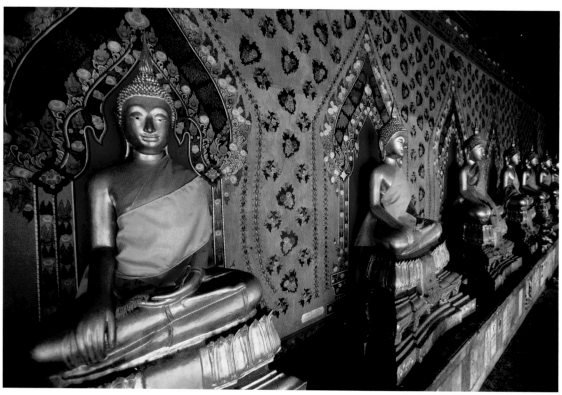

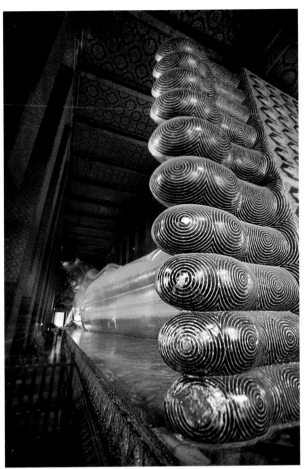

Reclining Buddha

⇐ If you have only a short time during a layover to spend in Bangkok, go to the Temple of the Reclining Buddha. The 46-meter-long and 15-meter-high statue is a wondrous sight to behold—and to photograph. You'll need a very wide-angle lens (I used my Canon 16-35mm set at 16m) and a high ISO setting (I used ISO 800) for a hand-held shot. Tripods are not allowed. You'll need to take off your shoes, so wear slip-ons.

⇓ Many of the hotels in Bangkok offer nightly cultural shows. Check start times in advance. Bring your flash and telephoto zoom for tight shots of the performers. Arrive early so you get a good seat. The performers are used to being photographed and may even pose for your after the show. A tip is appreciated.

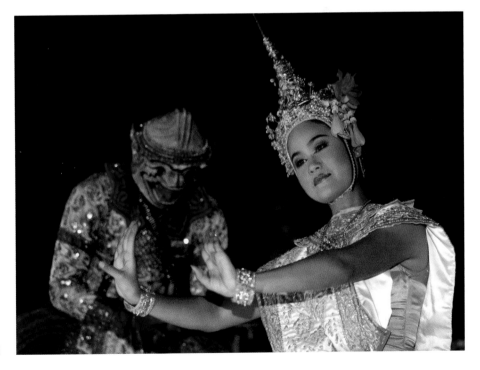

Dancer, Royal Orchid Hotel

I'd also like to share with you some pictures from a recent trip to Mexico.

Shoot Close-ups, Too

When visiting a city, don't forget to shoot close-up pictures. These pictures, taken in San Miguel de Allende, Mexico, illustrate the artistry of the shop owners in this beautiful city, and help bring back memories of walking down the cobblestone roads. When you travel, don't forget to zoom in on the details in foreign cities. They, too, can help capture the mood of your destination.

BE AWARE

I hope you have enjoyed taking a look at some of my favorite city pictures. Here is a final tip: Think safety first. You may find yourself standing in the street with oncoming traffic—cars, trucks, or even motorbikes—as I did in Ho Chi Minh City, Vietnam. Always be aware of your surroundings, and how you affect them.

Indoors

When we travel, we often find good photo opportunities indoors. The low light and artificial light we find indoors present special challenges. As is the case with outdoor photography, it is important to see the light—the color of the light, direction of the light, and how the light is illuminating the subject.

Go Wide

In many cases, wide-angle lenses are a good choice for indoor photography. They let us shoot at a slower hand-held shutter speed than telephoto lenses and are less prone to exaggerate camera shake. Wide-angle lenses also provide greater depth of field than telephoto lenses. Wide-angle lenses let us capture more of a scene in our pictures than telephoto lenses, which is a big advantage when working in confined quarters.

⇐ ⬀ These two pictures of the Chuang Yen Buddhist Monastery in Carmel, New York, were both taken with my 16-35mm zoom set at 16mm. I hand-held my camera at 1/30 of a second and my aperture was set at f/11.

The pictures illustrate the good depth of field that a wide-angle lens (or wide-angle setting on a zoom lens) offers. The pictures also show two very different views of the statues. When we are

looking for picture opportunities, we should try to vary our viewpoint to find the angle we like the best. Look for pictures through different lenses. You may see new photo opportunities that you may not have seen with the naked eye.

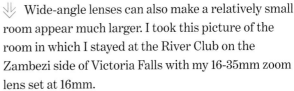 Wide-angle lenses can also make a relatively small room appear much larger. I took this picture of the room in which I stayed at the River Club on the Zambezi side of Victoria Falls with my 16-35mm zoom lens set at 16mm.

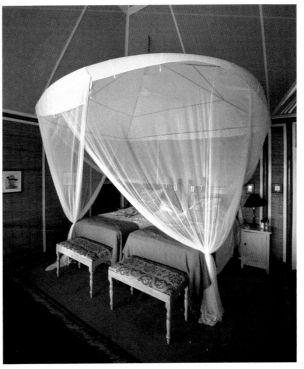

Set the White Balance

The first consideration for a camera setting in indoor photography is setting the white balance. As a reminder, by setting the camera's white balance to the existing lighting conditions, we are telling the camera that the whites in a scene should look white. If the whites look white, then theoretically, all the other colors in a scene should be reproduced faithfully. We'll get back to "theoretically" later on in this lesson when we take a look at the "sheriff" I photographed in Nevada City, Montana.

When Auto White Balance Is a Good Choice
When shooting under mixed light sources, I recommend setting the white balance to Auto. I used the Auto white balance setting to photograph a

model of the 1903 "Wright Flyer" at the National Air & Space Museum in Washington, D.C. If we are not pleased with the color in a picture, we can correct it later in the digital darkroom. ⇒

Choose a Specific White Balance

In situations when there is only one main light source, set the white balance to the existing lighting condition: Fluorescent, Tungsten, and Flash are the most common settings.

⇓ With my camera's white balance set to Tungsten, I photographed a replica of the façade of a building in Venice at the Venetian Hotel in Las Vegas, Nevada. Thanks to skillful lighting by the designers of the hotel, the indoor scene simulates the look of an outdoor square.

Choose the Lowest Practical ISO

We need to start at the lowest ISO settings to see which ISO setting will give us a shutter speed fast enough to hand-hold our camera without getting camera shake.

As we increase the ISO setting on our digital camera, we increase the amount of noise in our digital pictures. Low-end digital cameras have more noise at high ISO settings than mid-range and professional digital SLRs. We can remove some of the digital noise with Photoshop Plug-ins like nik Dfine, and with the Noise Reduction feature in Photoshop Elements 3.0 we can remove some of the digital noise. However, it is best to start with the cleanest possible picture.

When hand-holding a camera, avoid

a shutter speed slower than the effective focal length of the lens. For example, we shouldn't use a shutter speed slower than 1/100 of a second when using a 100mm lens. If your digital image sensor has a multiplication factor, you need to take that into consideration. For example, a 100mm lens on a digital SLR with a 1.6x magnification factor "becomes" a 160mm lens. Therefore, with this camera/lens set-up, we need to use a shutter speed of at least 1/160 of a second for a steady hand-held shot.

From experience, I've found that my lowest ISO setting for hand-held indoor pictures is usually 200 to 400. This natural-light shot of my son, Marco, eating an ice cream cone, was taken at ISO 400. At that relatively high ISO setting, we don't see or notice the digital noise. Digital noise is most visible in the shadow areas of a picture, and there are almost no shadows in the scene.

Naturally, in very low light conditions, a tripod is a big help in steadying our cameras. Here, too, we need to select a low ISO for the least possible noise in the digital file.

IS and VR Lenses to the Rescue

We can bend the shutter speed/hand-held rule with the aid of an image stabilization lens by Canon or a vibration reduction lens by Nikon. Through a series of motors and sensors, the lens is steadied. This reduces camera shake, which, of course, can cause blurry pictures. With an IS or a VR lens, most photographers can shoot at two to four times below the recommended shutter speed for a particular aperture setting. This is extremely helpful in indoor photography.

⇒ I photographed these emperor penguins indoors at the San Diego Zoo with my Canon 400mm IS lens set at

300mm. My ISO was set at 400. My shutter speed was 1/100 of a second.

Indoor Flash Photography

Sooner or later, we will need or choose to use a flash for our indoor pictures. If we take our time and make a few flash and camera adjustments, we can balance the light from the flash to the existing light for a more pleasing picture, one without harsh shadows. Basically, the technique is the daylight fill-in flash technique mentioned earlier in this book. As a review:

1) First, you'll need a flash unit with variable flash output control—that is, $+/-$ exposure control.
2) Turn off the flash.
3) In the Manual mode on your camera, set the exposure.
4) Turn on your flash and make an exposure with the flash set at -1-1/3. If your picture looks too much like a flash shot, reduce the flash output to -1-1/2. If it's still too "flashy," continue to reduce the flash until you are pleased with the result.

This techniques works because the flash will operate in the Automatic mode when the camera is in the Manual mode.

Indoor Fill-in Flash

⤢ Using the above technique, I was able to get a good exposure of this wax likeness of actress Salma Hayek portraying the famous Mexican painter Frida Kahlo at Madame Tussaud's Wax Museum in New York City.

Hiding the Background

When the background detracts from the subject, we don't want to light it up. When I photographed this Cirque du Soleil performer at The Bar at the Edge of the Earth on a Celebrity cruise ship, I wanted the background dark.

To darken background in low-light situations, set the ISO at 100, set the camera on the Program mode, activate the flash in the TTL (through the lens

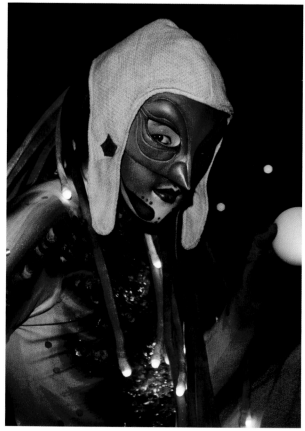

metering mode), and shoot. That's the technique I used for this photograph.

Why does the background go dark? Because when we turn on the flash, the camera usually sets the shutter speed at 1/60 of a second (or higher) and sets a medium f-stop. This shutter speed and f-stop combination is for the "correct" exposure of the subject, but one that is too low to exposure the background correctly.

If the background in your shot is still too light, it's easy to darken. Put your camera on Manual and meter the scene as if you wanted a correct exposure—that is, so you can see the detail in the background. Now, either increase the shutter speed by two stops or select a smaller aperture, again by two stops. If you took a natural-light picture at this point, the background would be very dark. Now turn on your flash, set it in the TTL mode, and shoot.

Harsh Shadows Are Usually Unflattering

↗ This picture of the "sheriff" of Nevada City, Montana, illustrates what happens when the light from the flash is not balanced to the available light and when we simply shoot on the Program mode. This picture was taken with the camera held in the vertical position with the built-in flash to my left. Holding the camera in that position in those lighting conditions created the unflattering and unnatural shadow on the subject's left (our right). Read on to learn how to correct this situation.

Avoid Harsh Shadows
⇒ Here we can see what happens when the flash is balanced more evenly to the available light. The shadow is less noticeable.

Note the Position of the Flash

⇑ In the previous example, we see the shadow on the wall in front of the man's face. In this example, I flipped the camera so the flash was positioned to my right. That changed the position of the shadow; it now falls to the subject's right (our left). Having the shadow behind the subject's head is more flattering that having it in front of his or her face.

A More Natural Approach

↗ Here is a much more pleasing picture of the "sheriff." It was taken using available light only. Let's see how we can have some fun with this image in the digital darkroom.

Digital Darkroom Enhancements

⇒ In the digital darkroom, we can use several techniques to create perhaps more original and artistic images from our originals. Here, using Adobe Photoshop CS, I turned my color picture into a sepia-toned image, and added some digital noise. Then I added a digital frame in the Photoshop Plug-in Extensis PhotoFrame.

Natural Light vs. Flash Pictures

On site, we may not know which type of picture we'll prefer when we get home, a flash picture with lots of detail or a natural-light picture with a softer look. Personally, I'll go with natural light whenever possible. In this situation, the natural-light picture of the wax likeness of country music artist LeAnn Rimes is softer. The flash shot looks harsh and has unflattering strong shadows.

Here is another example of a flash vs. a natural-light picture. The scene is a church in San Miguel de Allende, Mexico. I think you'll agree that the softer picture, taken with only available light, is more pleasing than that harsh flash shot.

More Creative Digital Darkroom Effects

I could not resist sharing this cool effect with you. The beams of the "spotlights" in this photograph were created in the digital darkroom using Mystical Lighting Effects, a Photoshop Plug-in from AutoFX Software (www.autofx.com). The effect is called, most appropriately, Spotlight, and is just one of many effects found in the Plug-in. For more on Plug-ins, see my book *Rick Sammon's Complete Guide to Digital Photography*.

Shooting through Glass

Have you ever tried to shoot through glass? If you have, you know it's a challenge.

First, the light level is often reduced even further, as was the case when I was photographing the leafy scorpionfish and jellyfish at the Monterey Aquarium in Monterey, California, and this mummy at the Mummy Museum in Guanajuato, Mexico. Very low light levels require us to boost the ISO even more than usual. For these shots I set my ISO at 1000.

Second, we need to reduce the reflection off the glass as much as possible. We could use a flash and shoot at a 45-degree angle to the flat glass panel. That will most likely eliminate the glare from the flash, but we still may see some reflections from other light sources.

Our best bet for natural-light photography is to cup our hand around the lens and hold our hand on or close to the glass. That technique will block out surrounding reflections.

When it comes to white balance in these situations, Auto white balance is a good choice, due to the possibility of mixed lighting conditions.

In choosing a lens, try a wide-angle lens and small f-stop for good depth of field.

In very low light conditions, an auto focus camera may not operate properly. In those situations, switch your camera to manual focus.

Undoubtedly, you will run into challenges in your indoor photography, but the resulting pictures can be worth the care and effort needed to take them.

Shooting Stage Shows

Photographing stage shows when we travel presents its own set of special challenges. The light level is usually very low, forcing us to use very high ISO settings, sometimes as high as ISO 1600. Even when we are using high ISO settings, we still need to shoot at slow shutter speeds, sometimes as slow as 1/60 of a second. We can't always get close to the performers, so we need to use telephoto lenses or telephoto zoom lenses. Finally, even if we were allowed to use a flash, we probably would choose to use the available light, because the flash would destroy the mood of the scene.

As you read earlier in this lesson and in "Jumpstart #2: Compact vs. SLR Cameras," digital SLR cameras will give us the best possible results (pictures with minimal noise).

⇑ I took this available-light picture of a Cirque du Soleil performer aboard the Celebrity cruise ship *Constellation* with my digital SLR set at ISO 1600. Had I used a compact digital camera, the noise at even an ISO setting of 400 in the low-light conditions (where noise is more visible) would have been quite noticeable. For a steady shot in the low-light/low-shutter-speed conditions, I used my Canon 70-200mm IS lens.

Close-ups

Nature offers us fascinating beauty if we look closely. Close-up photographs allow us to capture a unique view of our world, especially when that world is printed larger than life. Capturing small subjects requires careful attention to the technical aspects of photography: focus, lighting, sharpness, depth of field, exposure, and composition.

Bumble bee on morning glory

For newcomers to the fascinating, fun, and rewarding aspects of close-up photography, this lesson covers a few of the basics.

We'll begin by taking a look at some pictures that were taken with my Canon EOS 1Ds; my Canon macro lenses; and my Canon ringlight. We'll conclude with two examples that illustrate how we can use wide-angle lenses and natural light for close-up photography, too.

⇒ This picture of the larva (caterpillar) of a faithful beauty moth was taken with a Canon MP-E 65mm macro lens, which offers tremendous magnification, much like a bellows system for SLR cameras. It's a specially designed, manual focus lens that actually lets us fill the frame with subjects as small as a grain of rice.

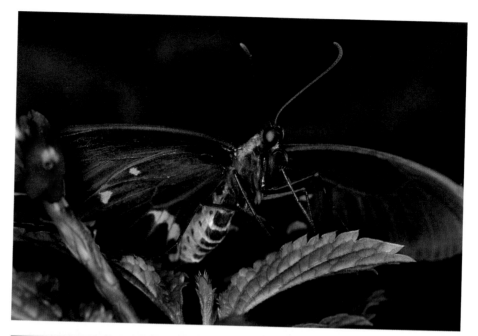

Focus Carefully

In close-up photography, as with telephoto photography, focus is critical. We need to focus on the most important element in a scene, such as the eye of an insect or small animal. It's also important to shoot at a small aperture (f/11 or f/22) for good depth of field. I set my 50mm macro lens at f/22 for these photographs.

Use a Low ISO

With digital cameras, as the ISO increases, so does the digital noise. I always try to shoot at the lowest possible ISO setting. My ringlight allows me to shoot at ISO 100. That gives me a picture with no noticeable digital noise.

Know the Subject

In other sections of this book I talk about how knowing something about your subject makes the photographic process much more enjoyable. Here is an example of what I'm talking about. Take a look at the left wing of the atlas moth on the left. Do you see anything that may deter a bird from swooping down

and eating this moth? Look closely. The moth's outer wing looks like a snake, which frightens birds. During evolution, this moth has developed this coloring and pattern to help it out of the mouth of a hungry bird. I learned that from my friend and butterfly expert Alan Chin-Lee. You might be able to see the snakes more clearly in the previous picture.

Set the White Balance and Image Quality Setting

When using a ringlight, set the white balance to Flash. When the light is mixed (daylight and flash), set the white balance to Auto.

For the very best result, set the image quality to RAW (or at least Fine or High JPEG). The RAW setting may give you a little more exposure latitude (be more forgiving) than the Fine or High JPEG setting.

Add Water Droplets

Flowers look especially beautiful when covered with tiny water droplets. To create that effect, use a plant mister, available at garden centers.

Take a Lot of Pictures

Due to all the variables involved in
close-up photography, taking several
pictures, while varying our composition,
lighting, and exposure, will increase our
chance of getting the picture we want.

Vary Your Angle

We need to be aware of how different angles and different shooting distances can greatly affect a picture. In close-up photography, moving just a few inches, or a fraction of an inch, for that matter, can provide a completely different view of the same subject.

Go Wide

Wide-angle close-up photography has an advantage over macro lens close-up photography: much more depth of field.

Wide-angle lenses usually focus closer than zoom lenses with wide-angle settings. With both types of lenses, it's important to set a small aperture, focus carefully, and consider the applicable aforementioned tips (ringlights can't be used for close-up wide-angle photography, unless you want a very bright area in the center of the frame).

I photographed these colored roses and butterflies in Mexico with my Canon EOS 1Ds and 16-35mm zoom lens. Both pictures were taken with my lens set at about 24mm.

Be Creative

Earlier in this lessons I mentioned that it's important to use a small f-stop for good depth of field. Usually, that's true. However, there are times when we want very shallow depth of field, such as when we want only a small part of the scene in focus and the main part of the scene out of focus.

This pair of pictures illustrates good depth of field (small f-stop) and very shallow depth of field (wide f-stop). For both photographs, I focused on the inside of the foreground flower.

The picture that is mostly out of focus was a mistake. But I like the way the softness seems to make the flower grow.

This picture reminds me of a famous photography adage: One out-of-focus picture is a mistake. A series of out-of-focus pictures is a style.

Have fun exploring your own close-up world, and creating your own style.

Underwater

There's a whole new, beautiful world beneath the water's surface, just waiting to be photographed.

To scuba dive, you need to be certified, which requires special training from a certified instructor. You'll also need scuba gear: self-contained underwater breathing apparatus. To snorkel, all you need is a mask, fins, and perhaps a snorkel vest to help keep you afloat.

To take underwater digital pictures, you need an underwater housing for your digital camera. Underwater housings are available for both point-and-shoot and digital SLRs. As with topside photography, SLR gives you the most versatility because of the range of lenses available for it.

Some seaside resorts rent complete digital underwater set-ups, usually including a camera, housing, and a flash—and a quick course on how to use the system. If you are serious about underwater photography, you will probably want your own gear.

In this lesson, we'll take a quick look at some basic underwater photography techniques.

Seahorse, Bonaire, Netherlands Antilles

Dive Shallow

We don't have to dive down to 100 feet to get dramatic underwater pictures. We can get great shots while snorkeling and while diving in shallow water. Near the surface, the sunlight is more intense, and therefore the colors are more intense. As we dive deeper, the camera records less color because the water absorbs sunlight. At 80 feet, a red soft coral looks almost black in natural light.

I took this picture of a whale shark while snorkeling in the Maldives. My 15mm lens let me get within a few feet. This fish is about the size of a school bus. It is harmless to humans but deadly to plankton (small animal and plant organisms).

Wide-Angle Photography

To capture underwater seascapes and pictures of our fellow scuba divers, we need a wide-angle lens. A wide-angle lens is necessary for sharp pictures, because

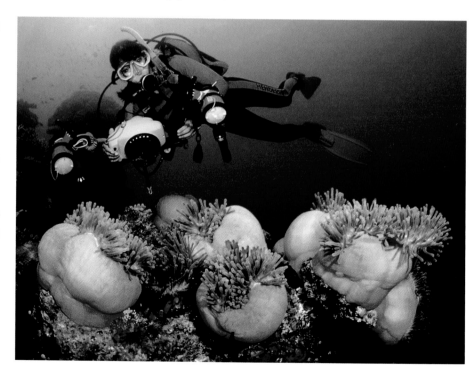

seawater is about 800 times denser than air and contains plankton and other floating particles that tend to soften images. Usually, we want to shoot with the widest lens we have or can rent, because the closer we are to our subject, the sharper the picture. I used a 16mm lens and two flash units for this picture of my friend Stella Covre scuba diving in the Maldives.

⇒ I also used a 16mm lens and two flash units for this picture of a school of blue-striped grunts in the Maldives.

Underwater Flash Photography

⇐ For the most colorful underwater pictures, we need a flash. If we use two flashes we'll get more even lighting over a wider scene than if we use only one flash. Two flashes are useful for both wide-angle and close-up photography. Here, my wife, Susan, holds a film camera with two flashes in Bonaire, Netherlands Antilles.

Underwater Fill-in Flash Photography

⇒ For a natural-looking underwater flash picture, we can try taking a fill-in flash photograph, one in which the light from the flash is balanced to the light underwater. This technique is described in "Lesson #1: People."

I used the daylight fill-in technique for this picture of Susan using an underwater fish identification guide in Bonaire. Two flashes were also used for even illumination.

Close-up Photography

Want dramatic underwater pictures that pop with color and detail? Then shoot close-ups.

For best close-up results, we need to use a macro lens and two flashes (for pictures with few or no shadows). That's the gear I used for this picture of a spotted moray eel in Bonaire, Netherlands Antilles, and of this green moray eel in the Galápagos Islands.

Night Diving

At night, when diurnal fish are asleep or less active on the reef, nocturnal critters like this cuttlefish are out and about.

Know Your Reef Creatures

As I mention in "Lesson #1: People" and elsewhere, learning about a subject makes photography much more enjoyable. When we are snorkeling and scuba diving, knowing what we are looking at makes the dive much more fun and interesting. This fish is called a decoy scorpion fish. The fish usually hides most of its body under the sand, leaving its dorsal fin exposed—to attract hungry fish. If the hungry, unsuspecting fish is just the right size, the deco scorpionfish darts out of the sand and gulps its down.

Knowing what you are looking at can also make a fish less intimidating. For example, the spotted moray eel pictured on the previous page may seem menacing and dangerous, but it is actually harmless (unless you stick your finger in its mouth). The eel opens its jaws wide so it can breathe. Unlike fish, which have gills on the outside of their bodies, eels have their gill in their throat.

Paul Humann and Ned DeLoach offer one of the best field guide series available on underwater creatures. See www.fishid.com.

One final word of advice when snorkeling and scuba diving: Think safety first, and always dive with a buddy.

Enjoy the underwater wonders, and please keep in mind the conservation-minded diver's creed: Take only pictures, leave only bubbles.

Gear for Travelers

We certainly need the right camera to record our memories. What's more, we often need accessories to protect our gear and to make our shooting experience more comfortable.

In this lesson, I've asked *Outdoor Photographer* magazine's Dikla Kadosh to compile a list of gear you check to be sure you have before you go on a trip.

Before Dikla gets going, here's the #1 accessory I recommend to travelers.

Small Plastic Bag

A small plastic trash bag is the most affordable accessory listed here, but it can save the day in the rain, sleet, and snow. It can make the difference between a photograph and no photograph. Sure, store-bought camera protectors are available, and some are listed below. But if you keep a plastic bag tucked in your camera bag, you will never miss a shot during a sudden downpour.

I recommend using small bags to avoid too much bulk around your camera. Before you go in the field, cut a small opening for the viewfinder in the bottom of the bag.

It was raining when I arrived at the Barbados Wildlife Reserve. Fortunately, I had my trusty plastic bag to protect my camera and lens while I walked through the lush reserve in search of a green monkey to photograph. All of the other picture-takers had to manage holding an umbrella while they were trying to take a picture.

If you look closely, you can see some raindrops on the monkey's face.

Okay Dikla, take it away.

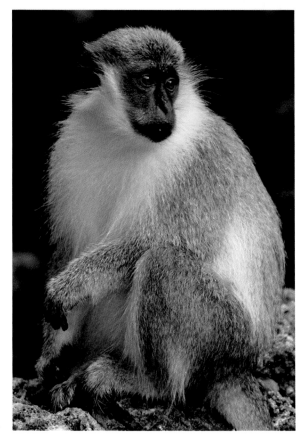

Green monkey, Barbados Wildlife Reserve

Let's begin with gear that helps us carry our cameras and accessories.

Tote Your Gear in All Weather

For the traveling photographer, the Stealth Reporter AW 500 shoulder bag from Lowepro allows you to access your gear, which can be organized however you like it with the removable, adjustable dividers. An all-weather cover and hood wrap entirely around the bag for ultimate protection against the elements. The bag also includes a foam-padded shoulder strap and waist belt slots to distribute the weight evenly. Contact: Lowepro, (800) 800-LOWE; www.lowepro.com.

Enter the Dry Zone

The Lowepro DryZone 200 backpack has a water-resistant exterior and a 100 percent watertight inner dry pouch, so even if you drop the bag into a running river, your gear is fully protected. Other great features of this rugged backpack include a well-padded interior that can be customized to fit your equipment, adjustable shoulder straps, a tuck-away tripod holder, self-draining mesh pockets, and attachment loops for accessories.

Have a Drink While Shooting

When you're walking or hiking, camera in hand, it can be inconvenient to stop and reach for your water bottle. With the L.L.Bean Aquifer Hydration Pack, you can keep moving and stay hydrated by drinking water through a tube attached to the built-in bladder. In addition, the roomy backpack, in which you can fit a small SLR system, has no-chafe shoulder straps and a well-padded back panel so you'll be comfortable carrying it all day long. Contact: L.L.Bean, (800) 809-7057; www.llbean.com.

Keepin' Dry

Photographing outdoors means you're going to run into all kinds of weather, including wind, rain, and snow. Kata's GDC Elements Cover 702 protects your camera so you can keep shooting under any conditions. The transparent cover can be adjusted to fit any pro digital SLR using the pull cords, and the hood accommodates a variety of lens diameters. The sleeves on either end are spacious, allowing you to access your camera's controls easily. Contact: Kata (Bogen Imaging), (201) 818-9500; www.bogenimaging.us.

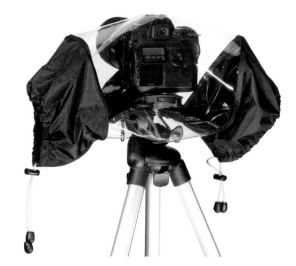

Protection in Rain, Sleet and Snow—and Even Underwater

Ewa-Marine flexible camera housings are designed for photographing underwater but can also be used to protect your camera from rain, ocean spray, humidity, and sand. The housings are made of thick PVC and come in several variations to fit nearly all types of digital compact and SLR cameras. Secure and durable, they adjust to the water pressure and allow you to take your camera to depths of 150 feet. Contact: Ewa-Marine (RTS Photo), (631) 242-6801; www.rtsphoto.com.

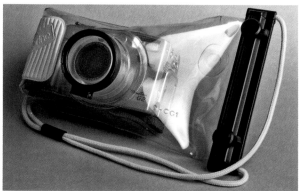

Take a Dive

The underwater systems offered by Ikelite are heavy-duty, thick wall housings that are molded from clear polycarbonate material. You can choose from the many different models to fit your specific camera. The compact systems, safe to use at maximum depths of 200 feet, give you full access to the camera's controls, sealing them with reliable Quad-Ring seal glands. A magnifier offers improved viewing while wearing a diving mask. Contact: Ikelite, (317) 923-4523; www.ikelite.com.

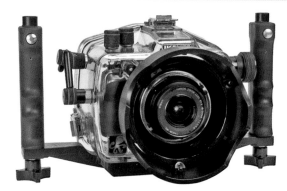

Rainy-Day Shield

Shield your camera and lenses from the rain with Aquatech's SS-Zoom rain cover. The waterproof, breathable fabric fits snugly around the camera body and lens, providing a watertight seal around the front and a protective sleeve on the side to operate the

camera's controls safely. A small flap covers the viewfinder when you're not using it. Contact: Aquatech (Roberts Imaging), (800) 726-5544; www.robertsimaging.com.

Steady and You Shoot

Gitzo's Mountaineer Sport Tripod, Model G1128, is a practical tripod for photographers who travel. Weighing only two and a half pounds, the tripod is compact and easy to carry, but still sturdy and capable of supporting up to 11 pounds of equipment. The light carbon fiber tubes are strong, resistant to bending, and very sturdy, even in extreme temperatures. For additional stability in windy weather, you can hang weights from the stainless steel hook at the base of the center column. Shown on the tripod is a Gitzo quick-release ball head that allows the camera to move in any direction for fast, easy composition. The quick-release bracket lets you mount and release a camera with a flip of a lever. The ball head provides fast and easy horizontal or vertical positioning of a camera. Notice the red camera strap on the tripod? That's Rick's personal invention. By attaching a camera strap to his tripod, he can tote it in the field and on city streets and still have two free hands for taking pictures. Contact: Gitzo (Bogen Imaging), (201) 818-9500; www.bogenimaging.us.

Easy Rotation for Telephoto Lenses

Working with large telephoto lenses can be quite a challenge, which is why a gimbal-type tripod head like the Wimberley Head is so beneficial. The specialized head lets you rotate heavy lenses around its center of gravity, rendering them practically weightless. Ideal for lenses that are 300mm or longer, the Wimberley Head can be adjusted to fit almost any telephoto lens with a rotation collar. Contact: Wimberley, (888) 665-2746; www.tripodhead.com.

Preserve Your Memories

Tiny memory cards are easy to misplace, especially when you're traveling and you have to keep track of all your gear. Storing them in Gepe's crushproof, floatable Card Safe Extreme case keeps the cards in one place and also protects them from shock, water, dirt, and electrostatic discharge. The card's vault's four transparent windows let you see which cards you have inside without opening it. Contact: HP Marketing Corp., (800) 735-4373; www.hpmarketingcorp.com.

Go to Extremes

Speaking of memory cards, when you are shooting in extremely cold and extremely hot conditions, you need a memory card that operates in extreme conditions. SanDisk offers Extreme memory cards, which have a working range of −13° F to 185° F. Contact: SanDisk, (408) 542-0500; www.sandisk.com.

Keep It Clean

It's important for all photographers to keep their equipment clean, but it's particularly critical for those of us who shoot outdoors. The Giotto all-purpose camera cleaning kit can be used to remove dust, dirt, and fingerprints from your camera, lenses, filters, and many other accessories. Included in the kit are a multi-optical cleaning solution, a microfiber cloth, a soft goat-hair brush, and cotton swabs with pointed tips for those delicate, small parts. Contact: HP Marketing Corp.

Rocket-Powered Sensor Cleaner

Want to blast tiny specks of dust (which can look like big blobs in a picture) off your image sensor? Don't use compressed air, which can damage the sensor. Rather, use a powerful blower, like the Giotto Rocket Blower. Contact: HP Marketing Corp.

Remove Specks, Avoid Blobs

Photographic Solutions offers Sensor Swabs Eclipse liquid for cleaning your camera's image sensor. Eclipse dries quickly and doesn't leave any residue. Before using, read all the instructions very carefully. If you damage the filter, the cost of repair may be more than the cost of a new camera. Contact: Photographic Solutions, (508) 759-2322; www.photographicsolutions.com.

Warm and Cozy Gloves

To keep your hands warm yet fully flexible so you can keep shooting on the coldest of days, consider wearing gloves such as Columbia's Skagway Gloves. The leather palm allows you to maintain a firm grip on your camera, while the fleece-lined interior ensures your fingers won't freeze up. For both men and women, the gloves come in four attractive colors. Contact: Columbia Sportswear, (800) 547-8066; www.columbia.com.

Really Serious Gear

For the extremely serious wildlife photographer, camouflage gear may help you get closer to wildlife, or vice versa. Different camo gear, as hunters call it, is available for different environments. That's me in the picture, and can tell you it helped me get very close to some wild turkeys. For the gear shown here, contact: Arkansas Duck Hunter, (800) 866-501-DUCKS; www.arkansasduckhunter.com. (Photo by Chuck Westfall.)

Comfort in the Field

Danner's Radical 452 GTX hiking boot is great for walking or hiking on rugged terrain. Made with waterproof, breathable Gore-Tex fabric, the durable boot not only prevents your feet from getting wet, it allows the perspiration from your skin to evaporate so that your feet don't get clammy and develop painful blisters. The high construction supports your ankle, while the lightweight materials keep you nimble. Contact: Danner, (800) 345-0430; www.danner.com.

Shine Some Light on the Situation

Ideal for use at dark, remote campsites, the 5-watt Luxeon Star Aluminum Hand Torch flashlight puts out up to 120 lumens and can last three full hours on a set of two 3V lithium batteries. The LED bulb can be used for an estimated 10,000 hours before you'll have to replace it. Constructed of water-resistant, high-strength aluminum alloy, the rugged flashlight still only weighs 8.8 ounces. Contact: Essential Gear, (800) 582-3861; www.essentialgear.com.

Power Up

To power up your camera, laptop computer, or other electronic devices in the field, you can use the Xtreme Power XP20 portable battery pack. The pack is capable of running two devices simultaneously and recharges in just four hours. It weighs only 1.3 pounds and measure 4.3x8x1.2 inches, making it easy to fit in your camera bag. Contact: Xtreme Power (MAC Group), (914) 347-3300; www.xtremepowerusa.com.

Be a Survivor

Photographers who spend time hiking and camping outdoors should always carry an emergency kit, such as the Adventure Medical Kits Pocket Survival Pak. The kit includes life-saving essentials such as a whistle to call for help, a highly reflective mirror to signal rescuers, a compass, a waterproof fire-starter, and other helpful tools. Waterproof survival instructions provide practical information on building shelter, starting a fire, and obtaining food that could definitely come in handy. Contact: Adventure Medical Kits, (800) 324-3517; www.adventuremedicalkits.com.

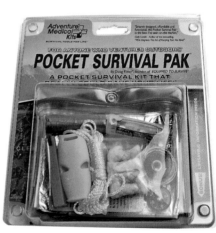

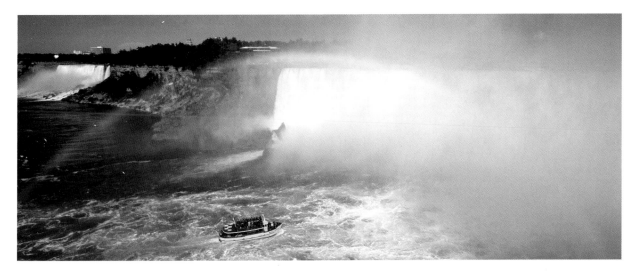

Expect the Unexpected

When we travel to take photographs, we need to be prepared not only for poor weather conditions but for challenging situations as well. Both of these pictures of Niagara Falls were taken on a beautiful, sunny day. However, the mist from the falls required serious camera protection, especially when I was shooting from the *Maid of the Mist*, a boat that takes visitors *very* close to the falls! Because I had packed a plastic camera bag, I was able to protect my camera and get the shots.

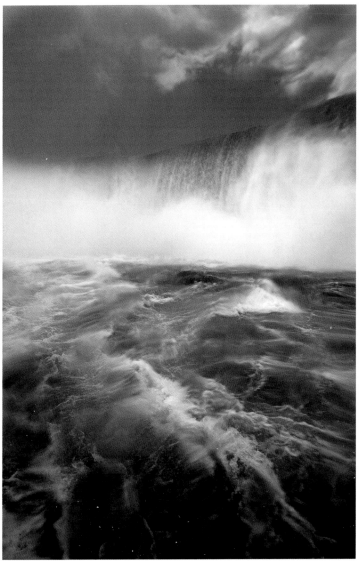

PART III

Postcards from My Favorite Places

Or, Where to Go for Good Pictures

By now, you are well on your way to becoming a wonderful nature and travel photographer. As a way of saying "bon voyage," I'll share some of my favorite images from some of my favorite places. I've included a quick tip for each location. We'll start with pictures that I've taken throughout North America. Then we'll visit other parts of the world.

In North America

Albuquerque, New Mexico

The International Balloon Fiesta in October draws photographers from all over the world. Get up before sunrise for the Dawn Patrol. You'll need a wide-angle lens for shots of the balloons on the ground (and for shooting inside the balloons), and a telephoto lens for airborne shots. Make your hotel reservations a year in advance. This balloon festival is one of the most popular in the world.

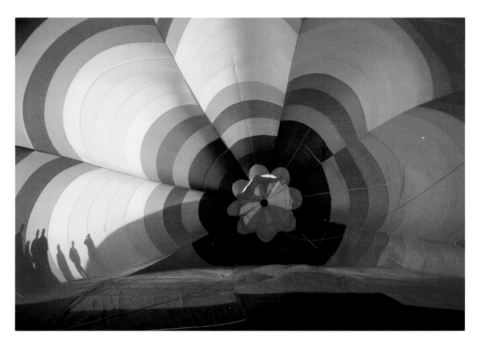

Arches National Park, Utah

Among all our national parks, Arches offers some of the most magnificent views and photographic opportunities, most of which are just a short walk from the road that winds through the park. The arches are beautiful, natural windows that frame the surrounding scenery and sky. Some can take your breath

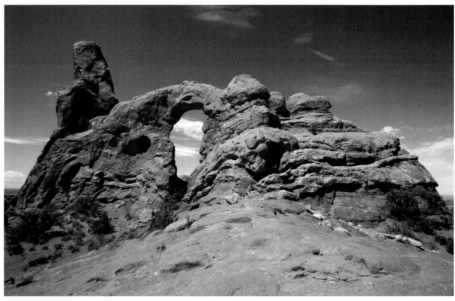

away, especially during sunrise and sunset. Read the newspaper-type flyer you get when you enter the park. It offers tips on the best times of day to photograph the different arches. Hiking boots are a must. So is plenty of drinking water. As for lenses, wide-angle is the way to go—the wider the better, if you plan to get close to some of the arches. Don't forget your polarizing filter.

Big Cat Rescue, Tampa, Florida

Dozens of different big cats, from lions and tigers to bobcats and leopards, are housed in natural-looking habitats in this conservation facility. A medium telephoto lens (at least 100mm) is a must, but a 100-400mm zoom is the lens I recommend for greater versatility. Openings in the wire fences of the pens that surround the animals let you get unobstructed shots. With careful composition, you can make wires in the background disappear.

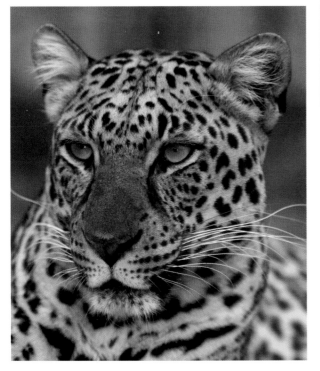

Bronx Botanical Gardens, New York

You'll find flowers galore in beautifully maintained indoor and outdoor gardens. It's a great place to practice your close-up photography year-round. For best results, use a macro lens and ringlight. Tripods are not allowed. If you don't bring a flash, be prepared to shoot at a high ISO setting for good depth of field when photographing flowers at close range.

Bryce Canyon National Park, Utah

Bryce is not actually a canyon but a natural amphitheater filled with hundreds of hoodoos (natural rock formations carved by the wind and weather). Photograph the big view, but also shoot some of the more interesting and dramatic hoodoos with a telephoto lens. Shoot the sunrise at Sunrise Point and the sunset at Sunset Point. For a very good panoramic photograph, shoot from Bryce Point.

Butterfly World, Coconut Creek, Florida

Go early in the day to see the greatest number of butterflies in flight. Here, macro lenses and ringlights rule, but tripods are against the rules. Learning the names of the dozens of different species beforehand will make your encounter truly enjoyable.

Dead Horse Point State Park, Utah

I've seen many stunning natural formations. Dead Horse Point State Park is at the very, very top of the list. The view from the official lookout point at sunrise and sunset is much more dramatic than a view of the Grand Canyon, and the crowds are a lot smaller. The best times for shooting are about an hour after sunrise and an hour before sunset. That's when the sun is high enough in the sky to illuminate most of the walls of the canyon. If you shoot at sunrise and sunset, much of the canyon will be hidden in shadows. Bring your widest-angle lens to capture the sweeping panoramic view.

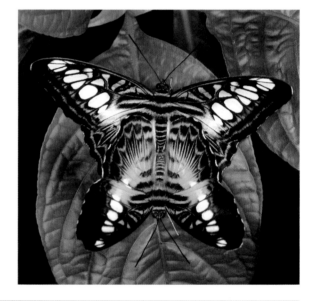

Devil's Garden, Escalante National Monument, Utah

Unique stone structures in this peaceful place were carved by the wind over the eons. For the best light, go early in the day or late in the afternoon. A four-wheel drive will help you navigate the rough, unpaved road that leads to the area. Stop at the Visitors' Center for a map and ask about the most picturesque photo locations.

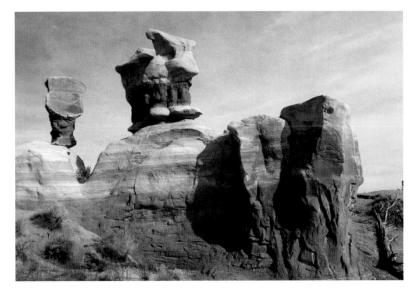

Double JJ Ranch, Rothbury, Michigan

You'll feel as though you are in the Old West when visiting this well-run ranch. Cowboys and cowgirls participate in roundups and stagecoach rides. Trail rides are available through forests and around lakes. Bring a telephoto lens to photograph the cowpokes and horses, and a wide-angle lens to photograph the scenery. Don't forget your cowboy boots!

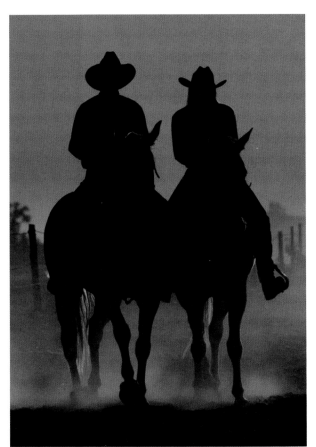

Fort Worth Zoo, Texas

This world-class and recently remodeled zoo is home to dozens of animals in natural-looking habitats. Don't miss the special exhibit on Texas animals. A telephoto zoom will help you get good headshots. Be prepared for plenty of walking.

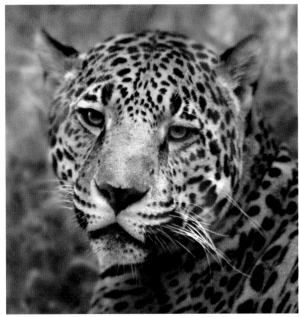

Fossil Rim Wildlife Center, Texas

If you can't get to Africa, this wildlife center offers Africa-like photo opportunities. You can even camp out overnight. Take the guided tour first. Then, trace your path with your own car, stopping whenever you want to take a photograph. Fossil Rim is only about one and a half hours from Ft. Worth, so you can visit both the Fort Worth Zoo and Fossil Rim over a weekend.

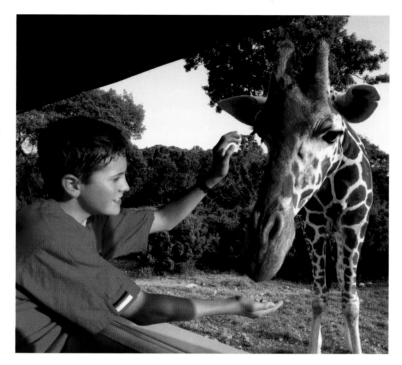

Grand Canyon National Park, Arizona

For a unique photo adventure, take the mule ride down into the Canyon. Riders can't wear backpacks or shoulder packs, so you'll need to strap your camera securely around your neck. I recommend a wide-angle zoom lens, as well as rain gear and a plastic bag to keep your camera dry in the event of a rainstorm. Good thing I had both!

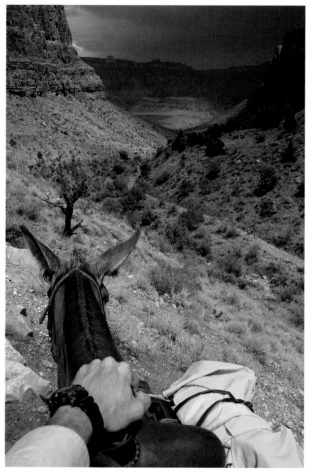

Guanajuato, Mexico

This colonial city in Central Mexico offers lots of action and photo opportunities, especially in the main square after the sun sets. In the low-light conditions, you'll need a flash to brighten the faces of your subjects, who come from around the country to perform.

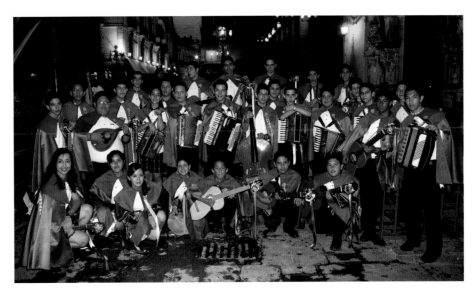

Homosassa Springs Wildlife State Park, Florida

The snorkeling adventure with the West Indian manatees draws visitors to this state park. But the park, 75 miles north of Tampa, Florida, offers much more, especially for photographers. It's a showcase for flamingos, egrets, pelicans, and bald eagles in natural habitats. Black bears, bobcats, alligators, and the smaller saltwater crocodiles are on display, too.

Horseshoe Bend, Arizona

Bring a very wide-angle lens, a polarizing filter, and a gradual filter to capture this unique natural formation of rock and water. Go early in the morning before other photographers get there. Be careful! Don't lean too far over the edge. Horseshoe Bend is only a few minutes from the Page, Arizona, airport, which is only about two and a half hours from Monument Valley. A great long weekend photo shoot.

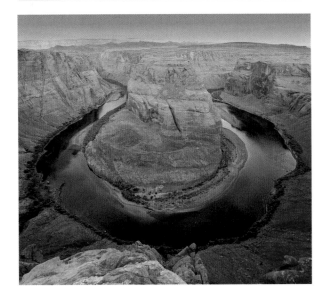

Hubbard Glacier, Alaska

You'll need to book passage on a cruise ship to see the magnificent glacier, the longest river of ice in North America and the most active glacier in Alaska. The cruise ships come to within about 300 yards of the face of the glacier, so you don't necessarily

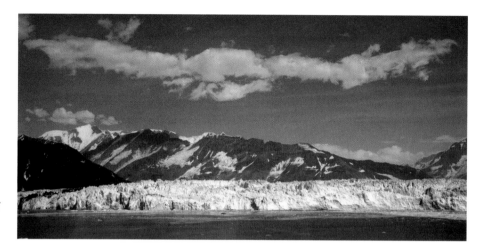

need a telephoto lens, although it is useful for pictures of isolated ice formations. Use a polarizing filter to reduce glare on the water and to darken the sky.

Las Vegas, Nevada

Vegas is not my top choice of destinations, but I make the most of my time there attending photo conventions by photographing the themed hotels. These two pictures were taken from the

balcony at the Venetian Hotel. For shots like this, use a wide-angle lens and a small aperture to get the entire scene in focus.

Montana

Sure, take pictures of the stunning scenery, but also try to line up a photo session with a Native American tribe through a guide and use the scenery as a stunning background. If you are near Kalispell, visit the Triple D Game Farm, where some of the animals in "Lesson #3: Captive Animals" were photographed.

Monument Valley, Arizona

To maximize your shooting time and opportunities, hire a guide with a four-wheel drive vehicle to show you the most picturesque photo spots. If rain is in the forecast, you may not be allowed to drive a non–four-wheel drive vehicle into the park. If you go in September or October, you'll probably encounter some rain. Pack a tripod for slow exposures at small f-stops in your late afternoon shots.

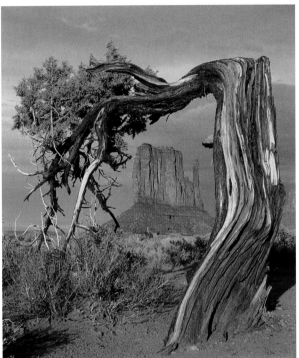

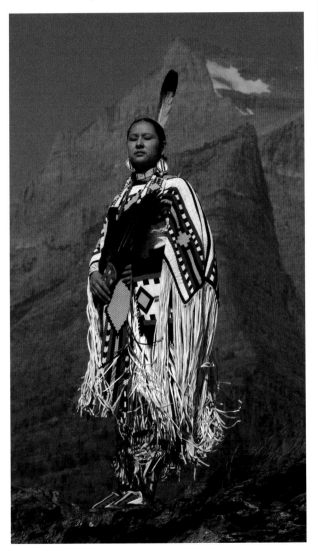

New York, New York

For a unique city perspective, take an early morning walk across the Brooklyn Bridge. Don't get bogged down with so much gear that you don't enjoy the walk. Shoot with a wide-angle zoom to capture the wide view. Use a polarizing filter to darken the sky and to cut down on reflections on water and glass.

Old Town, Cody, Wyoming

If you like classic Western movies, check out Old Town. Walking down the wooden sidewalks makes you feel as though you are in the Old West. Local character actors, some of whom have appeared in movies, dress up like Wyatt Earp, Jesse James, and Buffalo Bill Cody. When composing your pictures, include the background to add a sense of place.

Provincetown, Massachusetts

Magnificent sunsets and stunning beaches are the picture postcards from this seaside town. Sign up for a clambake on the beach if you want a peaceful and romantic evening. Shoot before and after you dine on sumptuous seafood. Pack your camera in a plastic bag inside your camera bag to keep out sand.

Queretaro, Mexico

After San Miguel de Allende, nearby Querataro is my favorite colonial Mexican city. You'll find many churches and old buildings to photograph, as well as interesting sculptures. I like the contrast of the new and old in this picture.

Red Rock Canyon, Utah

Don't miss this site if you visit Bryce. You'll find this small canyon near the entrance to Bryce Canyon. Park your car on a turnoff, get out, and hike around. You may come up with pictures just as stunning as those from Bryce Canyon.

Rockport, Maine

During the Maine Photographic Workshops, we often shoot along the beautiful coastline. Its lighthouses are favorite photographic subjects. Try underexposing the scene by 1/4 of stop for a more saturated image. And keep your eyes open for Maine roadside lobster stands.

San Diego Wildlife Park and Zoo, California

Visit the zoo first and then take a guided drive through the wildlife park in a safari vehicle. Telephoto lenses are a must. As the zoo is a center for conservation, many unique and endangered animals are showcased in the exhibits.

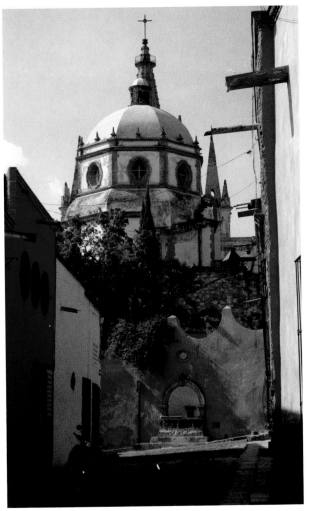

San Miguel de Allende, Mexico

Bring your most comfortable shoes and plan to walk the streets for hours, days, weeks, or years. Some travelers like the energy of this place so much that they never leave. If I could recommend only one lens it would be a 28-135mm zoom.

Sierre Chinqua, Michoacan, Mexico

If you like butterflies, book a trip to see the annual monarch migration in January in the mountainous area of Sierre Chinqua. Thanks to local conservation efforts, the area is now protected as a World Heritage Site.

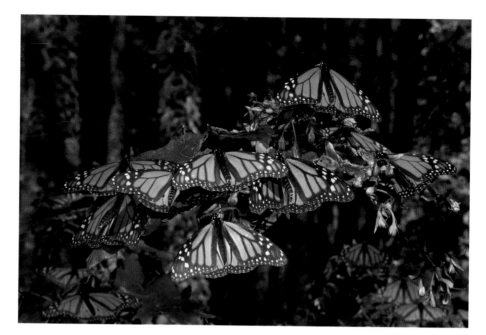

Slide Rock State Park, Arizona

Bring your wide-angle lens and polarizing filter to photograph the stunning rock formations. Also bring your bathing suit for a swim in the crystal-clear water. The picturesque town of Sedona is nearby. So is historic Route 66. Both offer additional photo opportunities.

Slot Canyons, Arizona

Pack a wide-angle lens and a tripod to photograph the stunning formations carved out of stone. Check the weather before you venture into the canyons, which are accessible only through the local Navajo, who consider the land sacred. Flash floods can be deadly.

South Beach, Miami Beach, Florida

Get up before dawn and photograph the art-deco buildings illuminated by the rising sun. After the sun sets, capture the neon-illuminated hotels. Capture the streaking taillights of passing cars in the foreground by mounting your camera on a tripod and using a slow shutter speed.

Stockyards, Ft. Worth, Texas

You'll find real-life cowboys here to shoot. Use the old Western backgrounds to add a sense of place to your pictures. Don't miss the daily cattle drive right through the middle of town. The cattle will be backlit, so in order to see their faces, you'll need to increase your exposure (perhaps by one stop) if you shoot on an automatic mode.

Taos, New Mexico

This tranquil city is a good base to use for photographing the magnificent New Mexico scenery, including the mountains, lakes, and small rivers on Georgia O'Keeffe's Ghost Ranch. In nearby Ranchos de Taos, don't miss the Spanish church of St. Francis that Ansel Adams made famous in his wonderful photographs. Wide-angle lenses are the name of the game here.

Triple D Game Farm, Kalispell, Montana

Book a session well in advance and bring some friends to get a group rate. A 100-400mm zoom will help you get great full-frame shots of the animals. Some of the animals are in the shade, so don't forget your flash. You may be more comfortable shooting in the summer, but winter offers photo opportunities of animals in the snow.

Wildlife Inc., Anna Maria Island, Florida

This private wildlife center specializes in birds. You'll be able to get up close and personal with several species of birds, including hawks, falcons, and owls, so you don't need a super telephoto lens. I was only two feet away from this hawk when I took this picture.

Yellowstone National Park, Montana

Old Faithful is fun to experience and photograph. To capture the beauty of the eruption, which takes place every 40 to 126 minutes, you'll need a clear day. Otherwise, the steam will be lost against the overcast sky. To avoid washed-out highlights in the steam, set your exposure compensation to −1/4 to start, and check your camera's LCD monitor to make sure you have the desired exposure.

Yucatán Peninsula, Mexico

Most people go to the Yucatán for the wild life, especially at the beaches and during spring break. However, you'll also find wonderful wildlife in this tropical paradise. Bring your telephoto lens when you go in the jungles. And don't forget insect repellent.

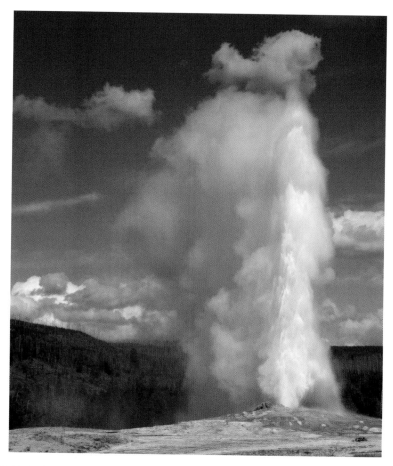

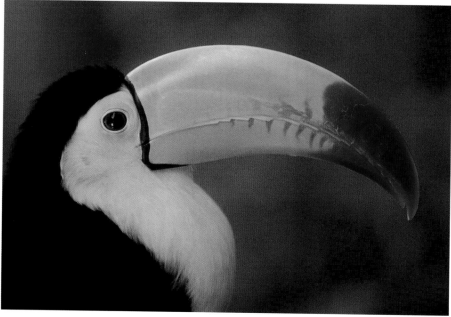

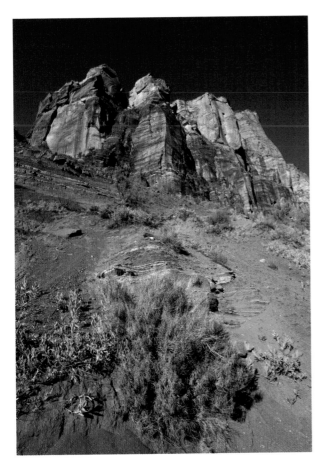

Zion National Park, Utah

You'll find majestic rock mountains reaching hundreds of feet into the sky. For the best photographs, simply drive through the park, stop at the turnoffs, get out of your car, and hike around. You can take the guided tours by bus into the park, but those trails are usually in the shadows and shade. Catch the sunrise and shoot all morning. Take a rest at midday, when the light is flat and cool, and then go back out in the afternoon and shoot through sunset.

Roadside America

The well-known destinations we visited on the preceding pages are indeed wonderful places to photograph. However, we don't have to go to such sites to make great photographs. We can find eye-catching photographs as we drive along the road—if we take our time to look.

Here are just a few of my many roadside America pictures, pictures that bring back good memories of my travel times.

About an hour from West Yellowstone, Montana, is the quaint town of Ennis. Many artists live here, and they display their work proudly. A wide-angle lens and small f-stop allowed me to get all the elements in the scene in focus. Drive down the road to Nevada City, an authentic Old Western town, and photograph the old buildings and character actors dressed in traditional Western wear. The "sheriff" in "Lesson #1: People" was photographed in Nevada City.

Art on a Jeep

While I was driving along Utah State Road 89, between Arches National Park and Bryce Canyon National Park, I spotted this abandoned farm. For an artistic photograph, I used my Canon 10D IR camera, which was converted to infrared-only by the IR guy. (To learn more about infrared-only cameras, see www.irdigital.net.)

Abandoned farm

As my family and I approached the South Rim of the Grand Canyon, Mother Nature called my son and I into the forest. The roadside wilderness was dense with dozens of trees. To create a sense of depth, I used a single tree as a foreground element. My 16-35mm zoom lens set at 16mm and f/11 allowed me to get everything in focus.

Birch trees

Classical gas

Along the road from Santa Fe, New Mexico, to Taos, New Mexico, I saw an old gas station named after the 1968 song "Classical Gas." After asking the owner if he was Mason Williams, the song's composer, and after he said no, I took some fun shots of the "props" that were around his establishment.

Marco at Dairy Queen

After leaving Las Vegas on our way to the Grand Canyon, my family and I stopped in Kingman, Arizona. I captured what at first may appear to be a grab shot of Marco. Actually, I took my time to compose the picture carefully. I also used a bit of daylight fill-in flash to light Marco's face.

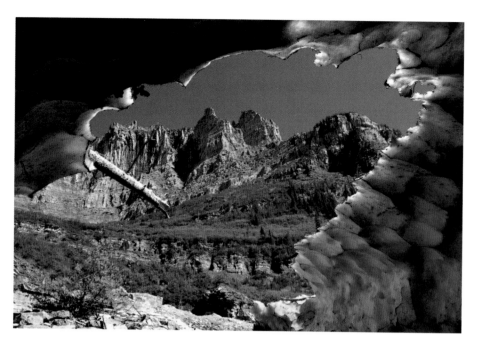

Ice cave

Recycled Art

I've taught photography workshops in Glacier National Park, Montana. One year, while driving through the park, our group spotted this ice cave. At first, everyone simply wanted to shoot the cave from the road. After they were finished, I encouraged some of the more intrepid shooters to venture into the cave. We all got basically the same shot with our wide-angle lenses. Our exposures and focus were set for the distant landscape.

If you are in Maine and plan to see the Pemaquid Light, you'll probably get there by driving from U.S. Route 1 to Maine State Route 32. One and a half miles south of Route 1 you'll find a wonderful place to take artistic pictures: Recycled Art and Wild Blueberries. Nate, the owner and artist, transforms everyday metal objects into works of art, which he gladly lets visitors photograph. To avoid harsh shadows and stark contrast, shoot on an overcast day or photograph Nate and his recycled art in the shade. Pick up some blueberries while you are there!

In Utah, where State Routes 89 and 9 meet, you'll see the Thunderbird Restaurant. If you drive from Bryce Canyon National Park to Zion National Park, you'll be on this road. It's worth stopping to grab a bite to eat, and, of course, to take a picture. In addition to the colorful adobe walls and neon sign, you'll probably see dozens of hummingbirds at the hummingbird feeders that hang from the building.

Thunderbird Restaurant

U.S. Highway 1, which runs along the coast of California, is famous for its spectacular scenery. I photographed this sunset near San Simeon, California, not far from another famous destination: Hearst Castle. For more dramatic color in a sunset photograph, reduce your exposure by −1.

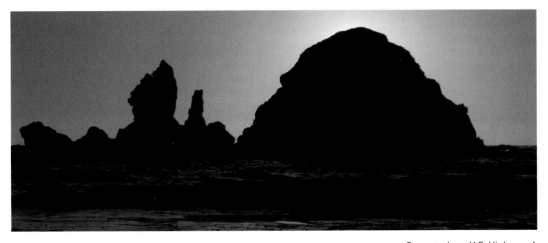

Sunset along U.S. Highway 1

Around the World

So far we've traveled throughout the United States. Now, let's go abroad for a look at some of the exotic locations I've visited and hope you get a chance to visit.

Antigua

The beaches—365, according to tour operators—and year-round warm weather draw visitors to Antigua. Some beaches are tourist hot spots. Others are more secluded. I found this beach while driving around the island with a local guide. I'd tell you exactly where it is, but then it might become a tourist hot spot. So if you go, get out and explore the island on your own.

Bahamas

Fun in the sun is what the Bahamas is all about. To avoid lens flare, use a lens hood to keep direct light off the front element of your lens. Heat can affect a digital camera's image sensor, causing the colors to be "off." Don't leave your camera in a hot car or in direct sunlight.

Bali, Indonesia

After shooting in the city, get out into the countryside. Visit the villages, where you'll find friendly people, such as these boys, often involved in a celebration. Pack light, so you can stay flexible. Before you leave your hotel, make sure your battery is fully charged and that you have enough space on your memory card.

Bangkok, Thailand

Bring your wide-angle lens to the Grand Palace in the heart of this bustling and crowded city. Get there early, before the crowds arrive. Wide-angle lenses will help you capture the grandeur of the palace.

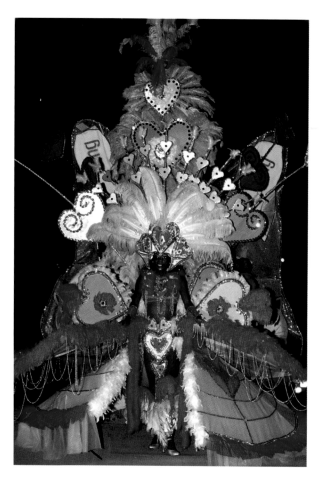

Barbados

If you like photographing high-energy festivals, you'll love the Crop Over festival, which draws dancers and performers from all over the Caribbean. Use a flash for daylight fill-in flash lighting.

Belize, Central America

The neo-tropical rainforest is a major draw of this tropical paradise, along with some of the best scuba diving in the Caribbean. If you definitely want to come back with animal pictures, spend some time at the Belize Zoo in Belize City, which is home to many species of rainforest animals in natural-looking settings. In the wild, many of the animals are difficult to find, yet alone photograph. I used a 70-200mm lens set at about 100mm to photograph this jaguar in a wire-fence-enclosed area.

Botswana

You'll find fewer tourists in Botswana than you'll find in Kenya and Tanzania, so the close encounters there are more personal. If you want to get very close to the animals, visit a private reserve, where you can drive off-road. You are not allowed to drive off-road in the national parks in Botswana, Kenya, and Tanzania. Weight restrictions on luggage are enforced, so pack wisely and check with your travel agent about this if you plan to fly from camp to camp.

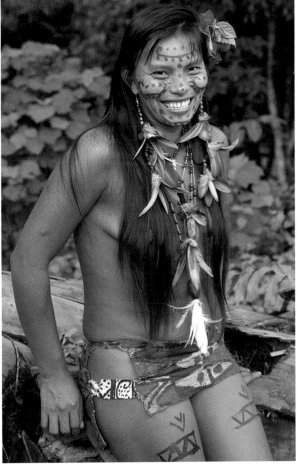

Brazil

Hire a good guide who can take you to some of the villages in the Amazon rainforest. For natural-looking pictures, try not to use a flash. Use a camera bag with a waterproof protector (built-in raincoat) to keep your bag and gear dry. Always respect the local culture.

Cambodia

The Temple of Angkor Wat is a must-see for many travel photographers. Shoot throughout the day to see how the changing light changes the mood of the temple and your photographs. I took this photograph in the late afternoon with my 16-35mm zoom lens set at 16mm. The Buddhist monks in "Lesson #1: People" were also photographed here.

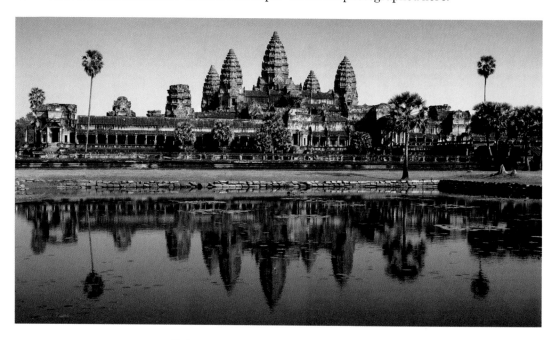

China

If you visit China, don't miss the Great Wall. To avoid the busloads of people in your pictures, stay until sunset, when the many of the buses have gone. For shooting in low-light conditions, use a tripod. For maximum depth of field, use a wide-angle lens and set a small aperture.

Cocos Island

If you've seen the opening of the film *Jurassic Park*, you've seen Cocos Island, off the coast of Costa Rica. This is one of the islands in the archipelago, Manulita Island. In the waters surrounding Cocos, you'll find some of the best scuba diving in the world and lots of sharks!

Costa Rica

Focus your telephoto lens on the wildlife living in the rainforest. For flash pictures of distant subjects, use a flash extender (a device that fits over the flash head and extends the range of the flash). Learning the names of unfamiliar animals, like this coati, makes your wildlife experience especially enjoyable and rewarding.

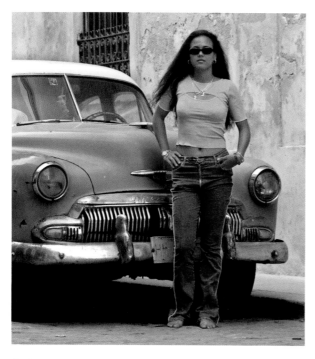

Cuba

Due to political restrictions, most Americans cannot visit the picturesque island of Cuba. However, if you go with a cultural or religious group, or if you are a journalist, you can get a license from the U.S. Treasury Department. If you can, try to get there before McDonald's and Burger King open for business and change the mood of the country. Old Havana and the city of Trinidad are wonderful places to shoot. Walking the streets for hours will give you a feel for the cities and the opportunity to get great street shots.

Dominica

This picturesque tropical island, the only World Heritage Site in the central Caribbean, draws conservation-minded travelers and nature lovers from around the world, thousands a year by cruise ship. Much of the island is covered by rainforest, most of which is inaccessible by road. Don't miss Trafalgar Falls, a highlight of most tours. You can shoot the falls from the observation deck, as I did. Use a tripod and slow shutter speed (at least 1/15 of a second) to blur the cascading water. However, busloads of cruise ship passengers arrive at the same time—I was in one of those groups—and their movement on the deck can shake your camera, resulting in an entirely blurry picture. Therefore, time your shots carefully.

Dominican Republic

Get out into the countryside and avoid the hustle and bustle of the cities and towns. Visit one of the many sugar plantations, where you can see and photograph the harvesting and transportation of the sugar cane. As in many tropical settings, it can be sunny one minute and raining the next. Don't leave your vehicle without a waterproof bag for your camera. Try not to include too much sky in your wide-angle pictures. The sky is usually filled with white clouds that can cause an underexposed foreground.

Fiji

You'll find wonderful beaches and people in this tropical paradise. Pack a polarizing filter to darken the sky and to reduce glare on the waves. In local villages, try the "kava," a drink that's said to offer a relaxing feeling—after slightly numbing your mouth.

Hong Kong

The streets of bustling cities, such as Hong Kong, offer endless photo opportunities. Stuff a wad of one-dollar bills in your pocket if you plan to take people pictures. Small tips thank your subjects in any language. Don't miss the floating village of Aberdeen, which is jam-packed with Chinese junks and water taxis.

The Galápagos Islands

You can't get much closer to wild animals than you can here. A 70-200mm zoom is great for wildlife photography, but pack a wide-angle zoom for landscape photographs. To visit the enchanted islands, you'll need to live on a boat for several days.

India

India is a land of tremendous contrasts. Seeing the poverty is hard on most travelers, but the people and the sites, like the Taj Mahal, are wonderful. Bring all your lenses and accessories to record your memories. Be prepared for chaotic traffic jams, in which the cab drivers marvel at the "lane system" we have in the United States.

Kuna Yala, Panama

Throughout the 365 islands (one for every day of the year, they say) of Kuna Yala, the women wear colorful, handmade dresses and have a special sense of dignity about them. Pose your subjects in the shade for soft and flattering lighting.

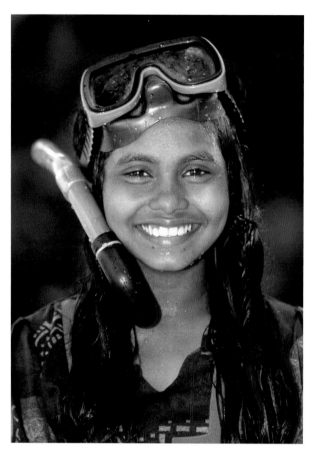

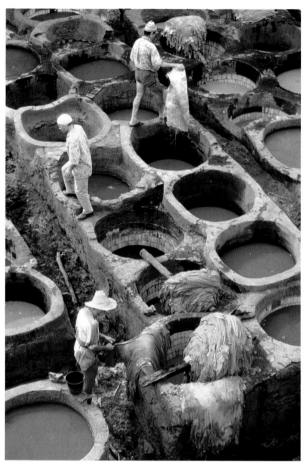

Maldives

You'll find some of the best scuba diving in the world in this chain of islands off the southwestern tip of India. You'll also find very friendly people. So, spend some time exploring the islands in this tropical paradise.

Morocco

The Fez tannery is perhaps the worst-smelling place I've been on the planet, but it provides unique photo opportunities. You'll get an overhead view from the top floor of the tannery.

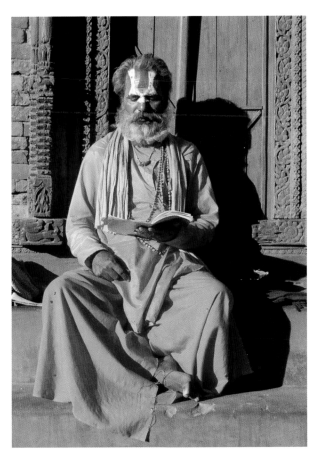

Nepal

This Himalayan country offers a spiritual place to photograph. There are photo opportunities everywhere, in the cities and in the countryside. Nepal is also a place where you want to take all your gear to document the endless sites. For a glimpse of this country, rent the movies *Himalaya* and *Kundun*.

Palau, Micronesia

When visiting this Micronesian country, take a one-hour flight in a small plane over these magical islands. For the best aerial photographs, ask to have the plane's door removed. Shoot at a fast shutter speed (at least 1/250 of a second) to avoid camera shake caused by the plane's engine. If you scuba dive, you'll find many underwater wonders on Palau's lush coral reefs.

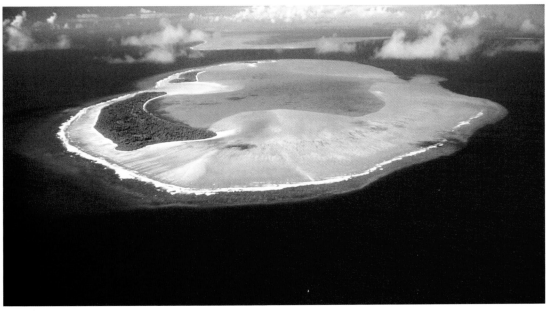

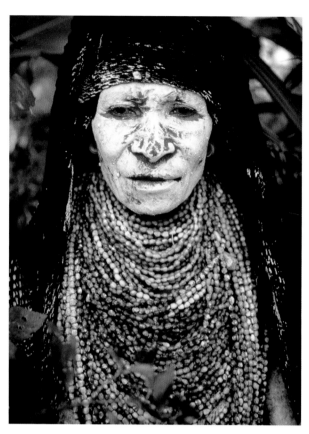

Papua New Guinea

Perhaps one of the last great photo adventures in the world. Pack light when you go out to shoot and watch all your gear very, very carefully. More than 800 (yes, 800) languages are spoken on the islands, on which live several different tribes, including the Mudmen. The members of this tribe (men and women) cover their bodies with white clay during ceremonies to commemorate previous generations who used the mud to scare off neighboring tribes. The Huli Wigmen are also interesting to see and photograph. In the digital darkroom, transform your color pictures into black-and-white images and add old-time creative digital frames for an old-time look.

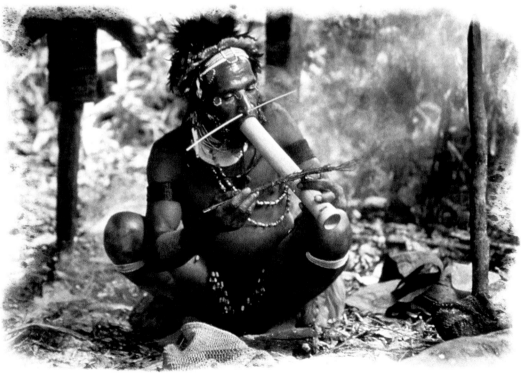

Red Sea, Egypt

The Red Sea is one of the Seven Underwater Wonders of the World. If you dive there, you'll see why. From a scientific standpoint, there is an incredible diversity of marine life. From a visual standpoint, the reefs are alive with color, and interesting animals, such as this Spanish dancer.

St. Martin

Street photographers will love Carnival, held at Easter time. Like Crop Over (mentioned earlier), the festival draws participants from all over the Caribbean. Take a lot of pictures to capture just the right expression of a performer. Stuff an extra battery and memory card (or two) in your photo vest or camera bag so you don't run out of power and storage.

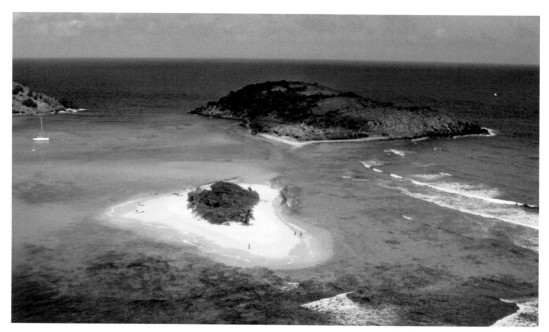

St. Thomas

After visiting St. Thomas, I think I need to do a Google search to find out if St. Thomas is the patron saint of shoppers. The main port is packed with shops, selling everything from trinkets to fine jewelry, rum and cokes to fine wine. It's also packed with up to eight cruise ships at one time. If St. Thomas is a stop on a Caribbean cruise, hop off the ship and take a helicopter ride around the island and surrounding islands. The scenery is breathtaking. Perhaps more importantly, you'll see that there are peaceful beaches on which to relax and recover from shopping.

Singapore

Singapore is a good stopping-off place on your way to Southeast Asian destinations. Spend a day photographing the Hindu and Buddhist temples. And don't miss the night safari at the Singapore Wildlife Park.

South Africa

As in Botswana, you'll see fewer people in the parks in South Africa than you'll see in East Africa. Because fewer people visit the parks, you'll have a good chance for personal, close-up encounters.

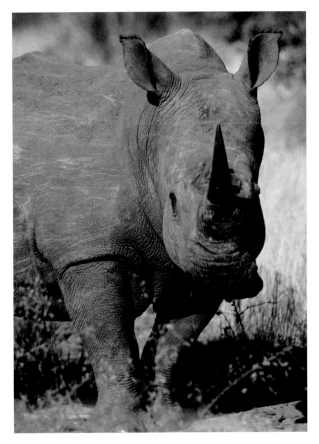

Tanzania

If you go to Kenya, be sure to visit Tanzania, or vice versa. The countries are neighbors, and both offer wonderful wildlife encounters. Photo safaris in Tanzania and Kenya are generally more affordable than in Botswana and South Africa. Whatever photo safari you join, bring plastic bags for your cameras and lenses to protect them from dust and rain.

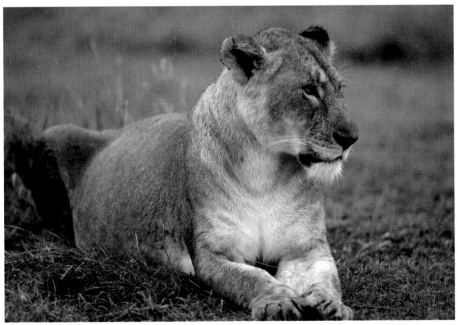

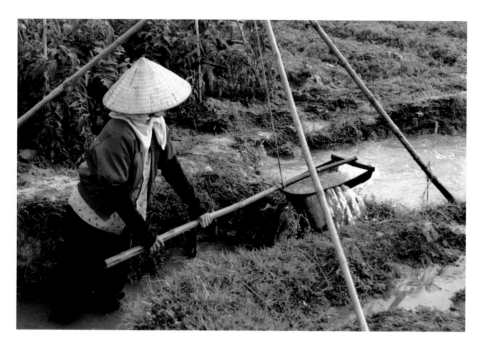

Vietnam

Ranks near the top of my list of favorite places to shoot. The people are warm and friendly and the food is great and cheap. As with all your photos, choose your Image Quality setting carefully. RAW will give you the best image quality and the greatest image flexibility.

So, there you have it: a sampling of the people and places I've had the privilege and pleasure of photographing. I hope you enjoy them as much as I have enjoyed sharing them with you.

Oh, yes, there is one more place I like to photograph, a place that is very special to me: Croton-on-Hudson, New York, where I live. It's about an hour's drive (provided there is no traffic) from New York City. You'll find beautiful scenery and wild animals, such as this saw-whet, to photograph. You'll also find a community filled with creative people.

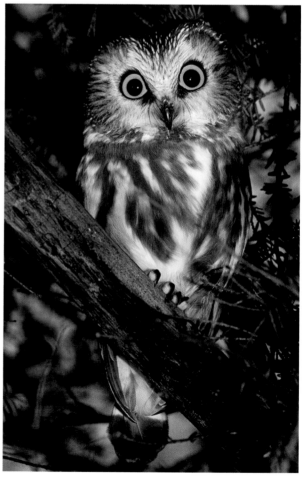

Missed Shot to Postcard Shot

Have you ever taken a seascape or landscape picture from a moving plane, boat, or car, in which the horizon line was tilted? And, have you been in a situation in which you had to work fast to get off a shot without making any exposure adjustments, which resulted in an over- or underexposed picture?

Well I have made both mistakes, one time while shooting from a helicopter around St. Thomas.

I was disappointed with a few of the out-of-the-camera images. But I knew they could be saved in the digital darkroom.

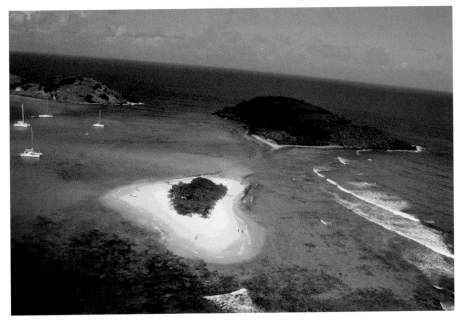

Here's a look at how I rescued a picture from the Trash icon on my computer. I used Photoshop CS, but you can use this technique with similar digital image-editing programs that let you crop, rotate, and enhances images.

My original image shows the horizon line quite tilted. The picture also lacks those beautiful colors that we are used to seeing when we look at Caribbean pictures. The dull color was due to a slight overexposure. What's more, I took the picture at midday, when the sky was a bit cloudy.

To level the horizon line, I first used the Magnifying tool while holding down the Option key on a Mac or Alt on a Windows computer to reduce the picture size on my monitor. That opened up some gray working space around the picture. Next, I selected the Crop tool and selected the entire image. When the Crop tool is moved outside of the picture area, we get a double-arrow icon that lets us rotate the picture.

Next, I rotated the Crop box so that the bottom crop line lined up with the horizon line.

After I pressed Return, my horizon line was level! But now I had some white space around my picture. And, as you can see, part of the original was now cropped out.

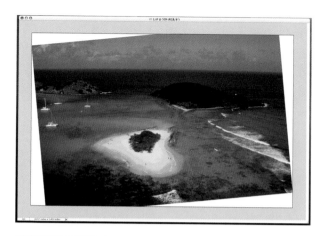

Next, I used the Crop tool to crop out the unwanted white areas of the image.

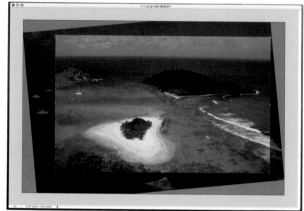

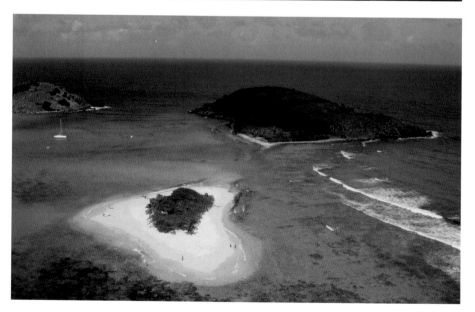

This is the result of a creative use of the Crop tool: a level horizon line.

To rescue the color from the lackluster picture, I boosted the Saturation in Hue/Saturation and darkened the picture with the Shadow slider in Levels.

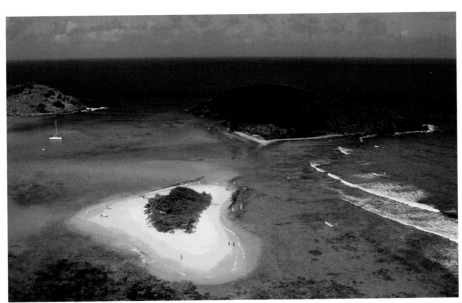

Now that's more like it. A poor snapshot was turned into a postcard shot in less than five minutes. Yes! It's the picture that's on page 286.

The moral of this lesson: Don't delete your snapshots too quickly. A quick fix may be only a few clicks away!

Postscript

It's April 2005 as I write this postscript. Susan, Marco, and I have just returned from Panama. We spent the first part of the jaunt photographing the Kuna villagers in the San Blás Archipelago, a short boat ride off Panama's Caribbean coast. The second part of our adventure took us to an Emberá village nestled in the rainforest, a one-hour car ride and then a one-hour boat ride by dug-out canoe from Panama City.

The trip was very special. I had the opportunity to share some of the pictures I had taken on a 2002 trip to Panama to photograph the Kuna and the Emberá. Rather than bringing prints to share, we brought a dozen copies of my book *Rick Sammon's Complete Guide to Digital Photography* and gave the books to the people whose pictures appeared on the pages. The book was a "thank you" to them for letting me into their lives for a brief moment in time, and for letting me photograph them.

I don't think we could have showed up with a better gift. The subjects were pleased to see their pictures, and soon the entire village was paging through the book, pointing to pictures, asking where they were taken, and inquiring about the subjects.

To these people, who lead relatively simple lives, we were world travelers who brought new information and new views of the world. To me, these people were gracious hosts, eager to share knowledge of their locale and their customs. I was greatly honored. The people were very proud to be included in the book, knowing that many others would get a glimpse of their lives.

So in the postscript, I'd like to share some of the pictures I took during this return trip, to provide a glimpse of our adventure and of Kuna and Emberá life.

But there is another reason I am sharing these pictures with you: the access we had and the acceptance we gained. The personal portraits I took were the result of something that we, as photographers, can do to make it easy for those who follow in our footsteps, sharing and giving back. The more we give, the more we get, as illustrated in the photographs that follow.

Here I am holding the book open to the page on which this Kuna woman's picture appears.

My guide's mother looking at her picture in the book.

Kuna women in typical, daily Kuna dress.

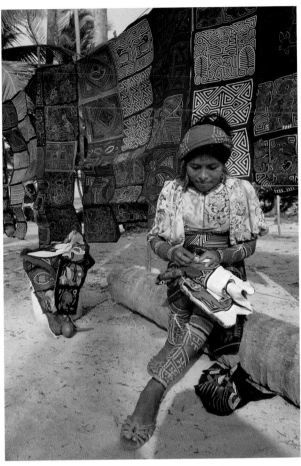

Woman sewing a mola on Pelican Island.

One of Kuna Yala's 365 islands.

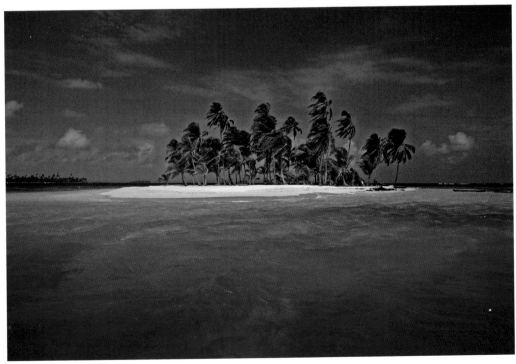

Schoolboy, Kuna Yala.

The trust the Emberá villagers granted me allowed me to join with the dancers during a celebration.

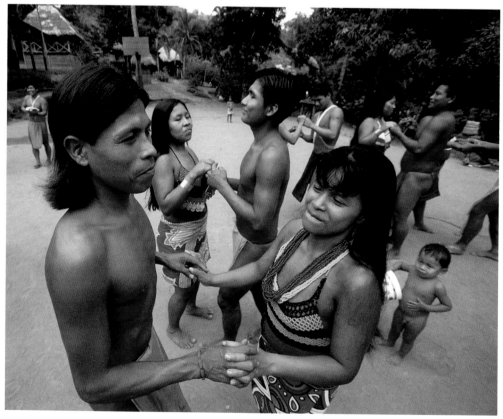

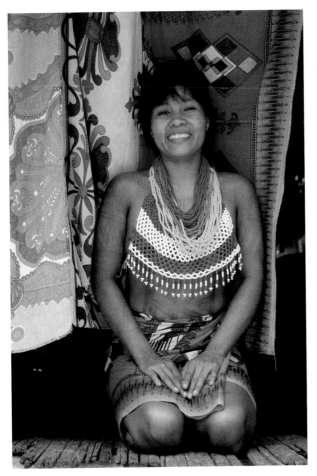

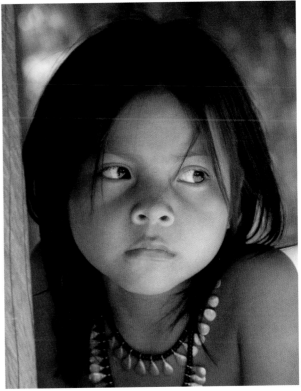

Two of my favorite portraits of an Emberá woman and a child.

I leave you with a photograph of my two traveling companions, Marco (wearing an Emberá mask) and Susan. For them, experiencing Kuna and Emberá life was a once-in-a-lifetime experience. The magic of photography helped me

gain acceptance in Panama. If we show courtesy and thoughtfulness as we travel, photography can do the same for us on every trip.

Acknowledgments

As with my all my books, more than a few dedicated and talented individuals, friends, and colleagues helped me with the production of this one. Here's a look at the key players.

As you may have read in the dedication, my wife, Susan, and son, Marco, made traveling and photographing a fun and rewarding experience, even if I was perhaps not so much fun when I was focusing on taking pictures.

Susan, and my dad, Robert M. Sammon, Sr., also helped me with the text for this book, reading every lesson and making suggestions that greatly improved the work.

Leo Wiegman, my editor for this book, my third with W. W. Norton & Company, helped me organize my photographs and text into an easy-to-read format. Leo's knowledge of photography also helped me express my ideas in a clear and concise manner.

Several other members of the W. W. Norton & Company team also helped transform my pictures, words, and screen shots into an easy-to-follow book. They include Carole Desnoes, Ingsu Liu, Sarah Mann, Amanda Morrison, Nancy Palmquist, Don Rifkin, Bill Rusin, Nomi Victor, and Rubina Yeh.

Julianne Kost, Adobe evangelist, gets a big thank you for inspiring me to get into Photoshop in 1999. As I mentioned in the introduction to this book, every picture was enhanced to some degree in Photoshop.

Addy Roff at Adobe also gets a big thank you from me. Addy has given me the opportunity to share my Elements and Photoshop CD tips and tricks with hundreds of dedicated enthusiasts around the country.

My photo workshop students were, and always are, a tremendous inspiration for me. Many showed me new digital darkroom techniques, some of which I used on the pictures in this book. During my workshops, I found a Zen thought to be true: The teacher learns from the student.

Other friends in the digital imaging industry who have helped in one way or another include Monroe Gordon of WYNIT; David Leveen of MacSimply and Rickspixelmagic.com; Rob Sheppard and Wes Pitts of *Outdoor Photographer* and *PCPhoto* magazines; Ed Sanchez and Mike Slater at nik multimedia; George Schaub, editorial director of *Shutterbug* magazine; Scott Kelby of *Photoshop User* magazine, Chris Main of *Layers* magazine; Bill Lindsay of WACOM; Ellen Pinto of Pantone; Russell Hart, Burt Keppler Mirjam Evers, Michelle Cast, and John Owens of

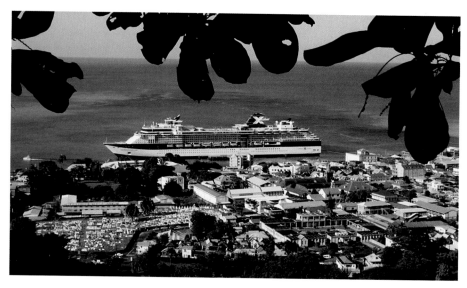

Popular Photography and Imaging magazine; and Lauren Wendel of *Photo District News*.

The staff and crew of the Royal Caribbean *Serenade of the Seas* (pictured in "Lesson #5: By the Sea") and the Celebrity *Constellation* (pictured here docked in Dominica), on both of which I wrote some of the text for this book, also deserve my gratitude. Thanks for the smooth sails.

A special thank you goes to my friends Tanya Chuang, Mike Wong, and Jim Gall of SanDisk, the company that makes the CompactFlash memory cards on which I record all my digital images.

SanDisk

And, last but certainly not least, Kelly Blok, Dave Metz, Steve Inglima, Peter Tvarkunas, and Rudy Winston at Canon have been ardent supporters of my work, as well as my photography seminars. The Canon digital SLRs, lenses, and accessories that I use helped me capture the finest possible pictures for this book.

Canon

Index

About the Author

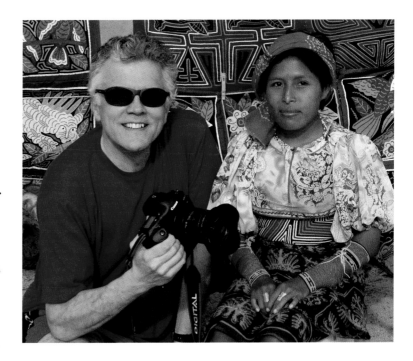

Rick Sammon's Travel and Nature Photography is the author's third book with W. W. Norton. His two previous books were *Rick Sammon's Complete Guide to Digital Photography* and *Rick Sammon's Digital Imaging Workshops.*

Rick is host of the Digital Photography Workshop on the Do It Yourself (DIY) network and the guest host of the Photo Safari on the Outdoor Life Network. Rick's recent nature photography projects include *Flying Flowers,* a large-format book on live butterflies in natural habitats. Rick has also produced two interactive training DVDs, *Adobe Photoshop Elements 3-Minute Makeovers* and *Awaken the Artist Within* (for Adobe Photoshop CS and CS2).

Rick is a regular contributor to *Outdoor Photographer*, *PCPhoto*, *Layers Shutterbug*, and *eDigitalPhoto*.

Rick gives more than a dozen workshops and presentations a year, including seminars at the Explorers Club in New York City, where he is a member.

Visit with Rick at www.ricksammon.com and www.rickspixelmagic.com.